Christmas 2020

Th't of you John Arne with your love of space + the mysteries of our beautiful moon

J J

An Hachette UK Company
www.hachette.co.uk

First published in the UK in 2018 by ILEX,
a division of Octopus Publishing Group Ltd

Octopus Publishing Group
Carmelite House, 50 Victoria Embankment
London EC4Y 0DZ
www.octopusbooks.co.uk
www.octopusbooksusa.com

Design, layout and text copyright
© Octopus Publishing Group Ltd 2018

Distributed in the US by Hachette Book Group
1290 Avenue of the Americas, 4th and 5th Floors,
New York NY 10104

Distributed in Canada by Canadian Manda Group
664 Annette St., Toronto, Ontario, Canada M6S 2C8

Editorial Director: Helen Rochester
Commissioning Editor: Zara Anvari
Managing Editor: Frank Gallaugher
Senior Editor: Rachel Silverlight
Picture Research: Jennifer Veal
Art Director: Julie Weir
Designer: Luke Bird
Publishing Assistant: Stephanie Hetherington
Production Manager: Caroline Alberti

All rights reserved. No part of this work may
be -reproduced or utilized in any form or by
any means, electronic or mechanical, including
photocopying, recording, or by any information
storage and retrieval system, without the prior
written permission of the publisher.

Robert Massey and Alexandra Loske assert the moral right
to be identified as the authors of this work.

Cover image © Stocktrek Images, Inc./Alamy

ISBN 978-1-78157-571-0

A CIP catalogue record for this book
is available from the British Library.

Printed and bound in China

MOON

Art, Science, Culture

Robert Massey & Alexandra Loske

CONTENTS

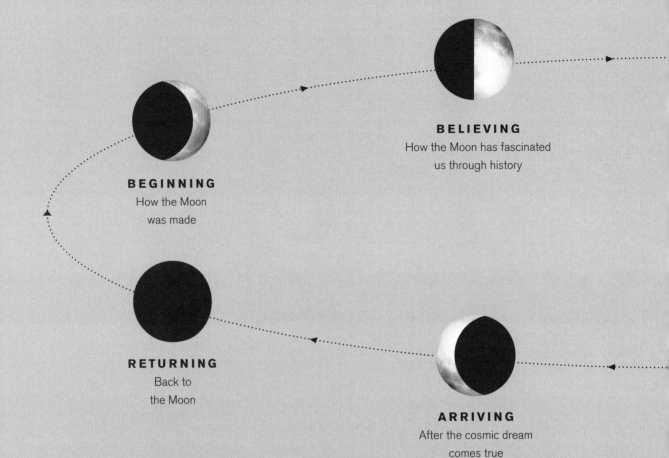

BEGINNING
How the Moon was made

BELIEVING
How the Moon has fascinated us through history

RETURNING
Back to the Moon

ARRIVING
After the cosmic dream comes true

Introduction ... 6	The Nebra Sky Disc ... 70
The Female Moon .. 12	Georges Melies' *Le Voyage dans la Lune* 75
Ancient Lunar Deities ... 26	*Earthrise* ... 76
The Melancholy Moon .. 34	Lunar Lava Tubes: Future Habitats? 80
The Moon and Death .. 39	Nasmyth and Carpenter's Visions of the Moon ... 86
The Moon in Eclipse ... 44	Soviet Space-Race Propaganda 90
The Lunar X: Drawing the Moon 50	Sergei Korolev .. 99
The First Men on the Moon 54	Margaret Hamilton ... 104
The Dress Rehearsal for the Moon Landing 63	Fashion in the Space Age 107

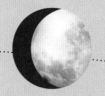

EXPLORING
A brief history of observing the Moon

ROMANTICIZING
The Moon as image; symbolic and sublime

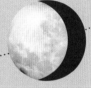

REACHING
Our long tradition of imaginary journeys to the Moon

TRAVELING
From the Space Race to the Apollo era and beyond

Paper Moons	115	Not (Just) the Man in the Moon	175
The Werewolf	126	The Names of the Moon	178
Lunacy	132	The *Blue Marble*	185
Supermoons	141	The Moon and Fate	186
Phases of the Moon	144	The Moon Gets Farther Away	195
Lunar Rovers: Driving on the Moon	156	Moon Base	195
The Great Moon Hoax	160	Essays (above)	204
Islam and the Moon	162	Index	238
Thomas Harriot's Moon Map from 1609	172	Acknowledgments	240

THE MOON: AN INTRODUCTION

Looking from the Earth into space, just two objects—the Sun and the Moon—appear to the naked eye as anything other than points of light. The Moon is still the only extraterrestrial destination visited by human beings, and for the time being, the one to which we are most likely to return. Bright enough to light our way at night, changing its shape daily, and with features of a violent past, astronomers, writers, artists, and astronauts have been inspired by the light and landscapes of our neighbor.

The Earth and Moon have a shared history. Early on in the life of the solar system, a Mars-sized object struck the larger precursor of our world in a collision far bigger than anything we see today. The Moon formed out of the condensed debris, leaving a stripped-down Earth behind. A wider "great bombardment" saw large rocks pepper the surfaces of the planets, the results of which have now eroded away on Earth. Without a thick atmosphere, and weather, the surface of the Moon, in contrast, is an almost pristine record of that early era. Even the largest features—the dark gray "seas" so obvious at full Moon—are the result of colossal impacts that punctured the lunar crust, allowing lava to well up from inside. The whole lunar surface is shaped by meteorites that collided with it at high speed to leave craters behind.

Without the Moon, life on Earth might be very different. This large natural satellite stabilizes the axis of the Earth, and the changing tides of the sea are important to whole ecosystems. The interplay between the two worlds—the Earth and Moon are effectively a "double planet"—keeps the Moon in captured rotation, where only one side is seen on Earth. That interaction is slowly giving orbital energy to the Moon too, and it drifts farther away from us by roughly an inch and a half each year.

The physical and familial closeness between the Earth and the Moon is reflected in our relationship with our cosmic neighbor. Human beings have pictured the Moon almost from the very origins of creative endeavor. The earliest Palaeolithic markings on rock, horn, bone, and stone suggest that the Moon was among the subjects of the first recorded stories of the human race. Ancient watchers and early civilizations often honored the Moon as a god, giving it supremacy even over the Sun, and gifting it many different names and personalities. Paradoxically both a symbol of darkness and hope, the Moon continues to be the subject of myth, legend, and superstition even in contemporary society, with a multitude of contrasting readings of its nature.

Like day and night, and the changing seasons, observing the Moon's phases gives us a natural way of marking the passage of time. Neolithic monuments mark moonrise and moonset, and in the Islamic lunar calendar, the sight of the new crescent Moon is the

sign that begins each month. Some of the greatest pre-telescopic observatories came from the Islamic world, and were set up to help calibrate this imperfect timekeeper. Ancient civilizations may have used the lunar calendar ritualistically to guide their activities through the changing seasons, and Native Americans name each month's full moon to mark the behavior of the season and its flora and fauna.

Our observation of the Moon has brought a resonance to the cyclical. Life, fertility, the seasons, and the tide are all linked to the Moon, sometimes physically and sometimes more metaphorically. Ancient associations with destiny and life's finite span have made the Moon an incredibly powerful and terrifying body, and it remains an enduring symbol of darkness, death, and related horrors.

Oscillating between fascination and fear, humans have nevertheless recurrently dreamed of setting foot on this highly desirable destination. Fanciful visions of space travel have permeated our literature, films, art, and culture for centuries. But it was not until the 1960s that our wildest imaginings became real.

Apollo 11 blasted off on July 16, 1969, with astronauts Edwin "Buzz" Aldrin, Neil Armstrong, and Michael Collins aboard. Four days later, on July 20, Neil Armstrong became the first human to step on the Moon. He and Aldrin walked around for two and a half hours, performed experiments, and collected samples.

Both the anticipation of this achievement and the photographs and film footage of the missions inspired the mass production of space-themed merchandise and ephemera, along with a new wave of science fiction literature and films, and even brought about a new aesthetic with astronaut-style fashions and interiors. The Western world was entirely absorbed by the Space Race, a political battle that fought for the Moon as both a future refuge and a symbol of power and ownership.

Upon Apollo 11's success, many embraced a new scientific understanding and feeling of possibility, and yet the Moon's demystification will never be complete. Even today, that silver disc in the sky remains a key protagonist in our legends, myths, and dreams. Yet while lunar images, rituals and beliefs persist, through reflection we might gain a new and enlightened perspective, both on the Moon and humankind.

Fifty years on from Apollo 11 and the first Moon landing, space agencies are thinking once more about crewed missions to the Moon. Japan, China, India, Russia, and Europe all aspire to explore with robots, and then people, taking advantage of recently discovered water ice in lunar soil to help supply a permanent base. Lunar scientists are pushing, too, to complete what they see as unfinished business—and that first outpost could be just the beginning of our journey into the solar system.

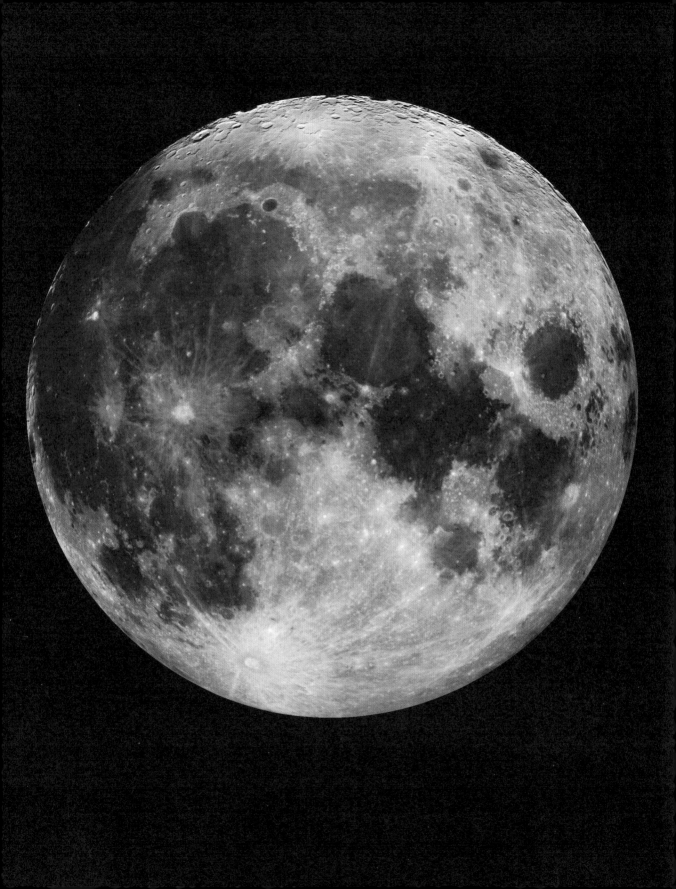

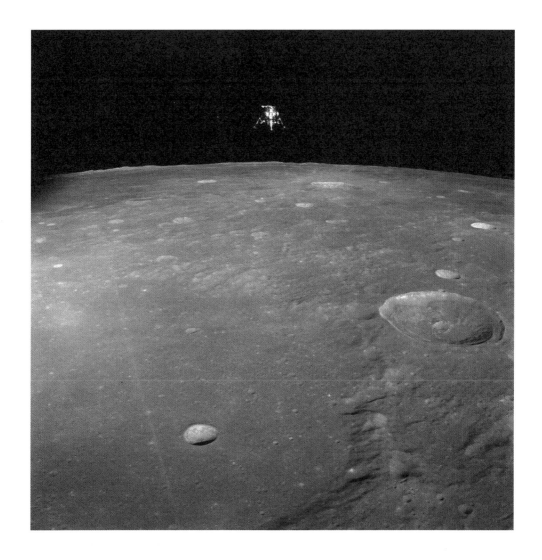

Earth's Moon *(left)*
Photograph – NASA, Galileo spacecraft, December 7, 1992

The maria visible in the image on the left include Oceanus Procellarum (far left), Mare Imbrium (center left), and Mare Serenitatis and Mare Tranquillitatis (center). The bright, distinctive feature at the bottom is the Tycho Crater. Its brightness is due to its relative youth—approximately 108 million years old; the oldest maria are about 4 billion years old. In time, the prominent rays will fade.

Apollo 12 lunar module Intrepid landing on the Moon's surface in the Ocean of Storms
Photograph – NASA, November 19, 1969

The Ocean of Storms, where the Apollo 12 lunar module touched down, is the largest of the Moon's maria, and in fact the only one to be given the appellation of Ocean. These maria were formed by ancient meteorite impacts that punctured the Moon's crust, and the resulting basins eventually filled with lava.. They appear as dark spots because the basalt of which they are composed is not very reflective.

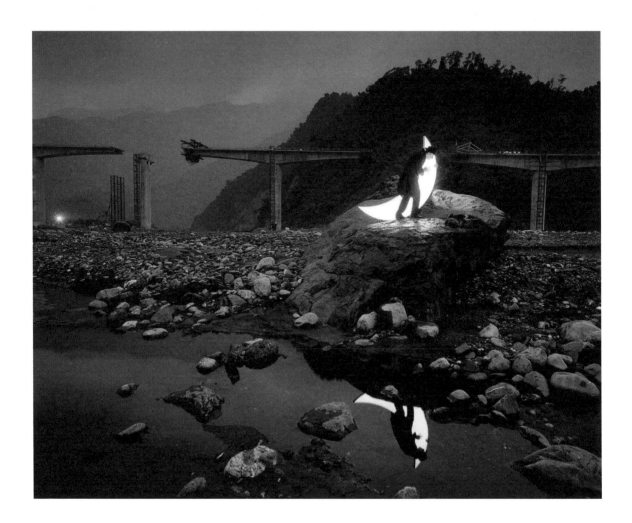

**Under broken bridge, Maolin, Taiwan,
journey of the Private Moon, 2012**
Photograph – From *Private Moon* series (2003–) by Leonid Tishkov
Photo by Leonid Tishkov and Po-I Chen, 2012

Since 2003, Russian artist Leonid Tishkov's has chronicled the adventures of a man who falls in love with the Moon. The project, which has taken the Russian artist around the world with his Moon explores humanity's universal interest in the celestial body, and the companionship it provides at night.

Field Columbian Museum's Moon model *(right)*
Plaster, wood, and metal
Johann Friedrich Julius Schmidt, Germany, 1898

Astronomer Johann Friedrich Julius Schmidt dedicated his life to studying the Moon. His Moon model took five years to build and was based on detailed maps he spent decades creating. In honor of his work, a lunar crater was named after him.

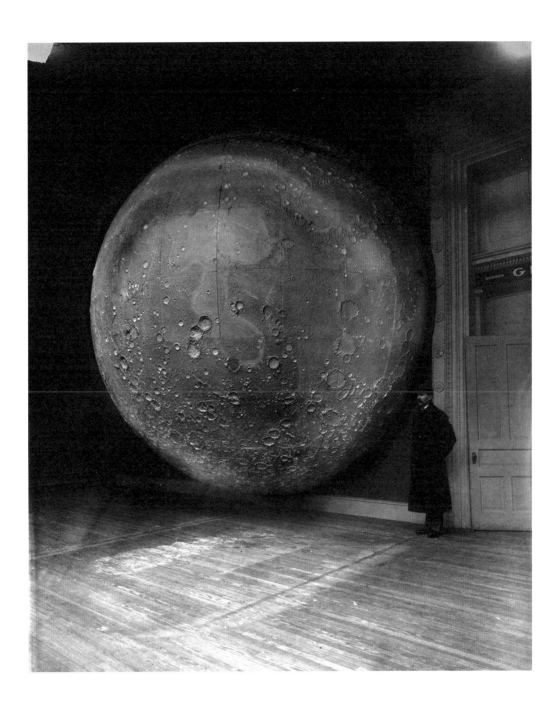

THE FEMALE MOON

A woman's menstrual cycle being roughly the length of a lunar phase cycle, it's not surprising that the Moon has long been associated with women, fertility, and perceived female traits. For thousands of years, the principle of male and female duality has been compared to the Sun and the Moon—the two most prominent objects in the sky. Across different cultures and ages, however, the gender of the cosmic deities has been interchangeable and non-exclusive. In many ancient cultures, the Moon was male or dual-gendered, either male or female depending on its phase. It is only relatively recently in human history (from around the Iron Age, notably in Greece) that the notion of the female Moon has become set in stone, at least in Western culture.

This shift may tell us more about the perception of gender roles than anything else. Parallels were drawn between the Sun and Moon's co-dependency, their apparent powers and weaknesses: for example the Sun as a great source of power, which can also be destructive, or the Moon as a stabilizing but changeable force and benign presence. Before it was generally understood that the Moon reflected the Sun's light—later an easy symbol for supposed feminine passivity—the Moon was a lesser light in the sky, albeit one which had the ability to temporarily obscure the Sun.

Awareness of the Moon's influence on the tides added to beliefs concerning the human body in general, and the female body in particular. In the Middle Ages, water was the lunar element, and the goddess Luna is frequently depicted with water attributes, or otherwise with exaggerated feminine features. Related myths developed alongside, for example that more babies are born during a full Moon than at any other time, or that women are more fertile during a full Moon.

Although countless books and websites offer guidance on how to maximize on the link between the Moon and female fertility, in reality there is no connection between the menstrual cycle and the lunar cycle. If this were the case, all women would have synchronized regular ovulation rhythms, in accordance with the Moon's phases, but hard statistics have proved these popular myths wrong.

Design for *The Magic Flute*: "The Hall of Stars in the Palace of the Queen of the Night," Act 1, Scene 6 *(right)*
Aquatint printed in color and hand-colored
Karl Friedrich Thiele, after Karl Friedrich Schinkel, c.1847–49

In Mozart's *The Magic Flute*, the Queen of the Night is a villain; devious, deceitful, and ultimately vanquished. Perhaps the crescent moon at her feet in Thiele's stage set represents duplicity; the changeable moon a stand-in for "feminine" unpredictability?

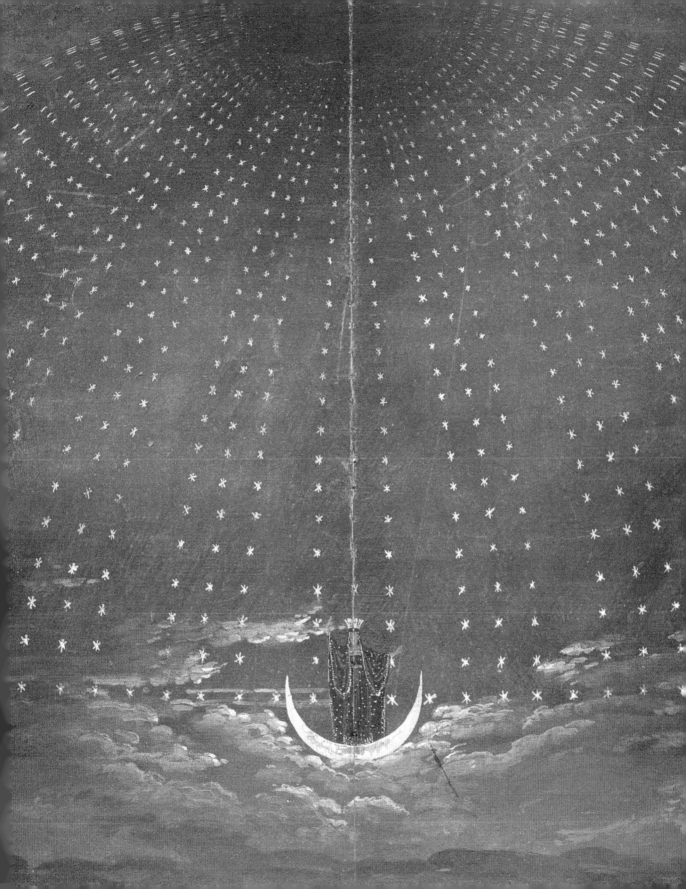

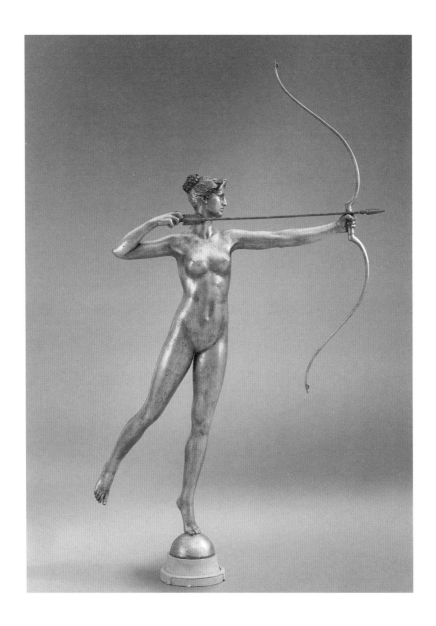

Diana
Bronze, gilt – Augustus Saint-Gaudens, 1892–93, cast 1928

Luna, from the Sala dell'Udienza *(right)*
Fresco – Pietro Perugino, 1496–1500

Above and right: In Greco-Roman mythology, there is no singular Moon goddess, but many female deities represent aspects of the Moon. Diana and Luna are both Roman Moon deities: Diana, the huntress, is the goddesses of fertility and the guardian of new life; her (older) Greek counterpart Artemis bares similar traits. Luna, meanwhile, symbolizes the Moon more literally, as its divine embodiment, and is often depicted traveling across the heavens in a chariot.

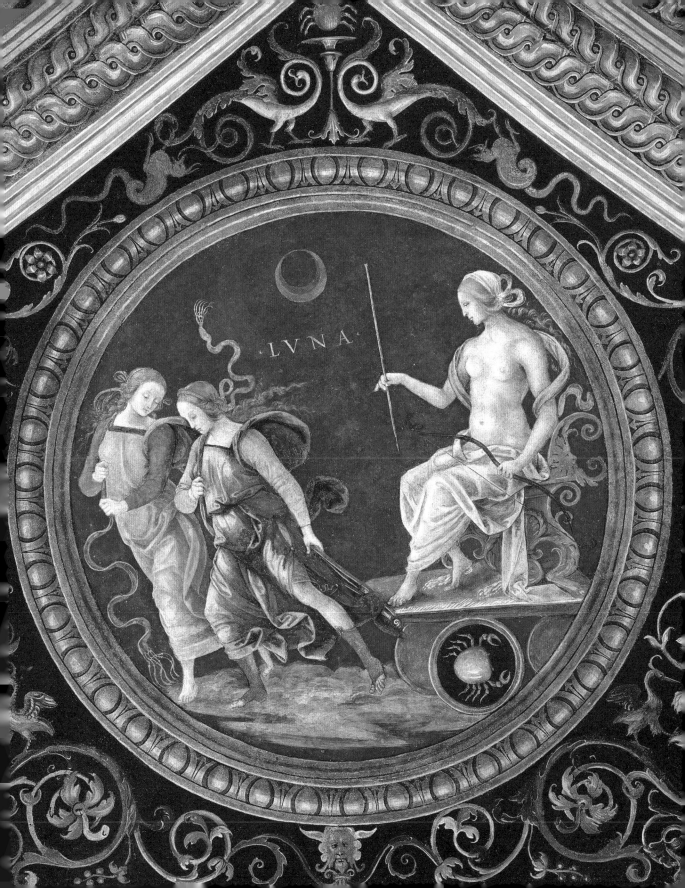

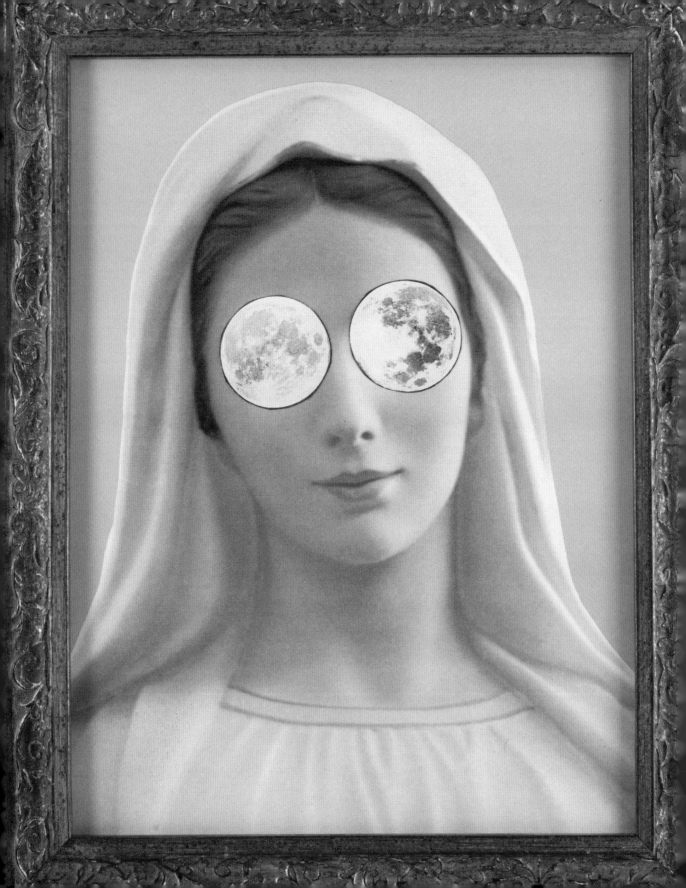

Space Age (left)
Collage – From *The Space Age Collages* by Aleksandra Mir, 2009

Mir draws parallels with religious worship and humankind's reverence to science and technology, as represented by our fascination in the Moon. Two Moons placed over her eyes suggest that the Madonna, too, is awed by the celestial body.

"Voilà donc comment" ("So that's how")
from *Around the Moon* by Jules Verne
Wood engraving – Émile-Antoine Bayard, 1870

The spectacle of the moon, reaching it, and the secrets it might hold about the universe captivate Verne's plucky protagonists in *Around the Moon*. Bayard's illustration juxtaposes a glowing, detailed full Moon with the figure of a woman.

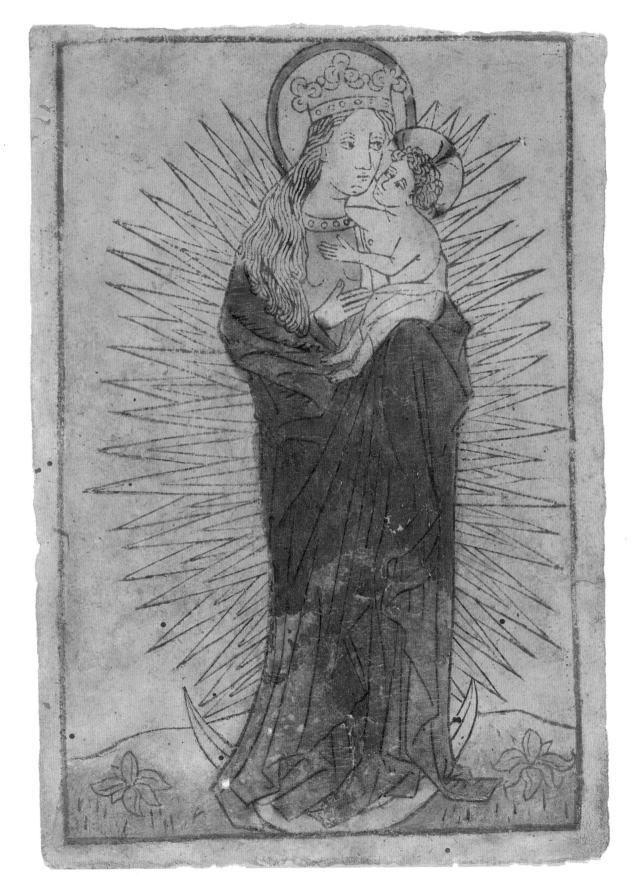

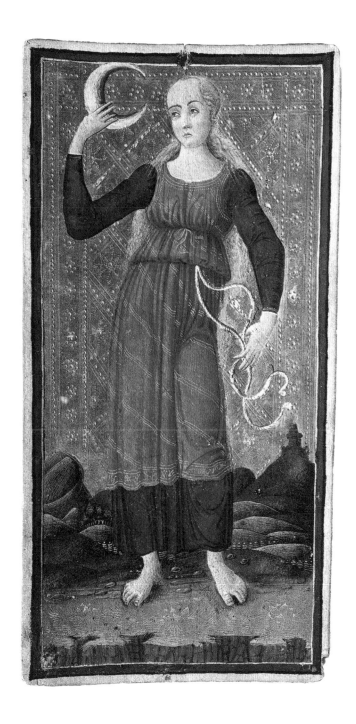

Madonna and Child on a Crescent Moon (left)
Woodcut – German, c.1450/1460

The Virgin Mary is often depicted with a crescent moon, perhaps drawing from the Greco-Roman lunar goddesses Artemis and Diana, who share her attribute of chastity.

Moon
Tarot card – Antonio Cicognara, 1490

One of 78 cards, from a 15th-century Italian tarot deck. The Moon card in a tarot deck is often personified as a woman, as it is in Cicognara's.

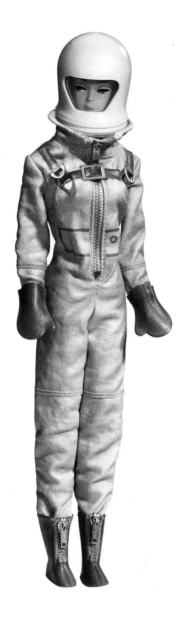

Barbie Miss Astronaut

Toy – Mattel, 1965

In 1965, Mattel succumbed to the excitement of the Space Race and sent Barbie on a mission to the Moon (Ken went too). Her silver space suit is noticeably similar to those worn to the Project Mercury astronauts of the era.

Frau im Mond (The Woman in the Moon) *(right)*

Poster, chromolithograph – Alfred Herrmann, 1929

Fritz Lang is best known for his groundbreaking 1927 film *Metropolis*. Featuring multi-stage rockets, the first "countdown to zero," and other features still found in modern space travel, his early science-fiction film was similarly pioneering.

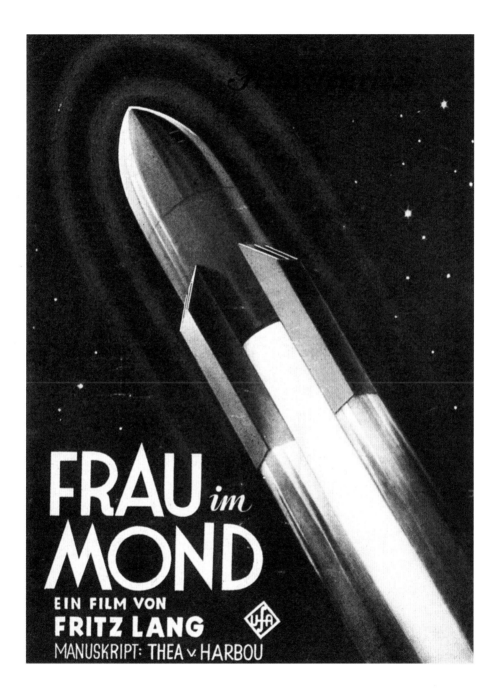

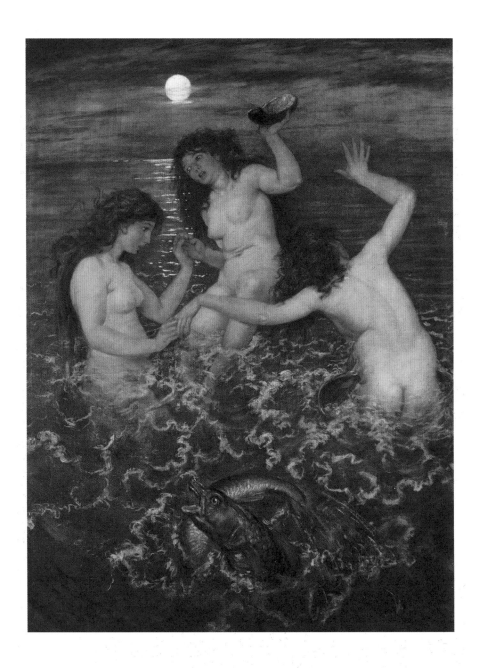

Drei Meerweiber (Three Mermaids)
Oil on canvas – Hans Thoma, 1879

Lake Reflecting Moonlight (right)
Oil on wood – Emil Parrag, 1989

Above and right: The Moon has long been associated with water, and Thoma's three mermaids recall the motif of the triple goddess, representing the waxing, full, and waning Moon: birth, life, and death. Parrag's abstracted full Moon sitting high in the night sky reflects onto the water in a ripple effect, a repeated pattern, echoing the phases of the Moon.

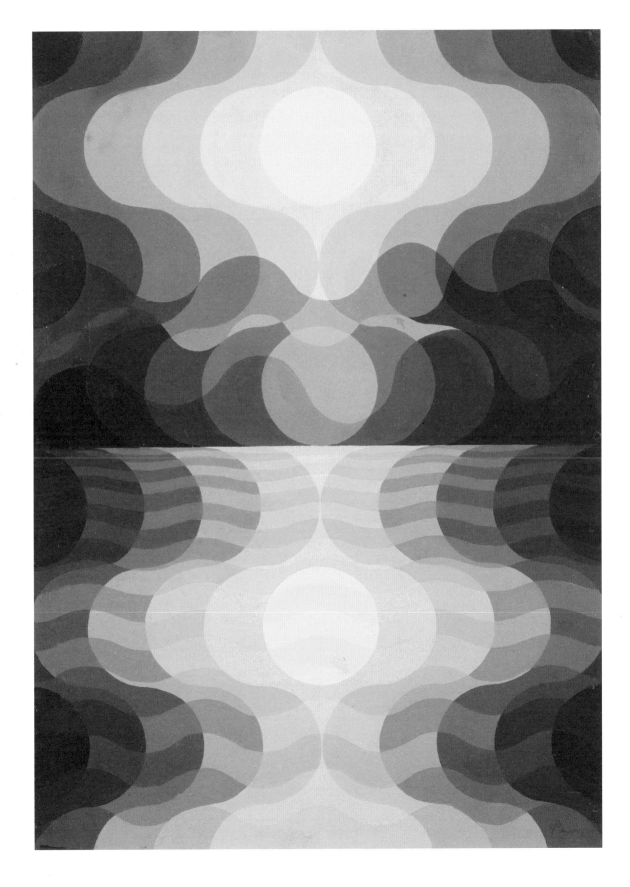

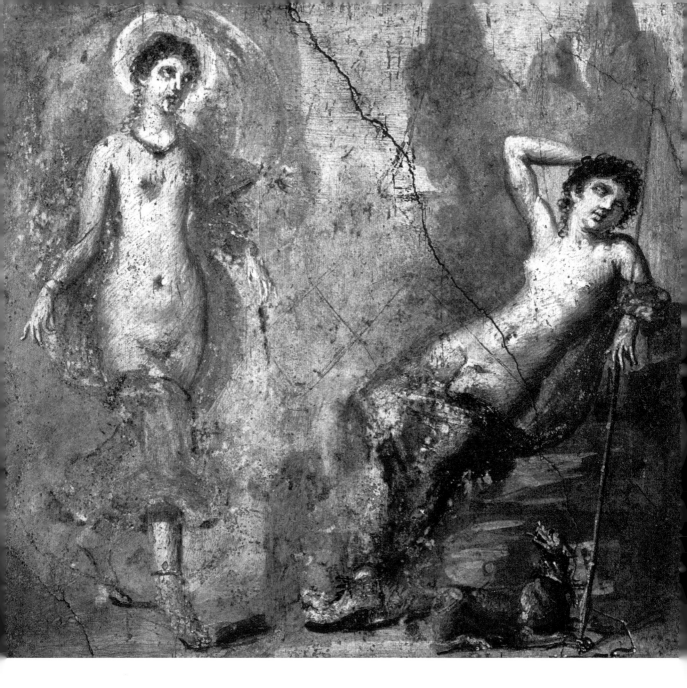

Selene and Endymion

Fresco – Roman, 1st century CE

In Greek mythology, Selenè is the personification of the Moon. Endymion, a shepherd, and the object of Selene's affections, was cast into an eternal sleep, enabling Selene to admire his everlasting youth and beauty for eternity. She bears him 50 children, thought to mirror the number of lunar months between each Olympiad.

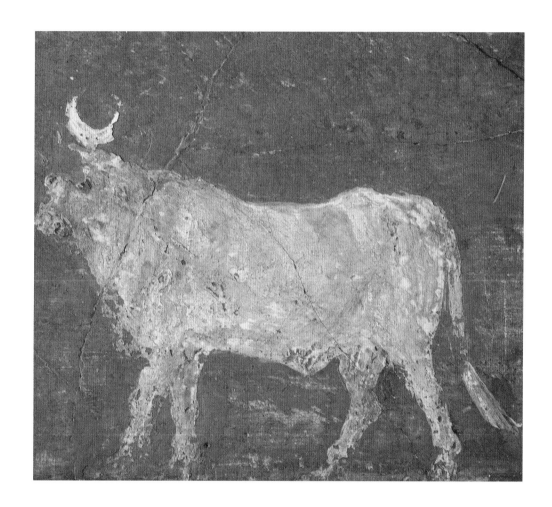

The Apis Bull with the Crescent Moon between its Horns
Painting – Roman, from Pompeii, 40–50 CE

The Apis Bull was sacred in Egyptian mythology. Said to be marked by a beam of moonlight from Heaven, it is often depicted with the crescent Moon between its horns. A symbol of strength and fertility, Apis is linked with the Sun deity Hathor, goddess of fertility and guardian of childbirth.

ANCIENT LUNAR DEITIES

Our primal fascination with the Moon means that we find examples of Moon worship in almost every ancient culture. Female lunar figures have dominated since the spread of Greco-Roman culture, infiltrating Judeo-Christian culture to this day. But there is no shortage of male Moon gods in older civilizations, such as Sin (or Nanna) in Mesopotamian culture, or Thoth, Khonsu, and Osiris in ancient Egypt; and in non-Western cultures, the Moon deity has sometimes remained male.

In Hinduism we encounter Chandra (or Soma) a Moon god whose name derives from Sanskrit and literally means "moon" or "shine." Chandra/Soma is frequently worshipped as a fertility god. The cosmic theme prevails in Hinduism with a pantheon of planetary gods (including Sun and Moon gods) known as the Navagraha. Cosmic phenomena are interpreted as the eternal power struggle between good and evil, and the work of demons, such as Rahu who devours the Sun or Moon to cause eclipses. The temporary absence of light is a sign of disorder, chaos, and danger to gods, planets, and humans.

Because of the associations with the cosmos, Chandra and other Moon deities are often depicted riding through the sky in chariots drawn by geese, white horses, or antelopes.

The iconography of gods traveling across the cosmos and toward the Moon in chariots drawn by birds or other creatures continues in both religious contexts and popular culture. In Greco-Roman mythology, Selene or Luna (respectively) is often depicted traveling across the sky in an airborne chariot, while in literature about imagined physical journeys to the Moon, flying machines powered by birds are a frequent motif. Possibly this eccentric mode of transport was inspired by descriptions of ancient Moon gods and goddesses.

But Chandra left another mark in lunar history: In October 2008, India sent its first lunar probe into space. The probe orbited the Moon for ten months, taking new high-resolution photographs. In reference to the Hindu god, they called it Chandrayaan-1.

A Tibetan representation of Rahu (right)
Painting – Tibet, date unknown

Within Hindu mythology, Rahu takes the form of a beheaded snake, the decapitation a punishment for drinking the nectar Amrita, which is also the source of his immortality. He swallows the Sun and Moon in acts of vengeance, however he cannot hold them down without a body, so they reappear: the reason for fleeting eclipses. Here Rahu is circled by some of the other cosmic deities called the Navagraha.

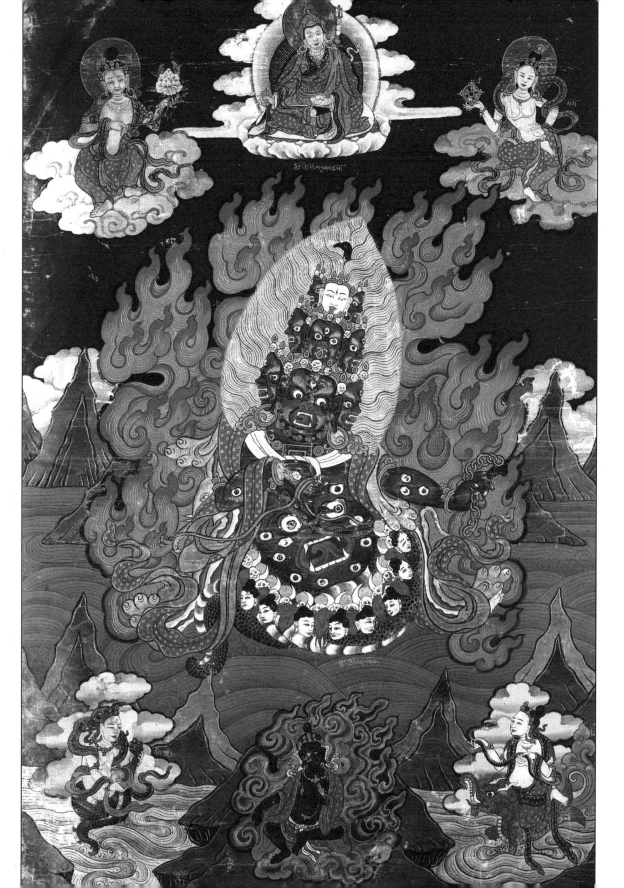

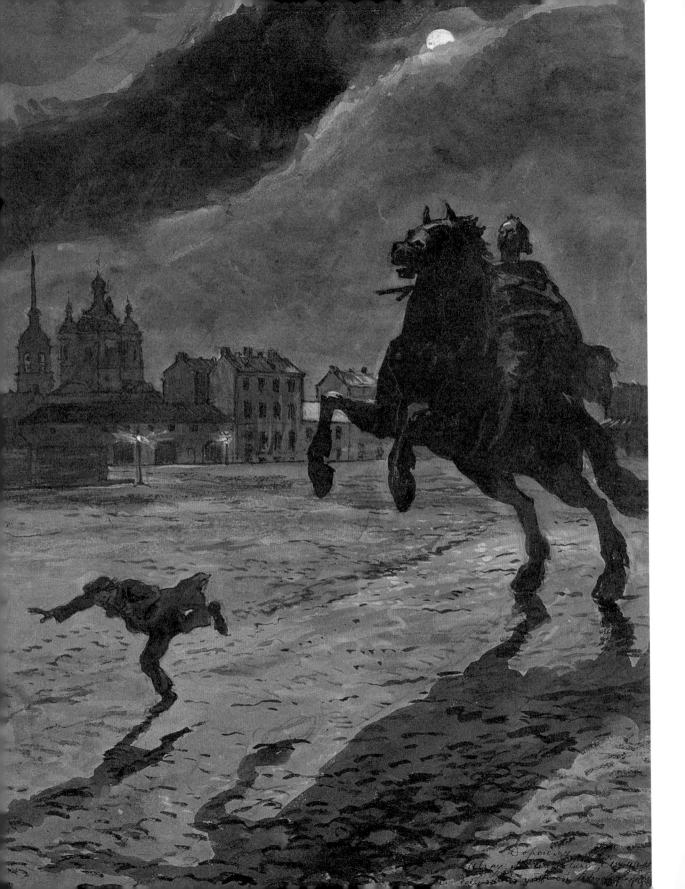

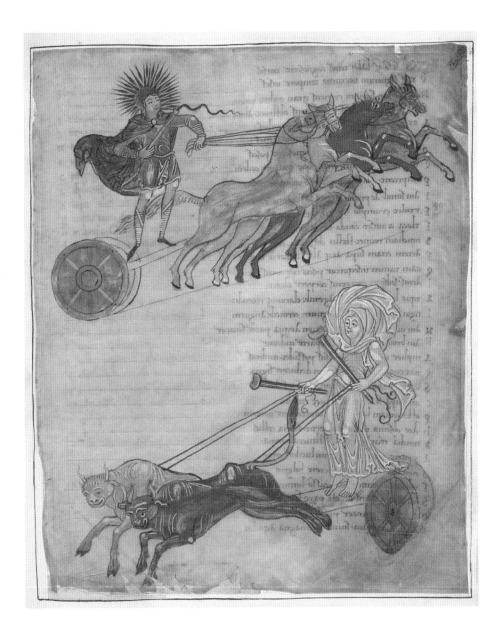

**Illustration for the poem "The Bronze Horseman"
by Alexander Sergeyvich Pushkin** *(left)*

Gouache on paper – Alexander Nikolayevich Benois, 1905–18

In art, the Moon often features to make the association between night and danger. Here it illuminates a dramatic chase scene between the titular horseman and a fleeing man, stumbling on cobbled streets.

***Chariots of the Sun and Moon*,
from Cicero's *Aratus***

Manuscript illustration, pigment on vellum – English, 11th century

Here, the Sun and Moon deities are depicted riding chariots pulled by horses and oxen, respectively. In ancient mythology, cattle, such as the Apis bull, are often linked with fertility, which is also seen as a lunar characteristic.

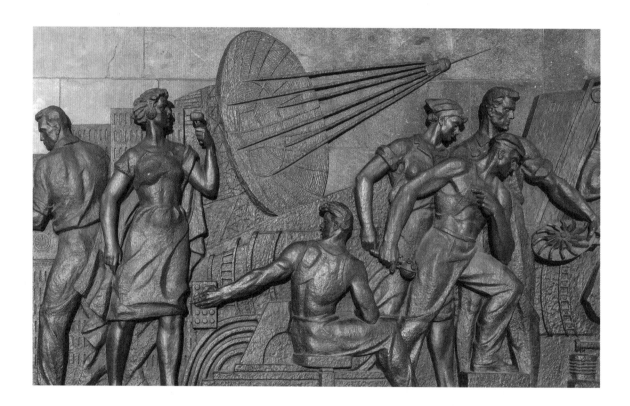

Monument to the Conquerors of Space, Moscow, Russia

Bas-relief, stone

A. P. Faidysh-Krandievsky, A. N. Kolchin, and M. O. Barshch, 1964

The "conquerors" of space in this relief include all the scientists, engineers, and workers that were employed in the Soviet space program. Soviet art from the Space Age often celebrated the collective efforts of the people (see pages 90–91).

Chariot of the Moon (right)

Relief, stone – Agostino di Duccio, 15th century

This marble relief by early Renaissance sculptor Agostino di Duccio adorns the Zodiac Chapel in the Malatesta Temple in Rimini, Italy. Here the mythological lunar goddess is pulled by a two-horse chariot and carries a crescent Moon.

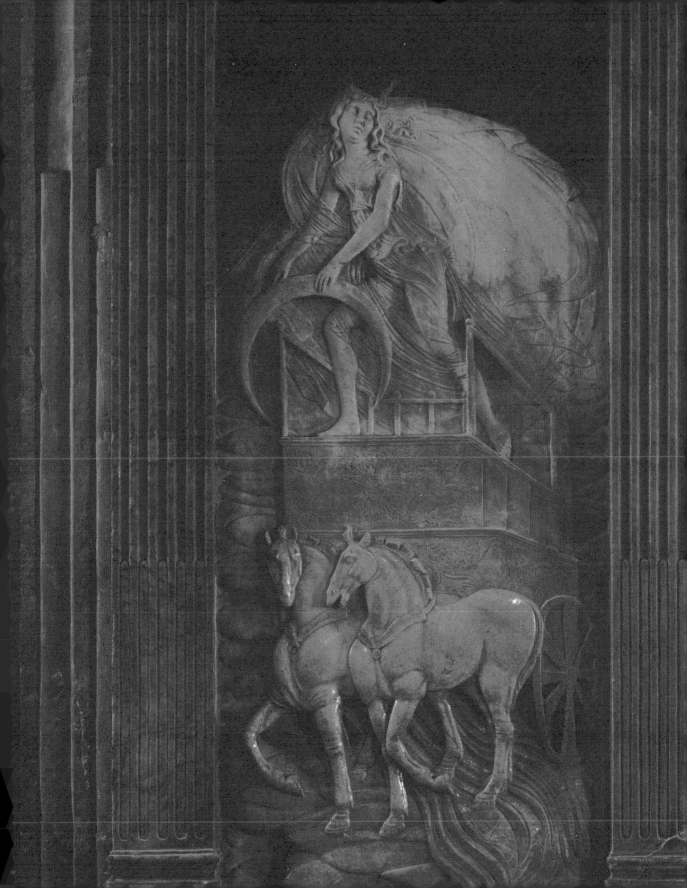

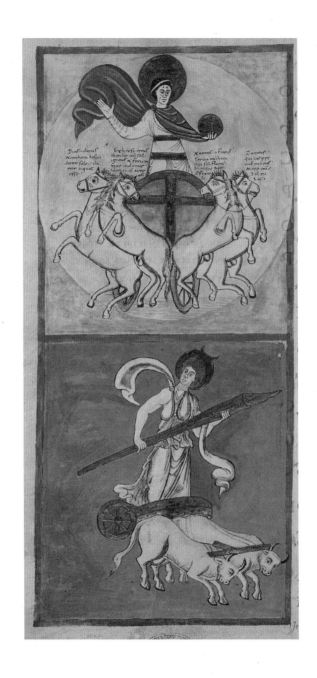

**Apollo as the Sun and Diana as the Moon,
from *Les Phénomènes* by Aratos**

Manuscript illustration, pigment on vellum – French, 10th century

As in the illustration on page 29, Helios, the Sun god, commands a four-horse chariot
while Selene, the Moon goddess, is pulled by two oxen.

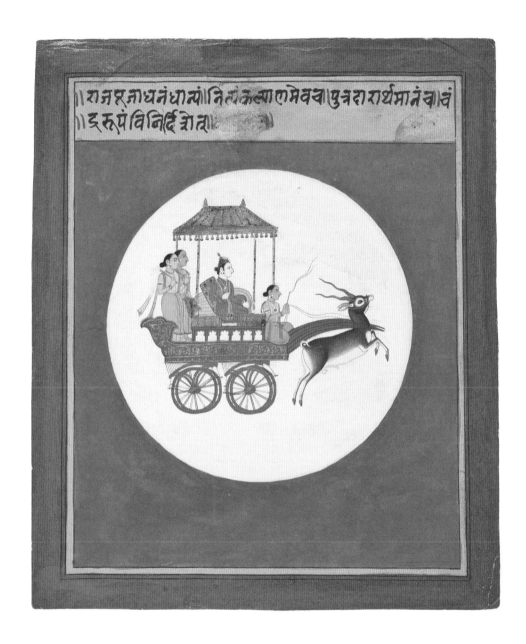

"Chandra, The Moon God" from a *Book of Dreams*

Opaque watercolor, gold, and ink on paper — Indian, 1700-25

Chandra (or Soma), depicted here in a chariot pulled by an antelope, is a Hindu Moon god, and one of the nine celestial deities that make up the Navagraha. He is the father of Budha, the deity for Mercury.

THE MELANCHOLY MOON

The Moon is an anchor for our thoughts. Often present through the dark hours of night, it is the companion of the insomniac, the lonesome wanderer, the reflective poet, and the yearning lover. In poetry, as in art, the Moon became a powerful symbol for these states of mind. The underlying tone tends to be melancholy, a pensive sadness experienced by humans reflecting on their life, purpose, and place in the world, but in this the Moon plays a passive role: it hangs in the sky reflecting our thoughts and feelings, a blank canvas and a silent listener. In one of the most popular poems in the English language, Thomas Gray's "Elegy Written in a Country Churchyard" (1750), a "moping owl does to the moon complain." Gray's contemplation on death and remembrance finishes with an epitaph that includes the line, "Melancholy mark'd him for her own."

The enormity of nature is a theme that, somewhat contrarily, seems especially pronounced at times of great scientific advances and discoveries. In the early nineteenth century, for example, when we had almost finished exploring and charting the Earth, we were beginning to understand how certain weather conditions were created, and we were on the verge of creating much faster means of transport. Images of small human figures simply gazing at vast landscapes or the horizon, with the Moon as a common focal point, seemed to strike a chord with the cultural conscious and became popular. Here, melancholy is often accompanied by a feeling of peace. Ever shifting but always reliable, in times of great change it seems we may turn to the Moon for a sense of comforting nostalgia.

A darker melancholy is present in the work of Edvard Munch, who also uses the Moon and moonlight as symbols of reflection and pensiveness. He places larger figures, on their own or in pairs, against moonlit landscapes or seascapes, and sometimes solitude turns into loneliness or even depression. His painting *Night in St. Cloud* (1890) powerfully evokes this atmosphere. In it, we see a man in silhouette, half-submerged in shadows, leaning at his window through which moonlight pours. The deep perspective and heavy darkness of the scene highlight the blue light, lending the painting a profoundly meditative atmosphere. Two years later, Munch began the series titled *Melancholy*, featuring figures with preoccupied expressions and similarly thoughtful poses, for which this painting is viewed as a precursor.

Night in St. Cloud (right)
Oil on canvas – Edvard Munch, 1890

The inner thoughts of the figure in this painting are more the subject of the work than the figure itself, as is the mood of the piece as opposed to the physical setting. A sense of melancholy pervades the image as a silhouetted man gazes out of the window to sea, deep in contemplation.

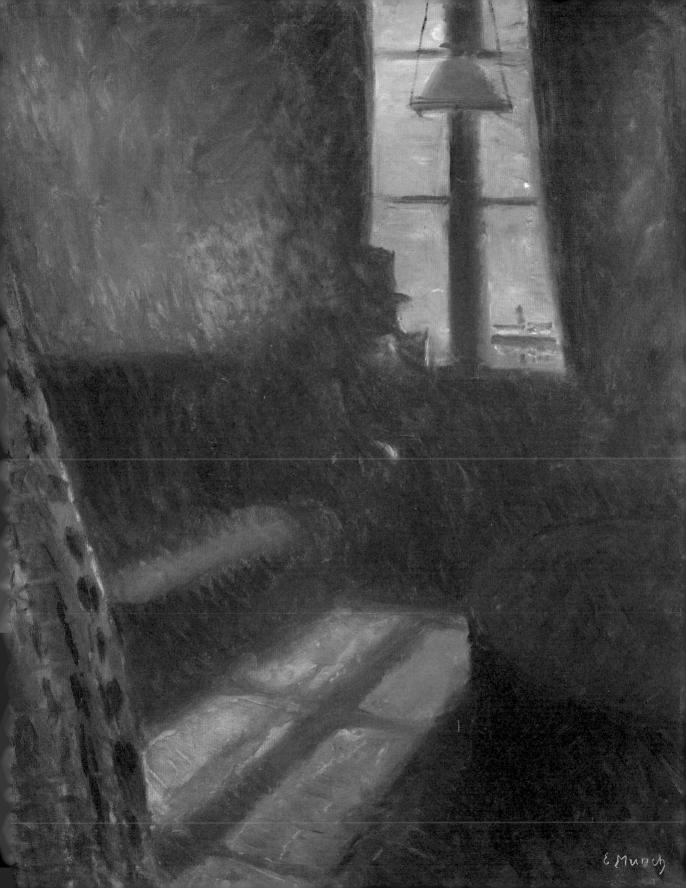

The Water-Sprite and Ägir's Daughters
Oil on canvas – Nils Blommér, 1850

In Norse mythology, Ägir is a giant of the sea who personifies the mighty power of the ocean. Sailors would pay worship to him and his wife Rán, also a goddess of the sea, for safe passage, fearful the pairs' vengeance might claim their ships. Together Ägir and Rán had nine daughters, who represent the waves, each named for a particular quality, including Hefring (lifting), Dröfn (foaming), Dúfa (pitching), Hronn (welling), and Unnr (frothing).

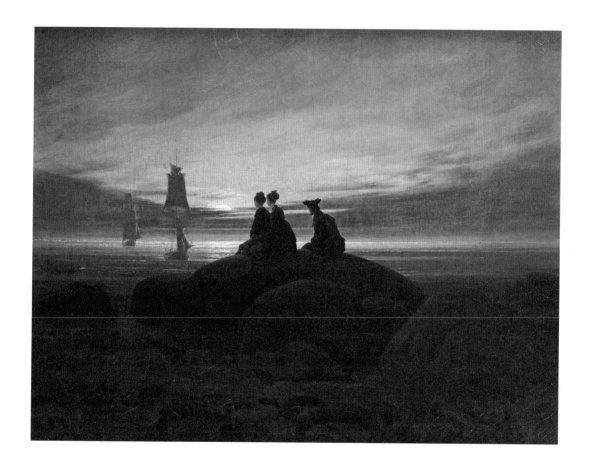

Moonrise over the Sea

Oil on canvas – Caspar David Friedrich, 1818

In this serene seascape, three companions, with their backs to the viewer, gaze out to a tranquil sea under the muted cloak of the rising Moon. The onlookers seem reflective, peaceful. It is a classic example of a Romantic painting, where artists like Friedrich aimed to express mood, atmosphere, and human sensation; a reaction to the Age of Enlightenment and its focus on science and objectivity.

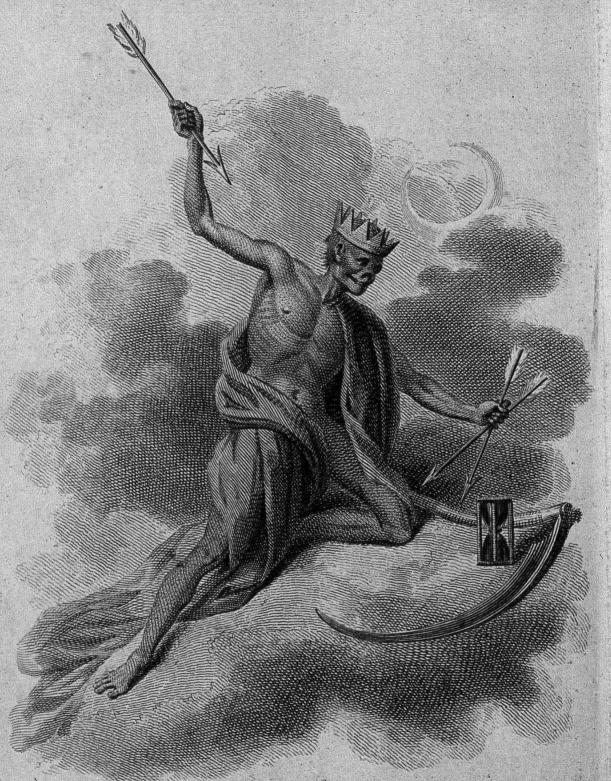

*Thy shaft flew thrice; and thrice my peace was slain;
And thrice, ere thrice yon moon had fill'd her horn.*

Night 1st line 212.

THE MOON
AND DEATH

We associate the Moon with many life-giving elements and figures, such as water, women, fertility, and the seasons; and the Moon can also be seen as a comforting source of light in the dark. But, partly because it appears most visible at night, the Moon is also associated with danger, unpredictability, and the unknown. There are many things that happen under cover of the night's darkness, from illicit trysts and minor misdemeanors to crimes such as theft, assault—and even murder.

In literature, the visual arts, and film, these scenes often occur by the light of the Moon because a dramatic scene needs some kind of illumination. The pitch black might be even more frightening in reality, but in fiction it can't compete with the atmosphere created by the Moon's stage lighting, or the visual drama of its watchful presence.

In classical Greek mythology, the gods Nyx and Erebus—respectively of the night and darkness—were parents to the twins Thanatos (death) and Hypnos (sleep). It is a small step from the Moon as a symbol of the night to the Moon as an omen of death. In pictorial art, particularly from the Romantic period onward, the Moon would often appear besides other representatives of the night, such as bats and owls—the latter often depicted as perching on coffins, graves, and ruined buildings.

The associations have been repeated ever since, in literature as well as art, and later in film and design. Even as recently as 1989, the same iconography was adopted for a poster campaign warning the general public about the then still little understood and deadly dangers of the AIDS virus. Against a black background, the full Moon stands out, while below, a menacing owl swoops out of the darkness.

"Thy shaft flew thrice; and thrice my peace was slain; And thrice, ere thrice yon moon had fill'd her horn." *(left)*
Etching – Published by Will M. Baynes, 1806

William Baynes's macabre etching is part of a series to illustrate an 18th-century poem by Edward Young entitled "Night-Thoughts," where the poet muses on life, death, and loss in nine parts (or "nights"). Baynes's Grim Reaper, the personification of death, looks set to strike. A crescent Moon is visible in the ominous parting clouds. The scythe, for "reaping" souls, is at the ready. The sand timer symbolizes fate and the inevitability of death.

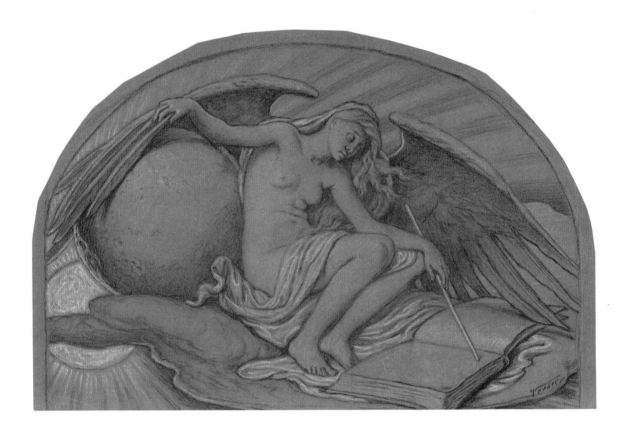

Study for *The Eclipse of the Sun by the Moon*

Charcoal and chalk on green wove paper – Elihu Vedder, 1892

A resting angel opens her wings to reveal the Moon nestled beside her. As she does it eclipses the Sun in the lower left corner. The illustration comes from Vedder's book of poetry entitled *Doubt and Other Things* following a poem titled "The Eclipse," while later in the book a depiction of Luna accompanies the verse: "We gaze on Thee, for they pale rays, Too often bring sad memories."

Harpy *(right)*

Chromolithograph – Hans Thoma, 1892

In Greco-Roman mythology, harpies were wind spirits that took the form of a bird's body and a woman's head. They had associations with the underworld, and would steal victims away to meet their punishment from the gods—the name "harpy" meaning "snatcher." Thoma's menacing creature keeps lookout under a ghostly sky, illuminated by a pale, shining full Moon.

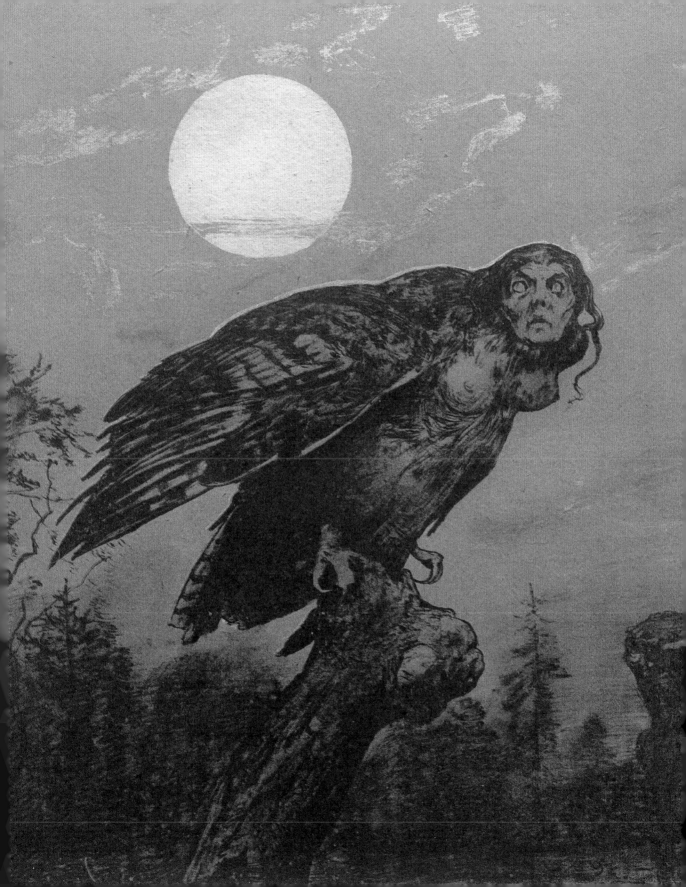

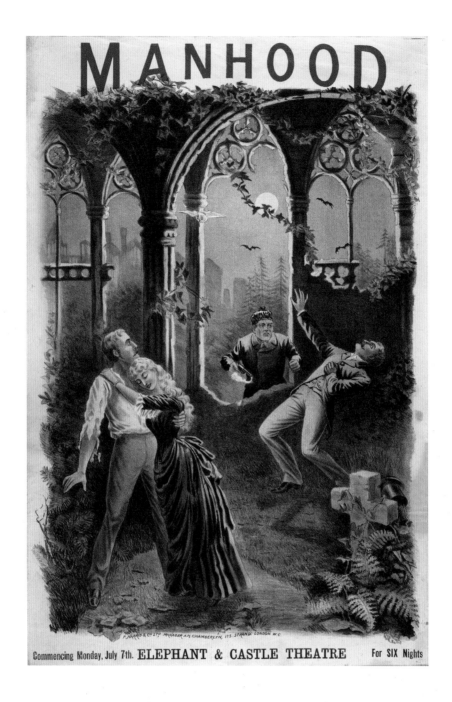

Poster for the play *Manhood*
Chromolithograph – Unknown, c.1890

A full Moon provides dramatic stage lighting for the unfolding drama being advertised in the play *Manhood*; Bats, a swooping owl, and a cemetery setting add to the sense of foreboding.

Bat Before the Moon *(right)*
Color woodblock print – Biho Takashi, c.1905

As creatures of the night, bats are common imagery in moonscapes in cultures around the world.

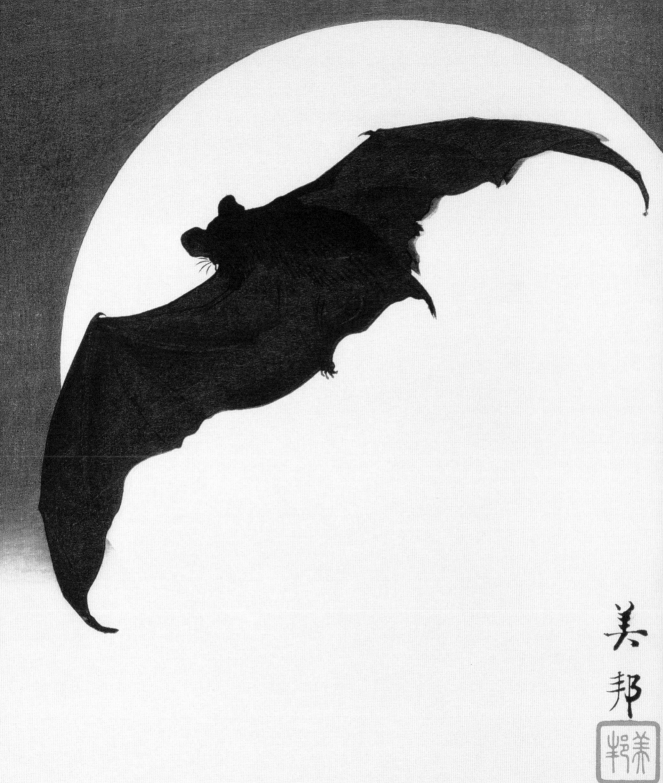

THE MOON IN ECLIPSE

Eclipses take place between four and seven times each year, when there is a near perfect alignment of the Sun, Earth, and Moon. The orbit of the Moon around the Earth is tilted compared to the orbit of the Earth around the Sun, and so the three bodies have to line up in three dimensions.

Total solar eclipses happen when the new Moon moves between the Sun and Earth, and for people within the narrow path of the lunar shadow, the light of the Sun is completely blocked out, reducing full daylight to a twilit gloom, and exposing the outer atmosphere—the corona—of our nearest star. Outside of this path, a much larger area is exposed to a rather less spectacular partial eclipse, where only some of the Sun is obscured.

Total lunar eclipses take place when the full Moon moves into the shadow of the Earth. The Moon darkens, but typically stays visible, with a color ranging from orange to dark red: although the Earth cuts off much of the sunlight, light in the red end of the spectrum is refracted through the terrestrial atmosphere (refraction is more commonly seen in a lens, where light rays are bent as they cross surfaces of glass and air). The result is a beautiful spectacle, with a red Moon hanging in the sky, looking almost as if Mars were suddenly a hundred times closer to the Earth.

Unlike the much rarer total solar eclipse, a lunar eclipse can be seen from anywhere on Earth where the Moon is above the horizon as it moves through the terrestrial shadow. For that reason, total lunar eclipses are much more commonly seen from any given location.

Like their solar counterparts, lunar eclipses were in the past often seen as bad omens. Christopher Columbus exploited this in the spring of 1504, when the original Arawak inhabitants of Jamaica refused to continue supplying his stranded crew with food, following increasing tensions. Columbus knew a lunar eclipse was coming and made his prediction to the island's inhabitants, warning them to cooperate with him. Sure enough, the Moon rose as a dim red ball, a frightening enough sight to persuade the islanders to end their embargo.

Super Blue Blood Moon (right)
Photograph – Bryan Goff, 2018

On January 31, 2018, viewers in some parts of the world witnessed the rare event of a "super blue blood Moon." This event saw the coincidence of the Moon being unusually close to the Earth, therefore looking slightly larger (the "super" of the epithet; see page 141), with it being the second full Moon in a month (a "blue Moon," although this is actually an erroneous use of the term; see page 178), and also a total lunar eclipse (the "blood" of the epithet—describing the moment the Moon appears to turn red).

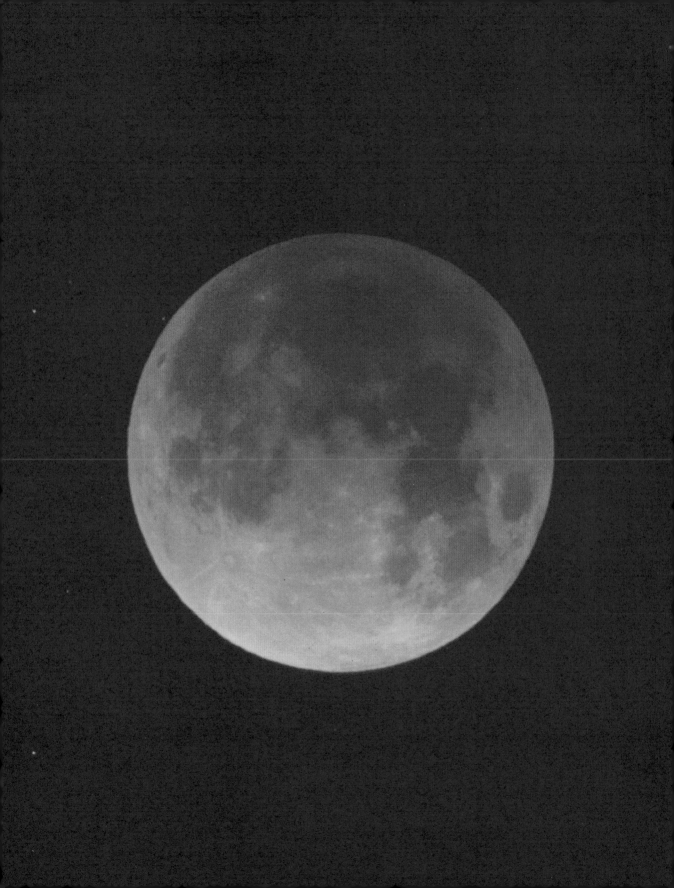

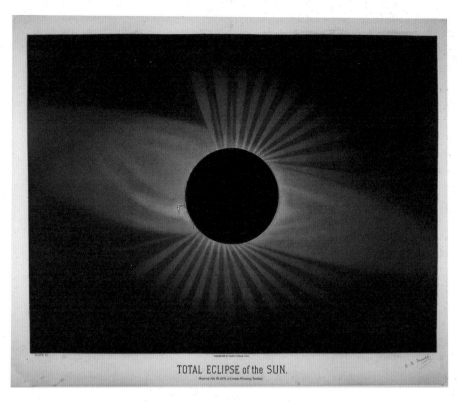

TOTAL ECLIPSE of the SUN.
Observed July 29, 1878, at Creston, Wyoming Territory.

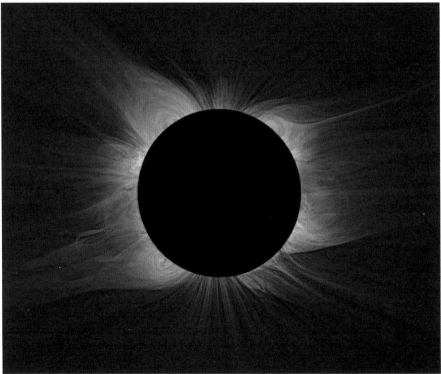

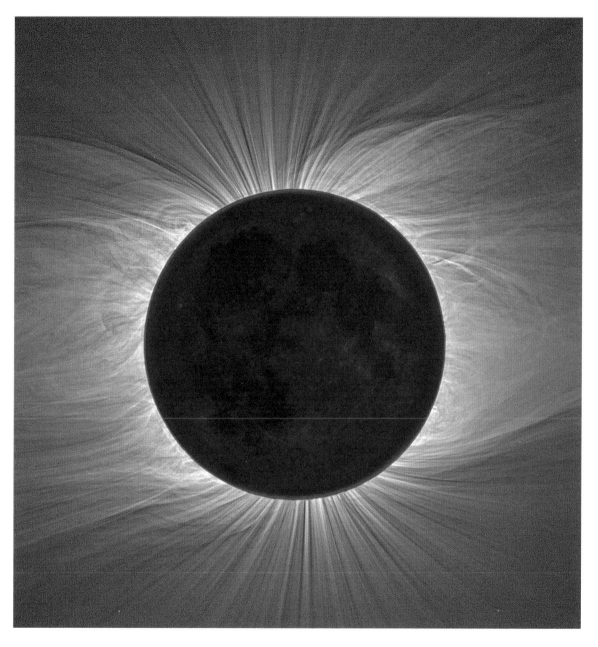

**Total Eclipse of the Sun.
Observed July 29, 1878, at Creston,
Wyoming Territory** *(left, top)*
Print – E. L. Trouvelot, 1881–82

**Total Solar Eclipse,
Takapoto Atoll, French Polynesia** *(left, bottom)*
Photograph – Miloslav Druckmüller, 2010

**Total Solar Eclipse, Inner Corona,
Enewetak Atoll, Marshall Islands** *(above)*
Photograph – Miloslav Druckmüller, 2009

The magnetic fields surrounding the Sun's surface affect charged particles in the Sun's atmosphere, creating "streamers, loops, and plumes." Chasing eclipses around the world, Czech mathematician and astrophotographer Miloslav Druckmüller provides beautiful examples of these effects, while a 19th-century drawing by E. L. Trouvelot is strikingly similar, if stylized, to the state-of-the-art photography used by Druckmüller.

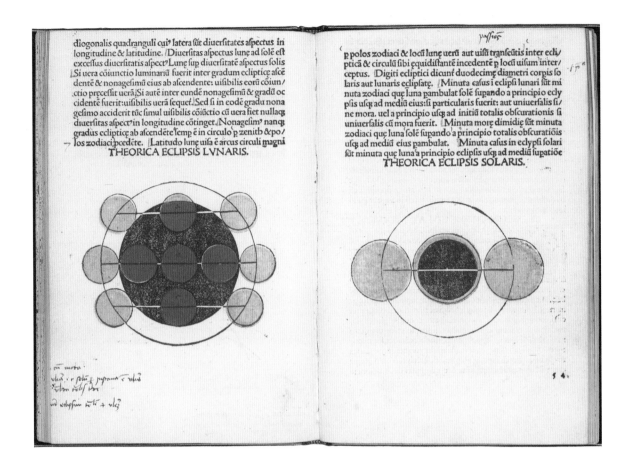

**"Theorica Eclipsis Lunaris" and "Theorica Eclipsis Solaris"
from *Sphaera Mundi* by Johannes de Sacrobosco**

Colored woodcut prints – George von Peuerbach, 1485

Humans have been charting the skies since antiquity. Shown above, a scholarly 15th-century book presents the work of several astronomers, including ten pages of eclipses based on the studies of Johann Regiomontanus and a treatise on the sphere by the 13th-century astronomer Johannes de Sacrobosco. It is the first book to feature three-colour printing (red, yellow, black) used on the illustrations.

Eclipse of the Sun and Moon (*right*)

Manuscript illustration – Russian, 18th century

The 18th-century Russian illustration shown is represents the idea of eclipses in a biblical context. It's hard to tell exactly what's going on here, but since the illustration comes from a manuscript entitled *Apocalypse*, one can assume it's nothing good.

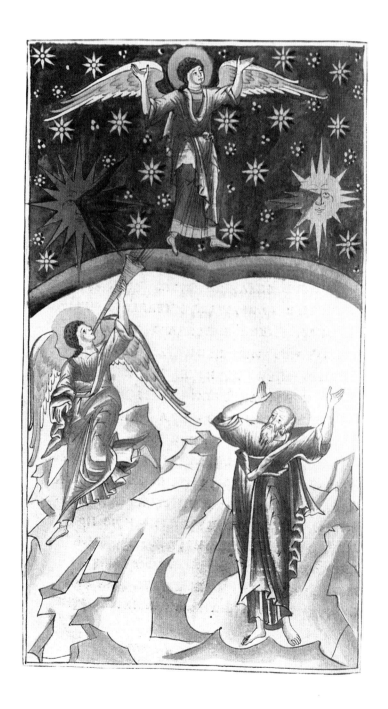

THE LUNAR X: DRAWING THE MOON

From the second half of the nineteenth century, photography, and now advanced digital imaging, superseded the need to make drawings and illustrations of the Moon. Nonetheless, many amateur astronomers still continue this tradition today.

This image, by UK astronomer and artist Sally Russell, illustrates the "Lunar X", a feature that appears for a few hours around the first quarter of each month (seven days after new Moon). As the Sun rises over the rims of the craters Blanchinus, La Caille, and Purbach, in the lunar highlands, the illuminated borders briefly appear to join together to create a letter X. The effect disappears once the Sun is higher in the lunar sky, and more of the craters are visible.

Russell and her peers describe the contrast between looking at even the finest digital images of the Moon and the thrill of seeing the lunar landscape with their own eyes, then recording it by hand. For this sketch from 2014, she was viewing the scene at magnification of 170× through a modest-sized but high-quality telescope. Like other modern-day astronomical artists, Russell divides her time between capturing small features in detail and larger scale work, like the whole lunar crescent.

Historically, astronomers took enormous care to record details in sketches, such that subsequent selenographers could build on their observations. Mapping an object like the Moon typically took several years, or even decades, with grids and anchor points stitching the different drawings together. Like their counterparts today, early observers strove to push their telescopes to the limit. Light travels 250,000 miles (400,000 kilometers) from the Moon to the Earth almost undisturbed. When it reaches the lower layer of our atmosphere, its path is shifted by air currents, leading to a shimmering image in a telescope. Anyone who looks through a telescope at the Moon sees the result: fine details of mountains, craters, and plains that continuously move, appear, and disappear. Hand-drawn maps represent painstaking recordings of the locations and shapes of those most subtle features.

Elaborate works by Berlin astronomers Wilhelm Beer and Johann Mädler (1836), and Johann Schmidt (1878) were the pinnacle of selenography. Though lunar scientist Mary Blagg later found it to have some errors, Schmidt's map was certainly comprehensive, recording nearly 33,000 craters, and using lunar shadows to calculate the heights of more than 3,000 mountains.

Things are different now. Helped by revolutionary advances in electronic sensors, even amateur astronomers can acquire images of the lunar surface in exquisite detail, so the need for drawing is long gone. Contemporary artist astronomers thus have different priorities to the cartographers of the past, but their work continues to capture a very human view of the Moon, and the subtle features that stand out in a sublime landscape.

Lunar X *(right)*
Pastel on black paper – Sally Russell, 2014

The Lunar X, the subject of this drawing, is only visible in the extreme contrast between deep black and bright white, created fleetingly as the rising sun slowly illuminates the Moon's surface more fully.

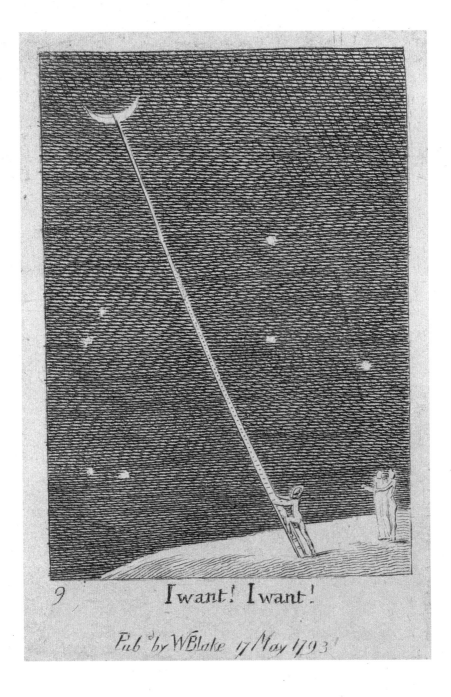

"I Want! I Want!" from *For the Sexes: The Gates of Paradise*
Engraving – William Blake, 1793

A lone figure reaches for the Moon—with the help of a giant ladder—in William Blake's book of poetry for children. This tiny image (2 x 2 ½ inches) inspires closer reading: as the tiny traveler gazes upward, two other figures cling to each other as they watch with trepidation. Is the climber's ambition folly?

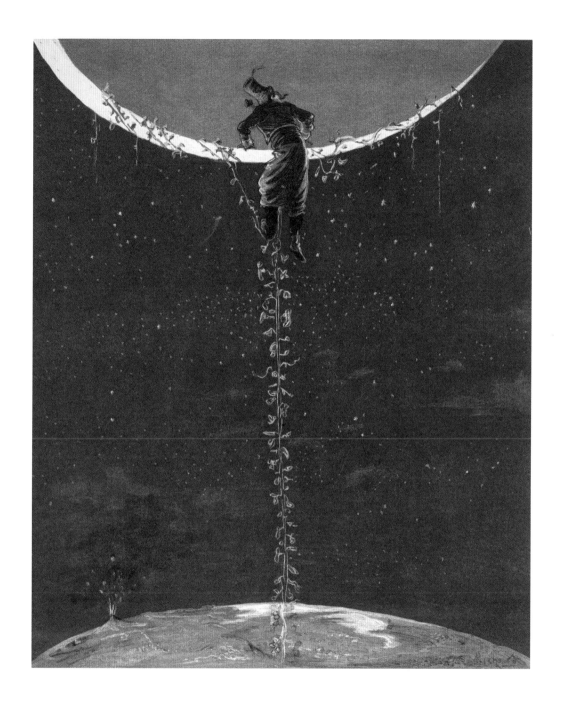

"The Somnambulant"
from *Aventures et Mésaventures du Baron de Münchhausen*
Chromolithograph – Adolphe-Alphonse Géry-Bichard, 1879

Space travel generally took a more whimsical, less technological, form before the turn of the 20th century.
Here, the titular protagonist reaches the moon Jack-style, via a giant beanstalk.

THE FIRST MEN ON THE MOON

When Neil Armstrong and Buzz Aldrin walked on the Moon, the two astronauts spent a little over two hours on the surface in their Extra-Vehicular Activity (EVA), installing scientific experiments, speaking with US President Richard Nixon in a phone call from the Oval Office, and sending live television pictures back to Earth. The black-and-white TV footage is mediocre in quality, not helped by the limited radio bandwidth from the lander, which was deliberately constrained to allow vital data to flow between the spacecraft and mission control.

In contrast, the still photographs from the Hasselblad cameras carried by the crew are crisp and vivid. In this most famous shot, and perhaps the most iconic image of the Apollo era, Buzz Aldrin stands on the lunar surface. The Moon's "magnificent desolation" that he described is very apparent, with a deep grey color and splashes of color in the US flag and valves on Aldrin's spacesuit, and the gold of the leg of the lunar lander. The footprints that mark the movement of the two astronauts around the lander, eroded only by the slow rain of tiny meteorites, could still be visible in hundreds of thousands of years.

The dust on Aldrin's boots is obvious too. Despite each crew attempting to brush it off, some dust inevitably found its way into the lunar module. The Moon dust was described in later missions as smelling like gunpowder, and in the case of Apollo 17 astronaut Harrison Schmitt, seemed to cause symptoms of hayfever.

Armstrong wore a camera mounted on the chest of his spacesuit, and took most of the images, so there are very few of the Apollo commander. Here though, the first man on the moon is visible as a reflection in Aldrin's helmet visor.

Buzz Aldrin on the Moon *(right)*
Photograph – Neil Armstrong, July 20, 1969

Commemorated as one of *Time* magazine's "100 Most Influential Photographs of All Time," it is the seeming fragility of Buzz Aldrin, *Time* argues, that makes this photo over others from the Apollo 11 mission so captivating. He stands, a small man on a monumental Moon, in "magnificent desolation." The distortion of the view in his visor adds to the surreal quality of the image.

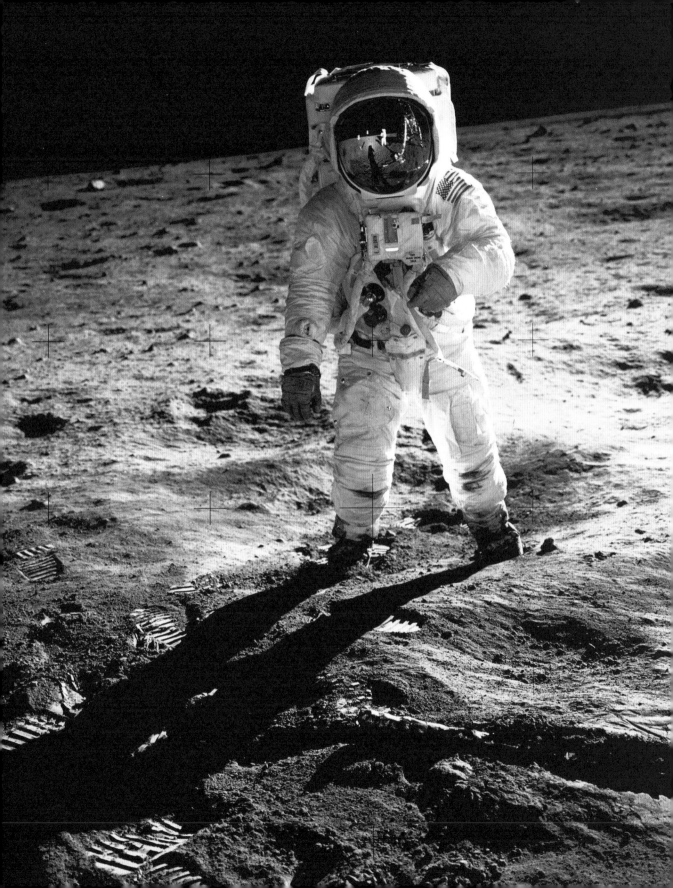

The New York Times

LATE CITY EDITION

"All the News That's Fit to Print"

VOL. CXVIII.. No. 40,721 NEW YORK, MONDAY, JULY 21, 1969 10 CENTS

MEN WALK ON MOON

ASTRONAUTS LAND ON PLAIN; COLLECT ROCKS, PLANT FLAG

Voice From Moon: 'Eagle Has Landed'

EAGLE (the lunar module): Houston, Tranquility Base here. The Eagle has landed.
HOUSTON: Roger, Tranquility, we copy you on the ground. You've got a bunch of guys about to turn blue. We're breathing again. Thanks a lot.
TRANQUILITY BASE: Thank you.
HOUSTON: You're looking good here.
TRANQUILITY BASE: A very smooth touchdown.
HOUSTON: Eagle, you are stay for T1. [The first step in the lunar operation.] Over.
TRANQUILITY BASE: Roger. Stay for T1.
HOUSTON: Roger and we set you vetting the ox.
TRANQUILITY BASE: Roger.
COLUMBIA (the command and service module): How do you read me?
HOUSTON: Columbia, he has landed Tranquility Base. Eagle is at Tranquility. I read you five by. Over.
COLUMBIA: Yes, I heard the whole thing.
HOUSTON: Well, it's a good show.
COLUMBIA: Fantastic.
TRANQUILITY BASE: I'll second that.
APOLLO CONTROL: The next major stay-no stay will be for the T2 event. That is at 21 minutes 26 seconds after initiation of power descent.
COLUMBIA: Up telemetry command reset to reacquire on high gain.
HOUSTON: Copy. Out.
APOLLO CONTROL: We have an unofficial time for that touchdown of 102 hours, 45 minutes, 42 seconds and we will update this.
HOUSTON: Eagle, you loaded R2 wrong. We want 10254.
TRANQUILITY BASE: Roger. Do you want the horizontal 55 15.2?
APOLLO CONTROL: That's affirmative.
APOLLO CONTROL: We're now less than four minutes from our next stay-no stay. It will be for one complete revolution of the command module.
One of the first things that Armstrong and Aldrin will do after getting their next stay-no stay will be to remove their helmets and gloves.
HOUSTON: Eagle, you are stay for T2. Over.

Continued on Page 4, Col. 1

VOYAGE TO THE MOON

By Archibald MacLeish

Presence among us,
 wanderer in our skies,
dazzle of silver in our leaves and on our
 waters silver,

silver evasion in our farthest thought—
 "the visiting moon" . . . "the glimpses of the moon" . . .

and we have touched you!

From the first of time,
before the first of time, before the
first men tasted time, we thought of you.
You were a wonder to us, unattainable,
a longing past the reach of longing,
a light beyond our light, our lives—perhaps
a meaning to us . . .

Now
our hands have touched you in your depth of night.

Three days and three nights we journeyed,
steered by farthest stars, climbed outward,
crossed the invisible tide-rip where the floating dust
falls one way or the other in the void between,
followed that other dawn, encountered
cold, faced death—unfathomable emptiness . . .

Then, the fourth day evening, we descended,
made fast, set foot at down upon your beaches,
sifted between our fingers your cold sand.

We stood there in the dusk, the cold, the silence . . .

and here, us at the first of time, we lift our heads.
Over us, more beautiful than the moon,
a moon, a wonder to us, unattainable,
a longing past the reach of longing,
a light beyond our light, our lives—perhaps
a meaning to us . . .

O, a meaning!

over us on these, silent beaches the bright
earth,
presence among us

Neil A. Armstrong moves away from the leg of the landing craft after taking the first step on the surface of the moon.

Col. Edwin E. Aldrin Jr. climbing down the ladder. The television camera was attached to a side of the lunar module.

Mr. Armstrong, right, and Colonel Aldrin raise the U.S. flag. A metal rod at right angles to the mast keeps flag unfurled.

A Powdery Surface Is Closely Explored

By JOHN NOBLE WILFORD
Special to The New York Times

HOUSTON, Monday, July 21—Men have landed and walked on the moon.

Two Americans, astronauts of Apollo 11, steered their fragile four-legged lunar module safely and smoothly to the historic landing yesterday at 4:17:40 P.M., Eastern daylight time.

Neil A. Armstrong, the 38-year-old civilian commander, radioed to earth and the mission control room here:

"Houston, Tranquility Base here. The Eagle has landed."

The first men to reach the moon—Mr. Armstrong and his co-pilot, Col. Edwin E. Aldrin Jr. of the Air Force—brought their ship to rest on a level, rock-strewn plain near the southwestern shore of the arid Sea of Tranquility.

About six and a half hours later, Mr. Armstrong opened the landing craft's hatch, stepped slowly down the ladder and declared as he planted the first human footprint on the lunar crust:

"That's one small step for man, one giant leap for mankind."

His first step on the moon came at 10:56:20 P.M., as a television camera outside the craft transmitted his every move to an awed and excited audience of hundreds of millions of people on earth.

Tentative Steps Test Soil

Mr. Armstrong's initial steps were tentative tests of the lunar soil's firmness and of his ability to move about easily in his bulky white spacesuit and backpacks and under the influence of lunar gravity, which is one-sixth that of the earth.

"The surface is fine and powdery," the astronaut reported. "I can pick it up loosely with my toe. It does adhere in fine layers like powdered charcoal to the sole and sides of my boots. I only go in a small fraction of an inch, maybe an eighth of an inch, but I can see the footprints of my boots in the treads in the fine sandy particles."

After 19 minutes of Mr. Armstrong's testing, Colonel Aldrin joined him outside the craft.

The two men got busy setting up another television camera out from the lunar module, planting an American flag into the ground, scooping up soil and rock samples, deploying scientific experiments and hopping and loping about in a demonstration of their lunar agility.

They found walking and working on the moon less taxing than had been forecast. Mr. Armstrong once reported he was "very comfortable."

And people back on earth found the black-and-white television pictures of the bug-shaped lunar module and the men tramping about it so sharp and clear as to seem unreal, more like a toy and toy-like figures than human beings on the most daring and far-reaching expedition thus far undertaken.

Nixon Telephones Congratulations

During one break in the astronauts' work, President Nixon congratulated them from the White House in what, he said, "certainly has to be the most historic telephone call ever made."

"Because of what you have done," the President told the astronauts, "the heavens have become a part of man's world. And as you talk to us from the Sea of Tranquility it requires us to redouble our efforts to bring peace and tranquility to earth.

"For one priceless moment in the whole history of man all the people on this earth are truly one—one in their pride in what you have done and one in our prayers that you will return safely to earth."

Mr. Armstrong replied:

"Thank you Mr. President. It's a great honor and privilege for us to be here representing not only the United States but men of peace of all nations, men with interests and a curiosity and men with a vision for the future."

Mr. Armstrong and Colonel Aldrin returned to their landing craft and closed the hatch at 1:12 A.M., 2 hours 31 minutes after opening the hatch on the moon. While the third member of the crew, Lieut. Col. Michael Collins of the Air Force, kept his orbital vigil overhead in the command ship, the two moon explorers settled down to sleep.

Outside their vehicle the astronauts had found a bleak

Continued on Pages 2, Col. 1

Today's 4-Part Issue of The Times

This morning's issue of The New York Times is divided into four parts. The first part is devoted to news of Apollo 11 and includes Editorials and letters to the Editor (Page 16).

Poems on the landing on the moon appear on Page 17.

General news begins on the first page of the second part. The News Summary and Index is on the first page of the third part, which includes sports news, obituaries (Page 31) and transportation news and weather reports (Pages 38 and 52).

Financial and business news begins on the first page of the fourth part.

Following is the News Index for today's issue:

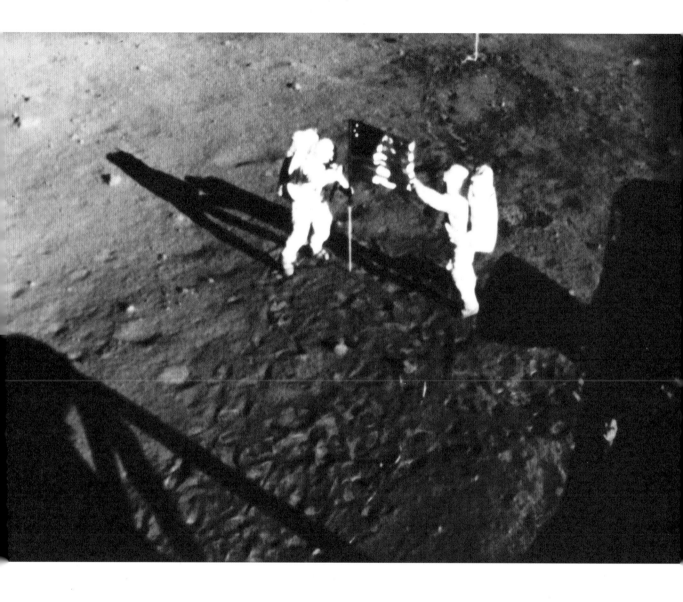

"Men Walk on Moon" (left)
Newspaper
The New York Times, July 21, 1969

The astronauts did indeed "Land On Plain; Collect Rocks; Plant Flag," as humbly reported by *The New York Times*. The cultural and historic significance of their achievement was celebrated the world over.

The planting of the flag (above)
Photograph
NASA, July 20, 1969

Neil Armstrong (left) and Buzz Aldrin plant the American flag on the Moon. They also left a plaque that reads: "We came in peace for all mankind."

The City of Chicago welcomes the Apollo 11 astronauts (overleaf)
Photograph
Photo researchers, August 13, 1969

What began as huge ticker-tape "heroes" parades in New York, Chicago, and Los Angeles extended into a 45-day "Great Leap" tour taking in 25 countries.

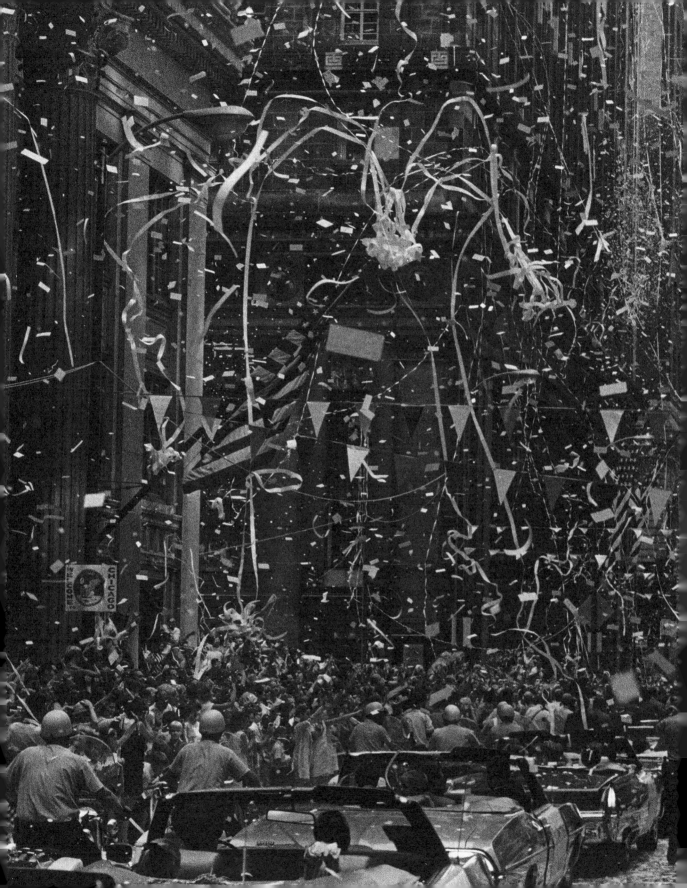

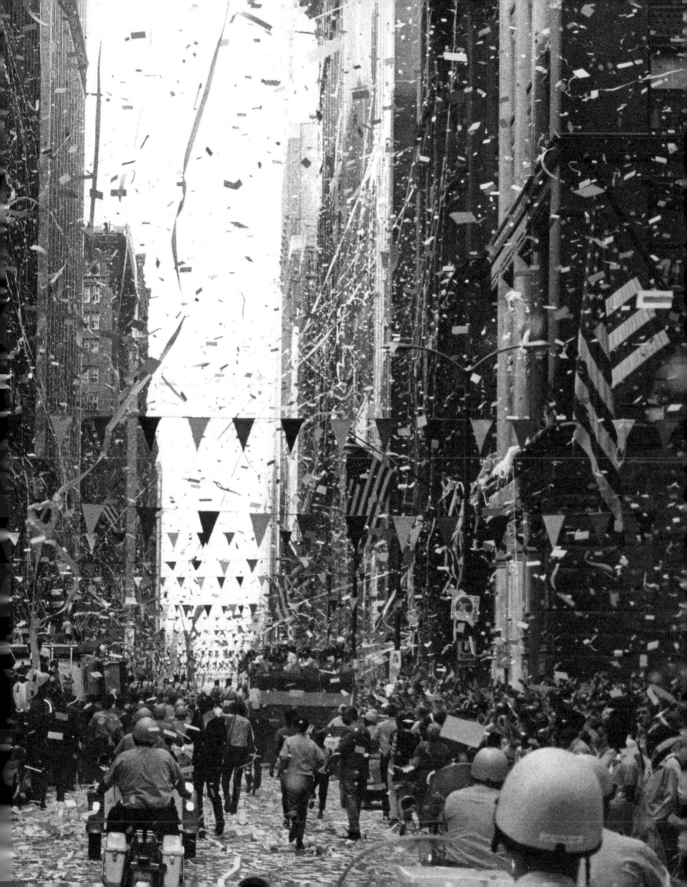

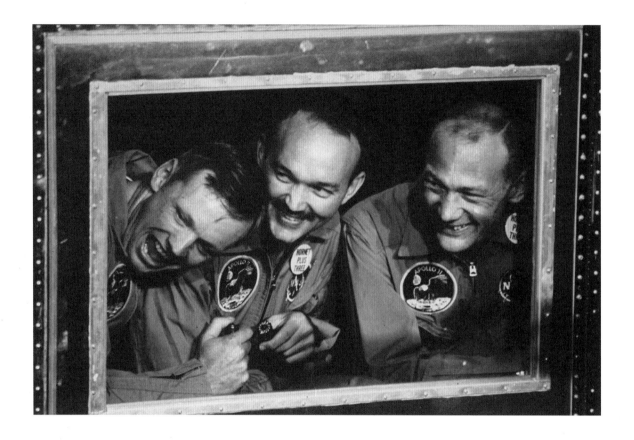

Apollo 11 astronauts (from left to right) Neil Armstrong, Michael Collins, and Buzz Aldrin in quarantine after returning from the Moon
Photograph – The LIFE Picture Collection, July 24, 1969

On returning to Earth, the Apollo 11 astronauts spent 21 days in quarantine in case they had brought any harmful contagions back from the Moon. This requirement was waived after the Apollo 14 mission, by which time it was proved the Moon contained no pathogens.

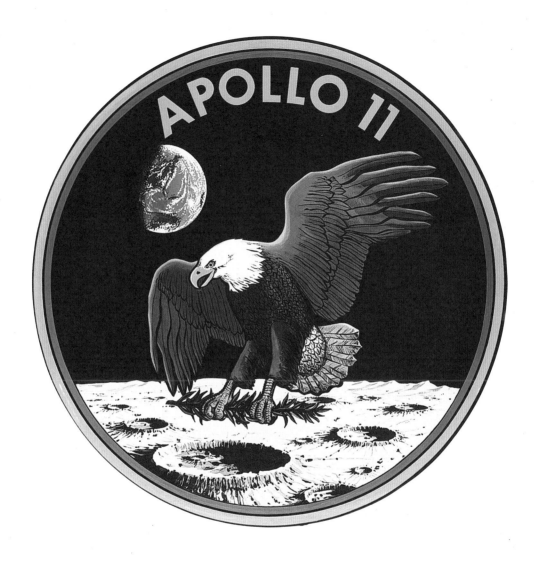

Apollo 11 mission patch
Concept artwork – Crew of Apollo 11, NASA, 1969

As was tradition, the crew members created their own mission patch, with Michael Collins credited for most of the design. Their names were deliberately left off, in respect to the huge teams of people on the ground working to make the mission possible. The "Blue Marble" of Earth sits above left, albeit with the shadow in the wrong place (it should sit horizontally on the lower half if viewed from the Moon). An Eagle—a reference to America's national bird as well as the name of the lunar lander—carries an olive branch in a symbol of peace.

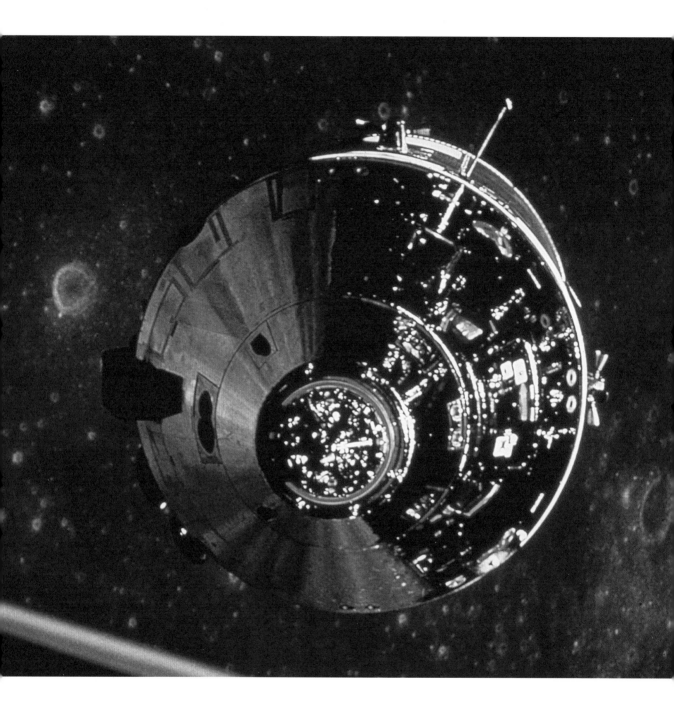

THE DRESS REHEARSAL FOR THE MOON LANDING

On the May 18, 1969, astronauts Thomas Stafford, John Young, and Eugene Cernan took off on a mission to test all the components and flight techniques of a successful Moon landing. Their flight, Apollo 10, was the essential dress rehearsal for Armstrong and Aldrin's triumphant touchdown two months later.

Arriving in lunar orbit on May 21, Stafford and Cernan boarded the lunar module the following day. Before Apollo 11, no space agency in the world had put people on another world (and for that matter, none has done so since), so trying out the spacecraft that would make the landing was a vital test.

Separating from Young, left behind in the command module, the two astronauts brought the lunar module down to within 10 miles (16 kilometers) of the surface, with Cernan later describing how they "painted the white line in the sky" for Neil Armstrong, so "all he had to do was land." This, though, overlooks the real drama that occurred on the way back up.

Later attributed to human error—a switch left in the wrong position meant that the lunar module tried to find the command module automatically at the wrong time—the spacecraft began an uncontrolled roll that could have led to it crashing onto the Moon below. After rolling for five minutes, the crew ejected the descent stage (the lower half of the lunar module) and flew back safely to rejoin Young. Starting back for Earth on May 23rd, the command module splashed down in the Pacific three days later.

Space travel was, and still is, risky, not least when spacecraft re-enter the Earth's atmosphere on the last leg of a journey home. Rushing through air at 7 miles (11 kilometers) per second—about 30 times faster than a rifle bullet—is estimated to heat space vehicles to almost 5,000 degrees Fahrenheit (more than 2,700 degrees Celsius), easily hot enough to melt most metals. To cope with this, Apollo crews were protected with just a thin plastic heat shield that burned away during their descent, leaving the astronauts inside at a comfortable temperature.

The charred Apollo 10 command module now resides in the Science Museum in London. Here is a spacecraft that once traveled into space and is now returned to public view—though it's only a tiny part of the Saturn V rocket and payload that launched. (The upper part of the lunar module, named "Snoopy," is now thought to be in orbit around the Sun.)

Whatever their private feelings, the crew showed no public frustration at missing out on a lunar landing, and all three astronauts later returned to space. Young would walk on the Moon in Apollo 16 before piloting the first Space Shuttle flight, Cernan went back to the Moon in Apollo 17, and Stafford became commander of the Apollo-Soyuz mission, the first time the US and USSR cooperated in space, in 1975.

The Apollo 10 command and service module as seen from the lunar module
Photograph – NASA, 1969

Two months before Apollo 11's successful Moon landing, the astronauts Thomas Stafford, John Young, and Eugene Cernan set off on a mission to practice the procedures that would make this possible.

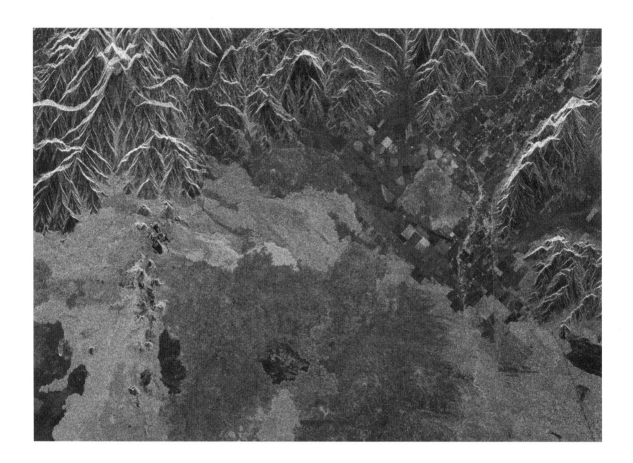

Craters of the Moon, Idaho *(above)*

Space radar image – NASA, 1994

Craters of the Moon National Monument and Preserve, Idaho, is an inhospitable place where lava flows created a rugged basaltic landscape not dissimilar to its namesake. In 1969, the Apollo 12 astronauts visited Craters of the Moon to learn more about the volcanic terrain, in preparation for their mission to the Moon.

Apollo 11 lunar module—the Eagle *(right)*

Composite photograph – NASA, July 20, 1969

This composite photograph helps us to picture the scene of Neil Armstrong and Buzz Aldrin guiding their lunar module down to the Moon's surface in the Sea of Tranquility, moments before Armstrong said the immortal words: "Houston . . . The Eagle has landed."

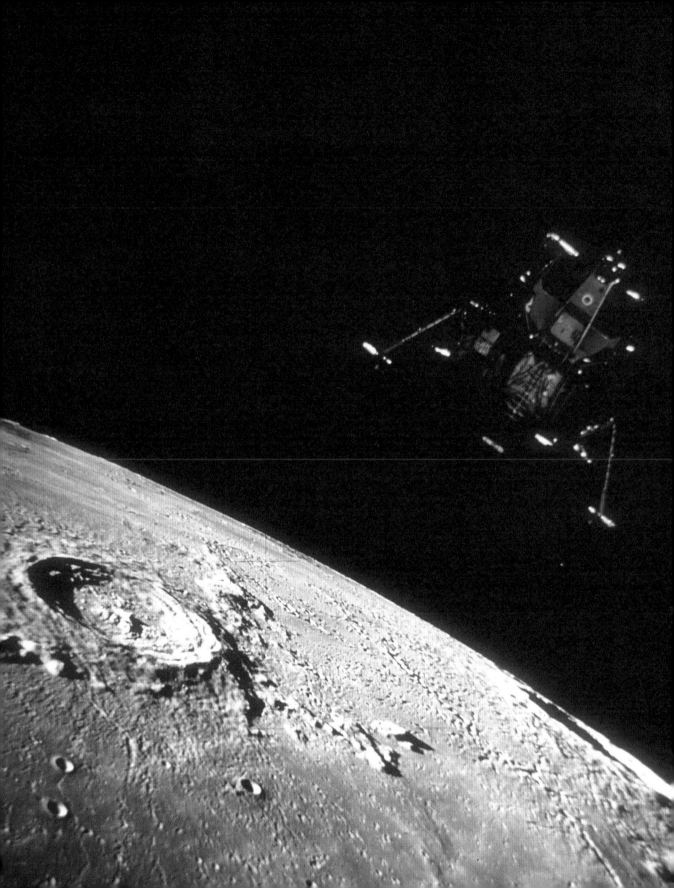

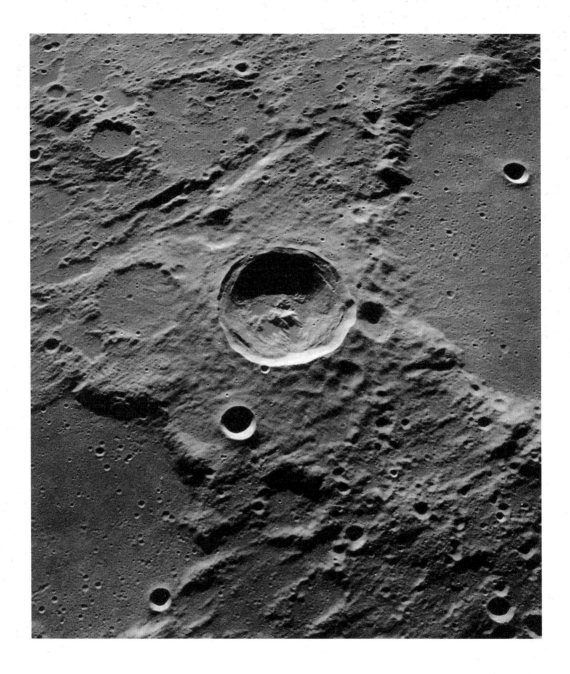

Herschel Crater

Photograph – Apollo 12/NASA, 1969

This lunar crater is named after William Herschel, a famed astronomer who discovered the planet Uranus.
The central peak is caused by the lunar surface rebounding from the impact.

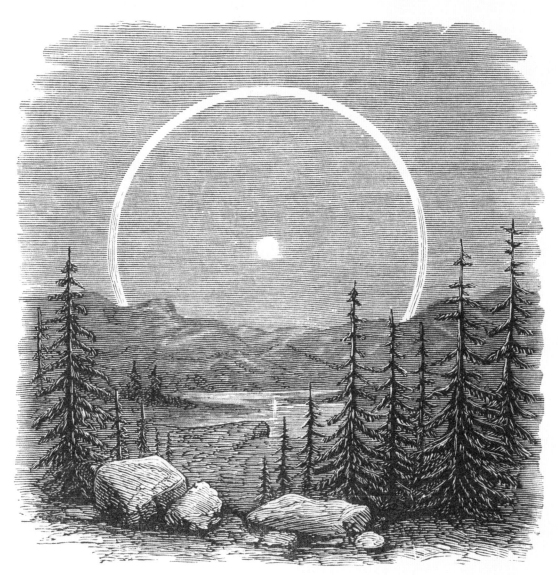

Fig. 3.—A Lunar Halo.

"A Lunar Halo," Fig. 3 from *Science for All*
Engraving – English, 19th century

A lunar halo is an optical effect caused by light from the Moon interacting with ice crystals in the upper atmosphere. When light travels through these crystals it is reflected at angles of 22 degrees or more, resulting in a ring 44 times larger than the Moon.

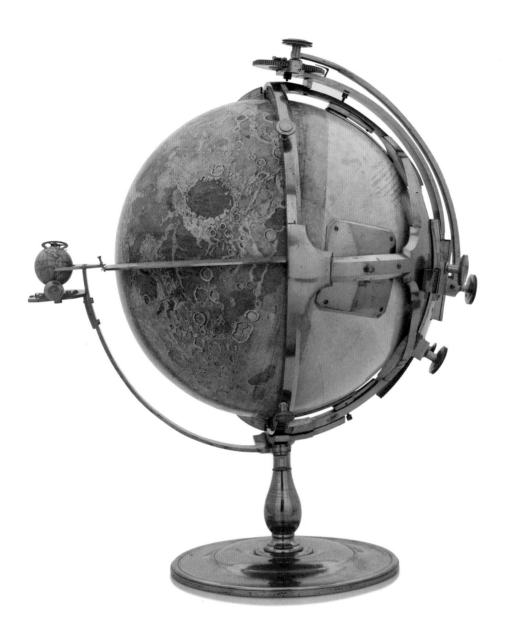

Globe of the Moon

Papier-maché and brass – John Russell, 1797

Russell's globe was built to show how the Moon (the larger sphere) moves around the Earth. The Moon is beautifully engraved with craters, seas, and mountains based on Russell's detailed Moon maps that he spent decades creating. Only one side is illustrated, as this is the side visible from Earth.

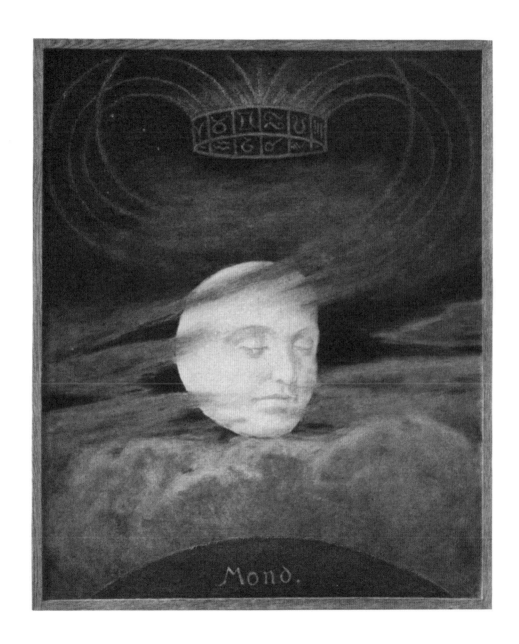

"Mond," from *Festkalender*

Chromolithograph – Hans Thoma, c.1910

Mythological themes feature in many of Thoma's works, including his *Festkalender* published in 1910.
In this particular illustration, the Moon has the face of a man, and it appears as though
a single tear is falling from his left eye. A halo, or crown of astrological symbols hovers above.

THE NEBRA SKY DISC

Humans have understood the principle of lunar phases and used the regular movement and changing appearance of heavenly objects to provide a basic calendar structure probably since the earliest civilizations. Knowing how and when the seasons change and when the tides come in would have been important for communities relying on fishing and agriculture for their survival. We find personifications and depictions of the Moon and other celestial bodies in most ancient cultures. Sky maps are rarer, which makes the Nebra Sky Disc a special object.

Dating from around 1600 BCE, the disc is the earliest known attempt to chart the sky, predating Egyptian sky maps by around 200 years. It measures 12 and a half inches (32 centimeters) in diameter, weighs around four and a half pounds (2 kilograms), and is made of bronze, now corroded to the green-blue color we see, decorated with gold motifs. It was found only in 1999 by treasure hunters (who later tried to sell it on the black market) near the town of Nebra in Germany.

Unfortunately, the fragile object was damaged when it was dug out of the ground, but the symbols on it are clearly visible. The disc shows a simple but striking image of the cosmos: a crescent Moon, a full Moon or Sun, three thinner sickle shapes, and 30 small discs, probably representing stars. A cluster of seven of these have been identified as the Pleiades cluster, while other stars have also been cautiously identified. This seems to confirm that the disc was intended to be an accurate depiction of the cosmos.

We still don't know what exactly the disc was used for. Given the prominence of the Sun and the Moon, it looks like a religious object, but could have been an astronomical tool, or possibly a combination of both. The Pleiades is an important star cluster, prominent in the Northern Hemisphere in the autumn sky, and therefore the harvest season, disappearing in the spring. It has been speculated that the disc describes the best (or sacred) times to reap and sow.

But there has also been controversy around the disc, especially given the dubious circumstances of its discovery. Such an artifact might have been expected of ancient Greek, Egyptian and Mesopotamian civilizations, but nothing like it had ever before been discovered in Europe, and at one point it was feared to be a hoax. Happily, scientific tests into the corroded surfaces have since confirmed that it can't be a fake, making this perhaps our earliest accurate image of at least a crescent Moon.

The Nebra Sky Disc (right)
Bronze and gold – German, c.1600 BCE

The Nebra Sky Disc amazed archaeologists when it was relieved from the hands of the racketeers, giving scholars in prehistory evidence of a more sophisticated culture than was previously believed to have existed at that time. It is thought to represent religious ideas—the lower crescent is possibly a Sun boat to transport the Gods—as well as provide agricultural instruction concerning "blessed" harvest times.

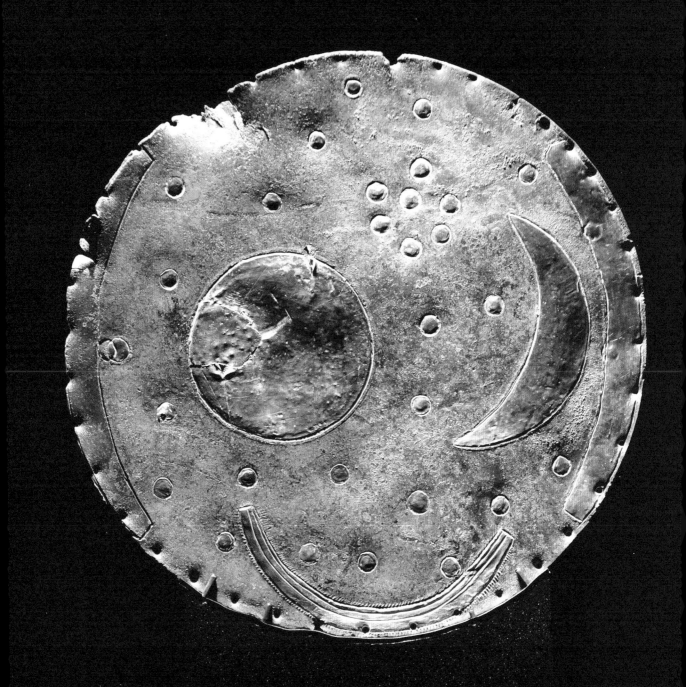

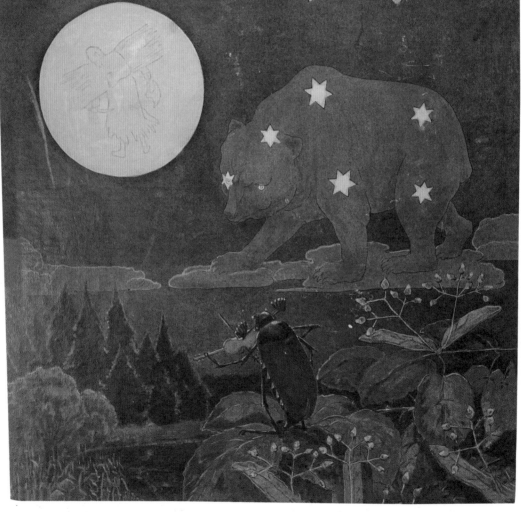

Peterchens Mondfahrt (Little Peter's Journey to the Moon) *(left)*
Book cover, chromolithograph
Gerdt von Bassewitz (author), Hans Baluschek (illustrator), 1915

Bassewitz's charming fairy tale features a delightfully novel method of reaching the Moon: a beetle's magical chant bestows two children with the powers to fly, in a mission to rescue the insect's stolen leg from the evil Man in the Moon. The Sandman's Moon chariot and a great bear (Ursa Major) provide transport in space.

Plate 100 from *Jerusalem*, depicting Los and Enitharmon
Etching with pen, watercolor, and gold on paper
William Blake, 1804–20

In William Blake's famed poem, the character Enitharmon is symbolized by the Moon. She is the "emanation" and wife of Los. In the background is Stonehenge. Completed in the Bronze Age, we still don't know exactly how or why it was built. Many believe it was used as a celestial observatory to study the movements of the Sun and Moon whether for religious or agricultural purposes.

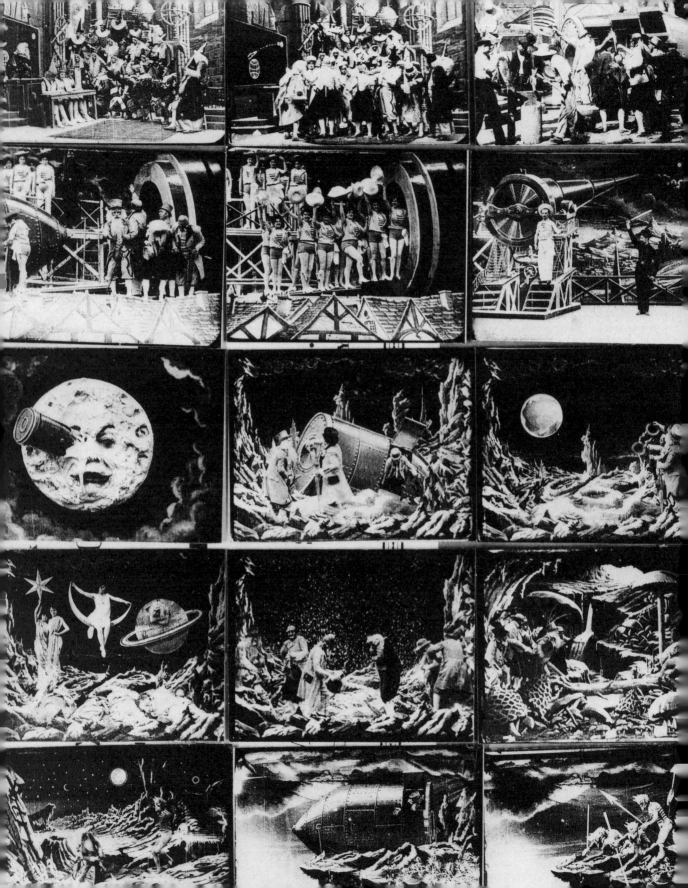

GEORGES MÉLIÈS' *LE VOYAGE DANS LA LUNE*

Often when the Moon plays a starring role in stories, fairy tales, or, in more recent culture, in advertising and film, there is a need to turn it into a more accessible character and, quite literally, give it a human face.

One of the most iconic images of an anthropomorphized Moon comes from a French film created at the very beginning of the twentieth century, when film was a brand-new medium. In film pioneer Georges Méliès' silent film *Le Voyage dans la Lune (A Trip to the Moon)*, in which the lead role is played by Méliès himself, a spaceship in the shape of a bullet is launched from a cannon on Earth and lands in the right eye of the Moon's face. The sequence of the spaceship crash-landing on the seemingly soft and squidgy surface of the Moon is probably the earliest use of stop-motion animation.

The image of the Moon injured by a rocket from Earth is clearly comical, and the film has often been considered a send-up of the popular science-fiction novels of Jules Verne and H. G. Wells that inspired it. There is little science in this fiction: the astronomers wear no spacesuits, and the Moon appears to have an atmosphere similar to Earth's. It even snows during the astronomers' visit. Méliès' Moon is inhabited by aggressive spear-wielding, insect-like Selenites, who combust in a puff of smoke when hit with force, or even when they fall over too hard. The Selenites briefly have the upper hand and bring the astronomers to their moon court, however the men manage to escape and flee back to their spaceship. Despite their rather ignominious misadventures, the explorers receive a heroes' welcome on their return, while an unfortunate Selenite who leapt onto the spacecraft as it fell back to Earth is paraded as a spectacle.

The hugely successful film is a fascinating insight into how space travel was imagined in popular culture, particularly as the motion picture was such a new medium. Méliès was more interested in exploiting the fun and fantastic possibilities of scenario than attempting any degree of realism. Despite the slapstick and silliness, however, there's a dark, violent undertone to the explorers' invasion of the Moon, while the astronomers themselves are ridiculed as bumbling fools. As well as an early example of science fiction in film, *Le Voyage dans la Lune* can equally be interpreted as a biting satire on imperialism.

Frames from *Le Voyage dans la Lune (A Trip to the Moon)* (left)
Film stills – Georges Méliès, 1902

During a time when cinematography was only just emerging, and mostly documentary, Georges Méliès pioneered the use of special effects and brought fantasy to the silver screen. He took a keen interest in stage magic and the work of the French magician Jean-Eugène Robert-Houdin, eventually purchasing his own theatre, and moving from creating illusions on stage to in front of the camera.

EARTHRISE

After the tragedy of the Apollo 1 fire in February 1967, it wasn't until the end of the following year that NASA attempted another Moon mission. Taking off on December 21, the crew of Apollo 8—Frank Borman, James Lovell, and William (Bill) Anders—were the first humans to complete a journey to, and around, the Moon.

En route, the three astronauts were already struck by the difference between the grays of the bleak lunar surface and the vibrant colors of the Earth and the absence of national borders. Even travelers to a low Earth orbit spend much of their time looking down at the beauty of a world teeming with life. That almost all life resides in a relatively thin layer between the base of the oceans and the lowest part of the atmosphere, and this layer looks particularly fragile from space.

By Christmas Eve the spacecraft had completed several lunar orbits, with the astronauts testing the systems and Anders photographing the surface with one of the modified handheld Hasselblad cameras used throughout the Apollo program. One or all of the crew (he does not recall who) simply said "Oh my God. Look at that!" as the Earth rose into view behind the Moon.

Anders grabbed a camera with color film and began shooting. The resulting *Earthrise* image has been described as one of the most influential ever taken, depicting a vulnerable world rich in life and color, adjacent to the bleak and sterile lunar desert. The photograph inspired the nascent environmental movement and the concept of "Spaceship Earth."

Earthrise became one of *TIME* magazine's *100 Photos* project, a showcase of images that "changed the world," which also includes Buzz Aldrin on the lunar surface, the Hubble Space Telescope's image of "the pillars of creation," as well as terrestrial subjects such as a 1971 image of Jackie Kennedy Onassis, and Joe Rosenthal's 1945 photo of American soldiers raising the flag on Iwo Jima.

Anders, and those who followed, continue to reflect on the contrast between the Earth and the black near-emptiness and lifelessness of space. He undoubtedly spoke for all astronauts, particularly the select few who have ventured beyond Earth's orbit, when he said: "We came all this way to explore the Moon, and the most important thing is that we discovered the Earth."

Earthrise (right)
Photograph – William Anders, 1968

Anders's evocative image of the Earth is a humble reminder to all of the magnificence of our extraordinary planet and the need to protect it. A sentiment that was echoed in Lovell's words in a live broadcast while the astronauts were in Moon's orbit: "The vast loneliness is awe-inspiring and it makes you realize just what you have back there on Earth."

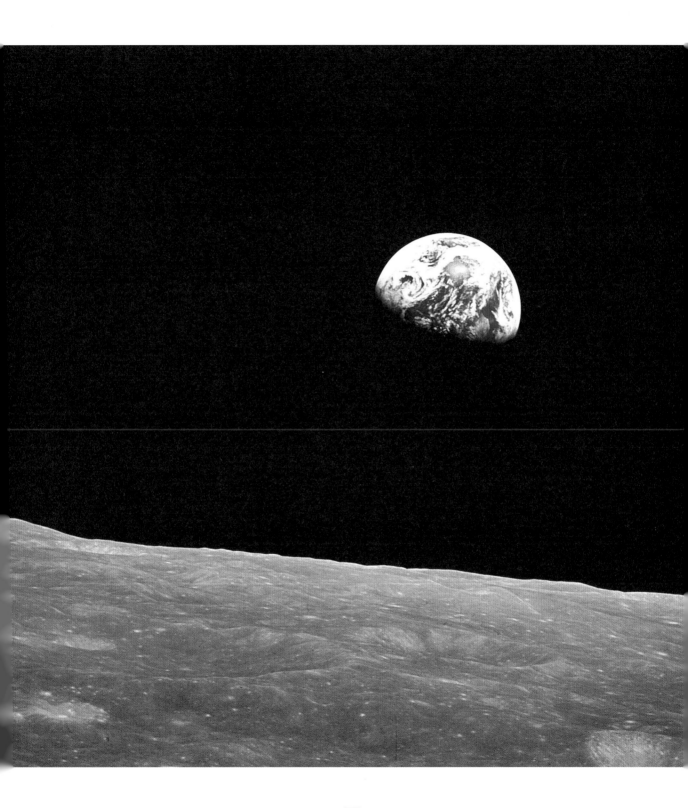

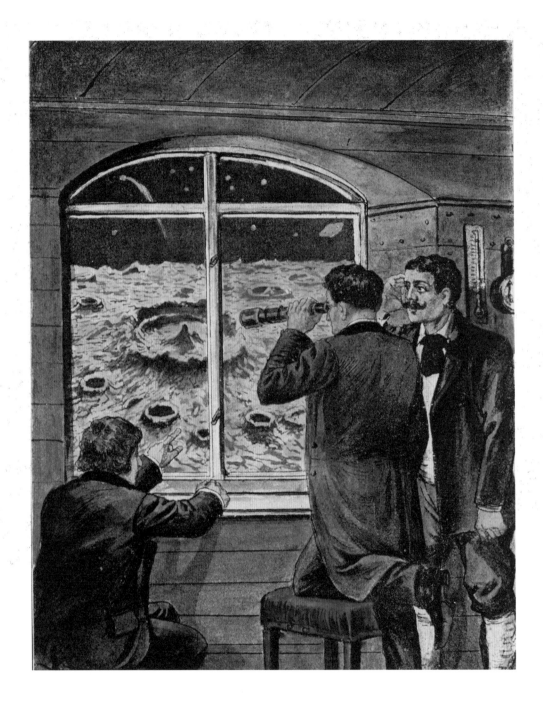

"Landing on the Moon," frontispiece to an 1890 German edition of Jules Verne's *Around the Moon*
Colored print – After drawing by R. Grünberg, 19th century

Verne's space travelers get trapped in lunar orbit in a disaster-struck mission to the Moon. Here they marvel at the craters on the surface from their spacecraft, while stars, a comet, and Saturn can be seen in the far-flung distance.

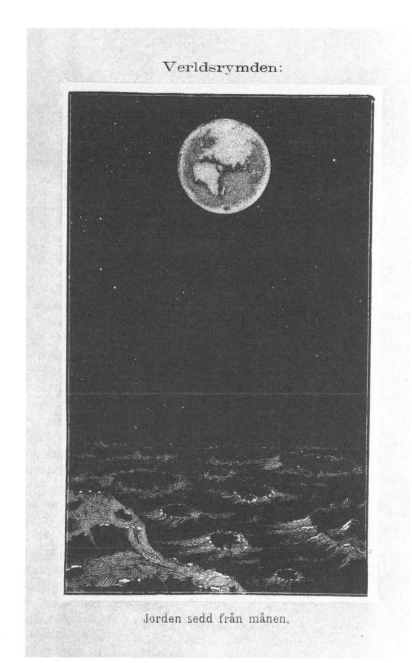

"Verldsrymden: Jorden sedd från månen"
("Space: The Earth seen from the Moon")
from *Menniskan* (*Humankind*)
Etching – Nils Lilja (author), 1889 edition

A delicate and atmospheric illustration of the view of the Earth from the Moon. The rugged craters of the Moon fill the foreground, while the Earth hangs in a star-speckled sky. The continent of Africa can clearly be made out.

NASMYTH AND CARPENTER'S VISIONS OF THE MOON

In 1874, just a year after Jules Verne's science-fiction novel *Around the Moon* (the sequel to his hugely popular 1865 novel *From the Earth to the Moon*) had been translated into English, British astronomer James Carpenter and Scottish engineer James Nasmyth produced a book that was to become a classic of Moon literature. While Carpenter had been working for many years at the Royal Observatory in Greenwich, Nasmyth had turned his interests to astronomy only after his retirement at the age of 48.

One of the aims of their fascinating work *The Moon: Considered as a Planet, a World, and a Satellite* was to present significant research into and knowledge of the Moon in an accessible style. They also wanted to illustrate the book with realistic images of the Moon's surface structure, alongside full views of the near side of the Moon and some phenomena, such as an imagined solar eclipse as seen from the Moon.

It is the nature of these photographs that makes the book so interesting. Only one plate is actually a photograph of the Moon. The rest are a mixture of curious and inventive visualizations of what the Moon might look like close up, and what may have caused the crater formations and starburst patterns visible from Earth. The authors stressed that their images of the Moon's surface were based on careful and lengthy observation through telescopes, but argued that the resulting drawings were still not realistic enough. They came up with the idea of "translating the drawing into models which … would faithfully reproduce the lunar effects of light and shadow." These plaster models, made with great skill by Nasmyth, were then photographed, resulting in startlingly realistic lunar landscapes, which were partly imagined images, albeit based on scientific observation. Some of Nasmyth's lunar models survive in the Science Museum in London.

The book's illustrations have an undeniable intrinsic beauty, and the book includes other effective visual comparisons with the Moon's surface and texture. The authors photographed the wrinkled back of a man's hand and a shriveled-up apple "to illustrate the origin of certain mountain ranges resulting from shrinkage of the interior." In another picture we see a delicate glass globe, cracked, but still in one piece, to illustrate a possible cause of the radial streaks around the crater Tycho.

Nasmyth and Carpenter's contribution to humankind's understanding of the Moon did not go unnoticed: both have craters on the lunar surface named after them.

"Back of hand . . . to illustrate the origin of certain mountain ranges resulting from shrinking of the interior," from *The Moon: Considered as a Planet, a World, and a Satellite* (right)
Lithograph – James Carpenter and James Nasmyth, 1874

In Carpenter and Nasmyth's ambitious book, descriptions of the Moon's features are illustrated with inventive representations, such as the back of a hand (right) or a wrinkled apple, to explain the origins of mountain ranges.

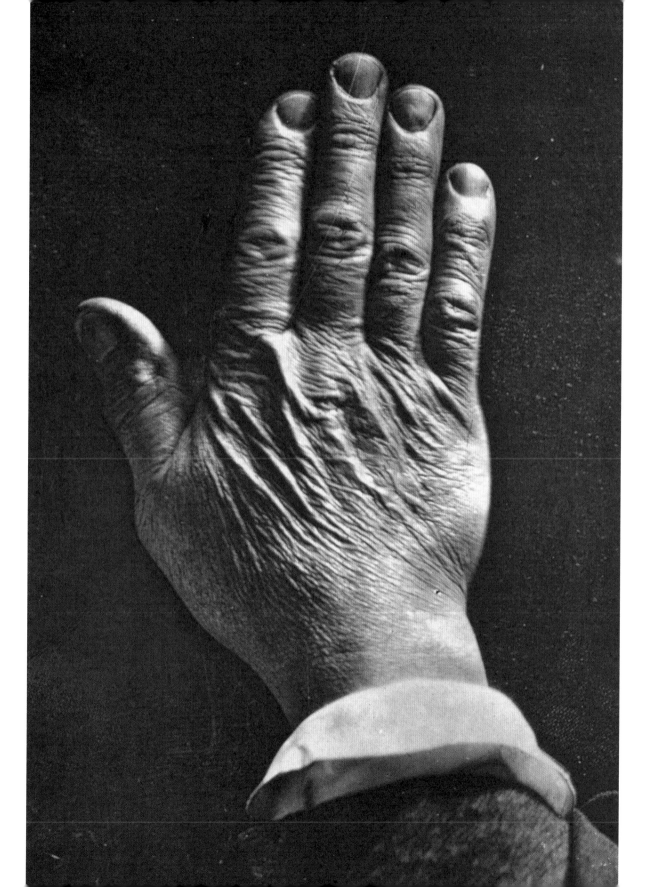

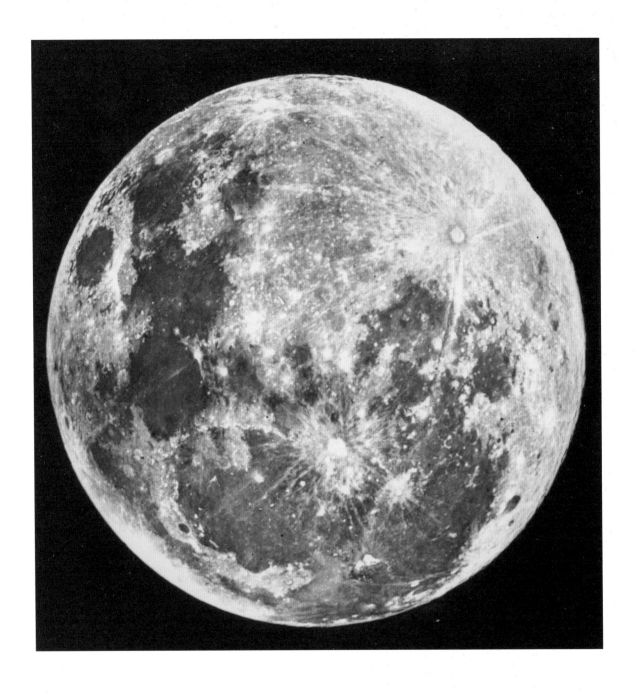

"Full Moon, exhibiting the bright streaks radiating from Tycho,"
Plate XIX from *The Moon: Considered as a Planet, a World, and a Satellite*
Lithograph – James Carpenter and James Nasmyth, 1874

Above and right: The image above is the only photograph of the actual Moon in Nasmyth and Carpenter's book; elsewhere they used figurative examples, like the globe seen right, and the back of the hand on the previous page. Realistic craters, mountains, and other features were also reproduced in intricate models crafted by Nasmyth.

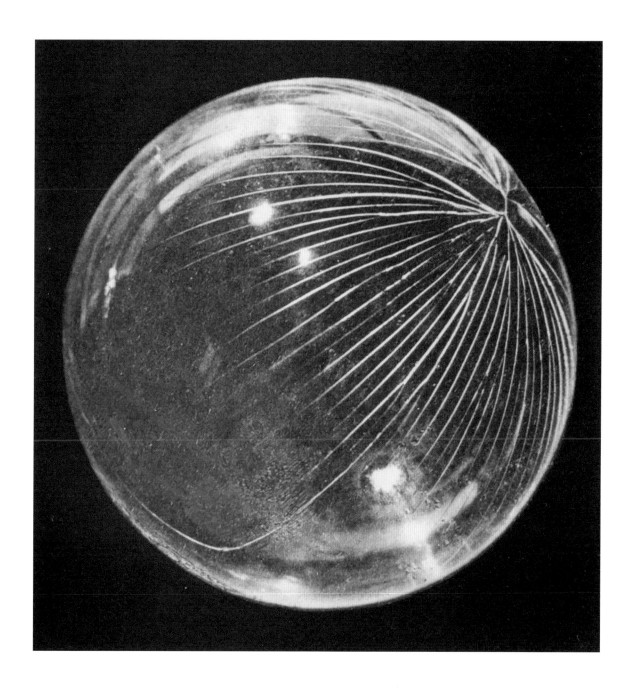

"Glass Globe, cracked by internal pressure, illustrating the cause of the bright streaks radiating from Tycho,"
Plate XX from *The Moon: Considered as a Planet, a World, and a Satellite*
Lithograph – James Carpenter and James Nasmyth, 1874

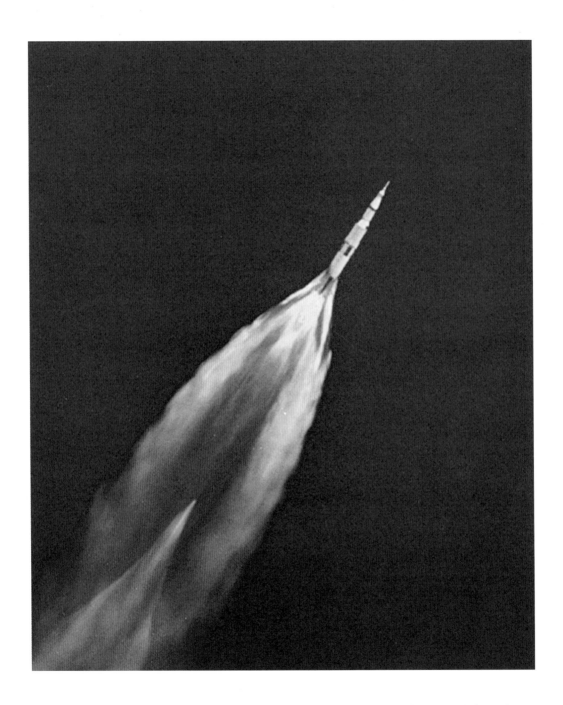

Launch of Apollo 11

Photograph – Dennis Hallinan, 1969

A simple but striking image, powerfully illustrating the force it takes to launch a rocket into space. Astronauts undergo special training to prepare for the extreme g-force they will experience during lift-off.

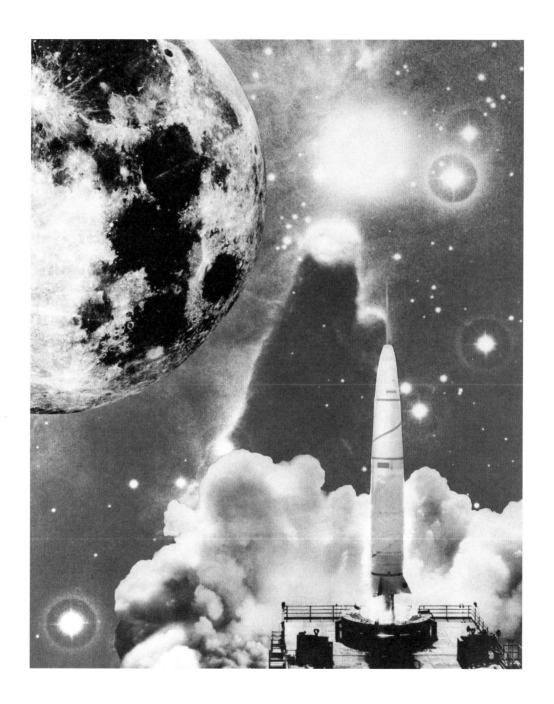

Rocket, Moon, Space
Composite image – Unknown, c.1950s

A launching rocket, starry universe, and glowing Moon combined in this image illustrate the mood of the 1950s and '60s, where human imagination was captivated by space and the race to reach the Moon.

LUNAR ROVERS: DRIVING ON THE MOON

The final three Apollo missions, 15, 16, and 17, each carried one of the most expensive cars ever built. The Lunar Roving Vehicle (LRV), popularly referred to as a lunar rover, was a 38-million US-dollar electric vehicle (equivalent to well over 200-million US dollars today) driven around the lunar surface by a pair of astronauts on each of the three missions.

Only four LRVs were made, and the three that went to the Moon are still there. With aluminum frames, the rovers were relatively light, and were unfolded on arrival. As electric cars operating in a low-gravity environment, the LRVs had a maximum speed of around 8 miles (13 kilometers) per hour—about the same as a slow cyclist on Earth. Nonetheless, the vehicles greatly extended the range of astronauts on the surface.

Apollo 15 astronauts David Scott and James Irwin used the rover in three trips over a total of 16 miles (27 kilometers); first to the lava channel Hadley Rille, then a distance in parallel with the Apennine Mountains, and finally to nearby craters. On Apollo 16, John Young and Charles Duke drove a similar distance around the Descartes region, and Apollo 17 saw Eugene Cernan and Harrison Schmitt travel 19 miles (30 kilometers) across the Taurus-Littrow valley to two different mountain ranges. These cars were expensive, but invaluable. Even traveling a short distance away from the landing craft took the crews to different sites where they could see different landscapes and collect samples of different rocks. On one such drive Schmitt found the famous "orange soil," later connected to an ancient volcanic eruption.

The rovers were reliable, but not indestructible. Before setting off, Cernan managed to knock a part of the wheel arch off from the Apollo 17 rover. When driving, this protected the crew from dust sprayed up from the surface in plumes and arcs in so-called "rooster's tails." On the Moon this dust could be a real hazard, darkening spacesuits and making them absorb more sunlight, and potentially scratching the suit visors. Cernan and Schmitt eventually stuck the piece of arch back on with duct tape, until a few hours later that fell off too. With more duct tape, and advice from Mission Control, they found a more durable solution. Taping together laminated maps to replace the missing wheel arch, the new repair lasted for the rest of the mission, and 15 more hours of lunar driving.

James Irwin and Apollo 15 Lunar Roving Vehicle (right)
Photograph – David Scott, 1971

The Apollo 15 mission marked the first time a lunar rover was deployed, allowing the astronauts David Scott and James Irwin to cover more ground than previously possible. The crew were tasked with exploring the Hadley-Apennine region and performing scientific experiments.

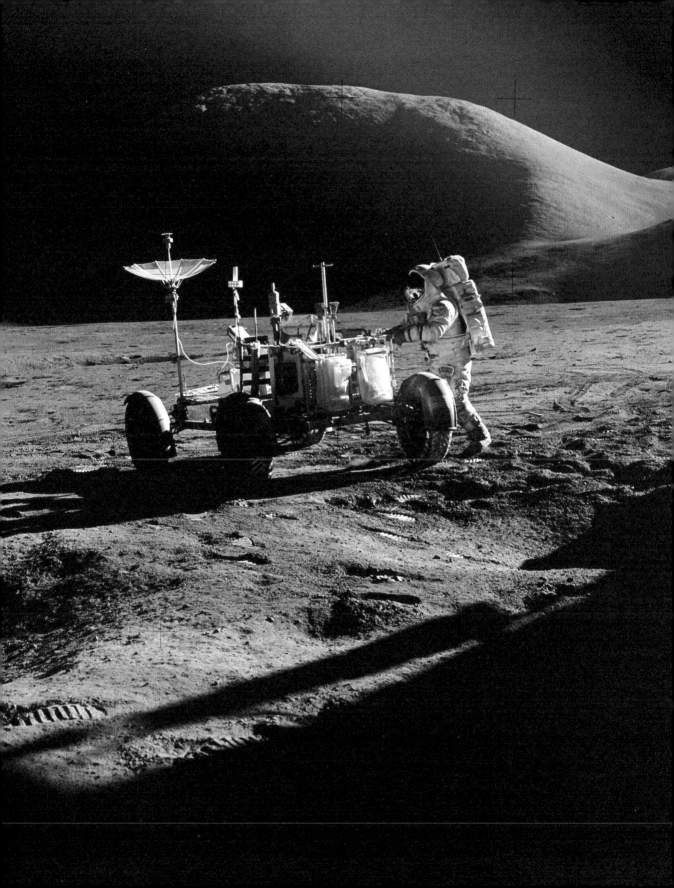

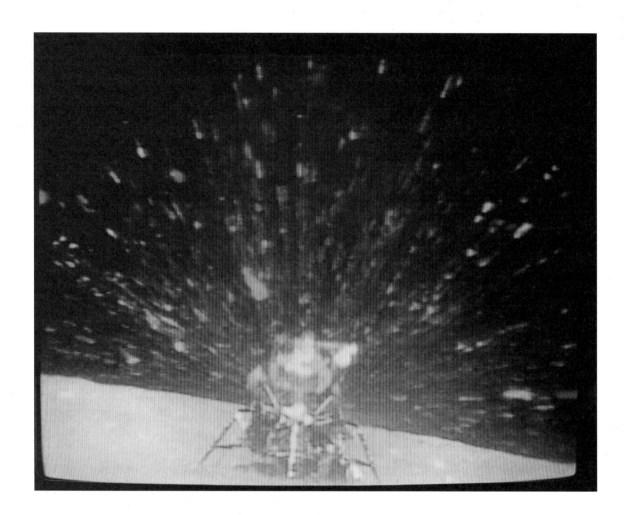

Apollo 16 lunar module Orion lifting off from the lunar landing site

Photograph of television transmission – NASA, April 22, 1972

Video captured by a lunar rover shows the take off of the Apollo 16 lunar module Orion carrying astronauts John Young and Charles Duke back to Ken Mattingly in the command module to continue their journey back to Earth. It was the penultimate Apollo mission to land on the Moon.

Simulated landing of a lunar lander *(right)*

Multiple exposure photograph – NASA, April 11, 1967

NASA's Langley Research Facility based in Hampton, Virginia, was used to test the Apollo lunar modules in simulations where the astronauts could practice their piloting skills.

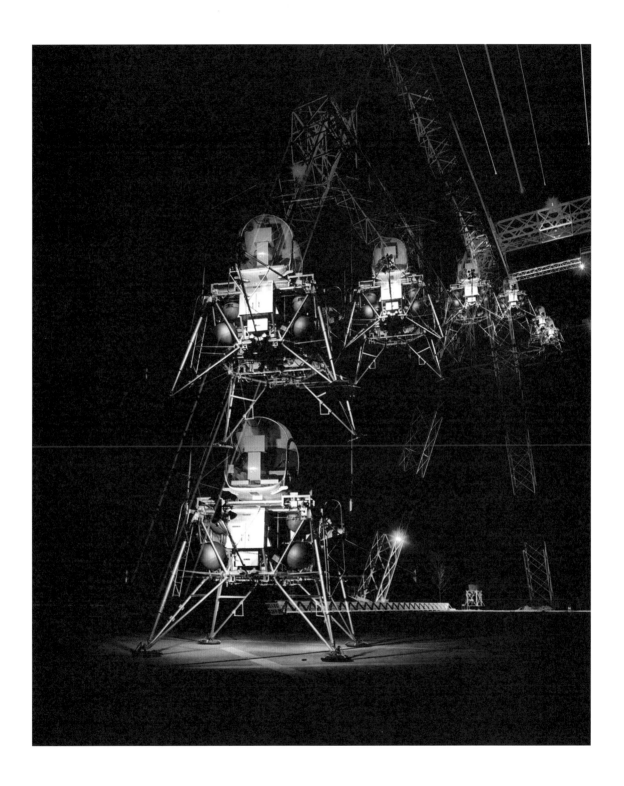

SOVIET SPACE-RACE PROPAGANDA

It is easy to forget that until the mid-1960s the Russians were ahead in the race to the Moon and had made significant breakthroughs in space exploration. The first Sputnik satellite was sent by the Soviet Union into orbit in 1957, while US launch attempts resulted only in humiliating failure. The Soviet probe Luna 3 had sent the first images of the far side of the Moon back to Earth in October 1959. These were grainy pictures, but they were of huge political significance in the Cold War period.

The clarity, bold colors, and sharpness of the posters and other promotional material produced by the Soviet Union in relation to space exploration was a deliberate contrast to the fascinating but fuzzy monochrome images transmitted from space. Even television and newspaper reports of space exploration were still in black and white, so the possibilities of printed propaganda were exploited as much as possible.

The quest for the Moon, and the science that went along with it, made a brilliant narrative which was easily translated into images such as this, where we see a glorification of the Space Race as a metaphor for progress, the ideal citizen, and the ideals of a nation in general. For Americans the Space Race offered the same opportunities in respect of propaganda, but it is noticeable that their imagery focused on technical detail and science, while Soviet iconography was more graphic, symbolic, and ideological. This was public art and imagery, deliberately placed and disseminated for political reasons.

Posters depict athletic cosmonauts, sometimes alongside older engineers, with a clear focus and goal: the Moon. Reaching the Moon and possibly colonizing it was the perfect project that would reflect the Soviet Union's strength, determination, and political power in the Cold War period. Images of strong, smiling cosmonauts (both male and female) and bold and colorful geometric designs of space rockets reaching for the Moon and stars can still be found in and on many public buildings in former Soviet countries, in stained-glass windows, murals, and mosaics.

Worker and engineer of the Soviet Union (right)

Soviet Union, c.1957–63

Poster

A Soviet poster featuring a worker and an engineer admiring the Moon conveys pride and ideology. The five-pointed red star is a symbol of Communism, and the blue arch it travels along is a frequent motif in Soviet Space Age propaganda: a similar "shooting star" design can also be seen in the poster on page 101.

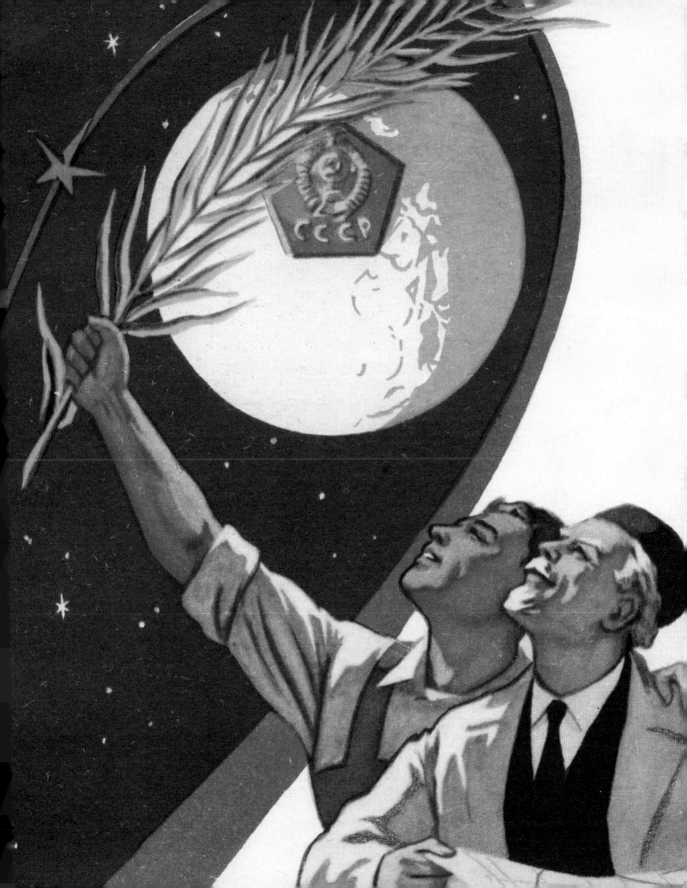

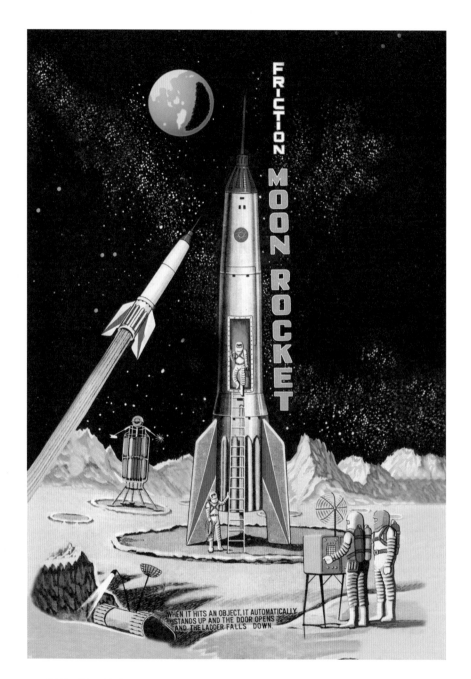

Friction Moon Rocket

Toy packaging – US, made in Japan, 1950

Above and right: These two packaging designs for toy spacecraft mix realism and fantasy. Care has been taken to depict authentic-looking technology, while the artists have taken more creative licence with the rocket launching from a smooth lunar surface and a space-walking astronaut with a gun.

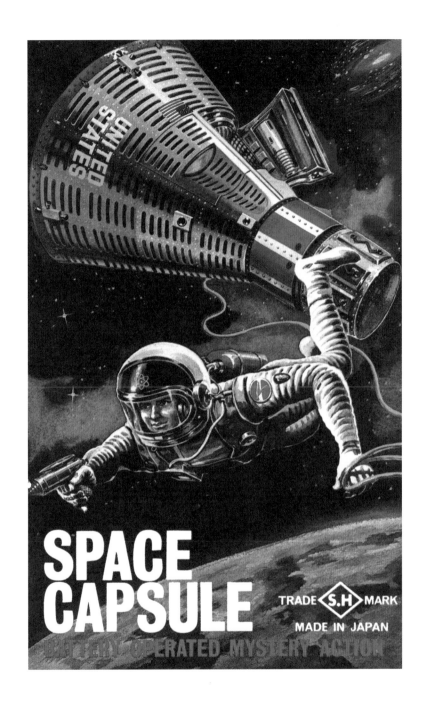

Space Capsule
US, made in Japan, 1960
Toy packaging

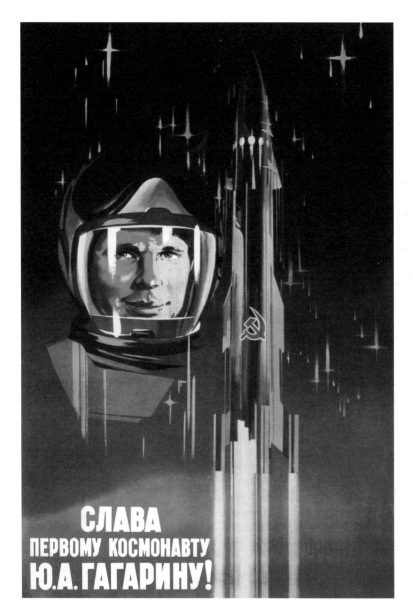
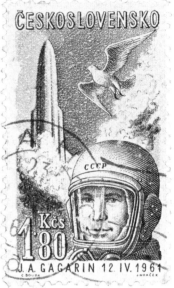
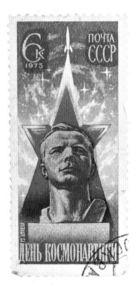

"Glory to the first Cosmonaut, Y. A. Gagarin!" *(this page, left)*
Poster – Valentin Petrovich Victorov, 1961

Yuri Gagarin was the figurehead of the Soviet space program, being the first human
to travel to space. His death in 1968 coincided with the end of the Soviets' Space Race chances,
as the US space program began to overtake.

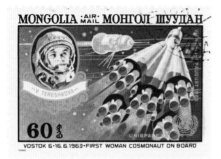
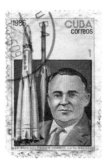
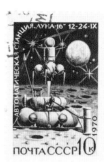
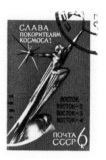

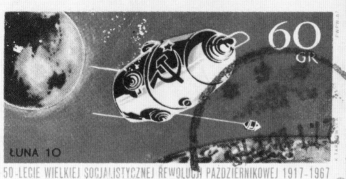
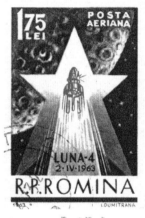
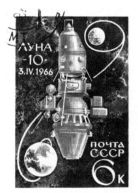
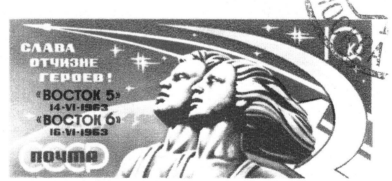

A collection of stamps celebrating the Soviet space program *(this page and near left)*
Postage stamps Various, 1961–86

This collection of stamps features popular icons of the Soviet space program—cosmonauts Yuri Gagarin and Valentina Tereshkova, and the Luna and Vostok spacecraft—along with Communist symbols such as the red star and the hammer and sickle emblem.

LA PREMIERE FEMME DANS LE COSMOS

NUMERO SPECIAL 18 JUIN 1963

Les Nouvelles de MOSCOU

HEBDOMADAIRE, RUE GORKI 1612, MOSCOU Prix : 3 kopecks.

La cosmonaute-VI Valentina TERECHKOVA

"Le Premiere Femme Dans le Cosmos"
(The First Woman in the Cosmos) *(left)*
Newspaper – *Les Nouvelles de Moscou*, June 18, 1963

The first woman to travel into space, Valentina Tereshkova also remains the only woman to have ever been on a solo mission there too. She was selected to train as a cosmonaut from 400 applicants.

Mechanical Space Man
Toy packaging – US, made in Japan, 1950

In real life, the Apollo astronauts "came in peace for all mankind"; however, toy spacemen come armed, just in case.

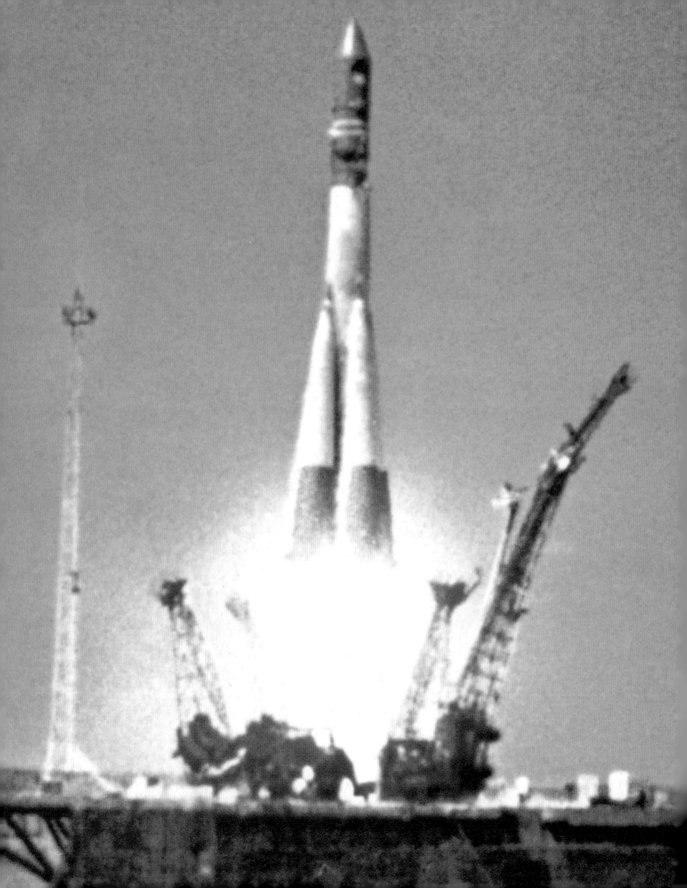

SERGEI KOROLEV

The US space program in the 1950s and 1960s developed largely in the public eye. Controversial advocates such as Wernher von Braun cultivated the press and broadcast media, and NASA's successes and failures during the Space Race were well documented. In the Soviet Union, things were different. With a censored press, only successful missions came to light, for a time giving the impression that the Soviets were far ahead of their American counterparts. Entirely unknown in the West and to the public in the USSR, Sergei Korolev was the chief designer and engineering genius who led the triumphant early years of the Soviet effort.

Born in 1906 in Ukraine, Korolev trained in aeronautical engineering at the Kiev Polytechnic Institute. Later joining the University of Moscow, he set up the Group for Investigation of Reactive Motion (GIRD) in 1931. Later that decade, Korolev became a victim of Stalin's purges that saw hundreds of thousands of people executed and imprisoned for alleged anti-Soviet activities. His GIRD colleague Valentin Glushko, arrested in 1938, denounced Korolev to reduce his own punishment.

Korolev received a sentence of ten years in prison, spending several months in the notoriously brutal Kolyma gold mines in the Soviet Far East. After the intervention of the head of the NKVD, the Soviet interior ministry responsible for implementing the worst repression of the Stalin era, Korolev came back to Moscow for a retrial. His term was reduced to eight years, and Korolev served this time in a prison for intellectuals, working on rocket motors for military aircraft during the Second World War. After the war, his efforts turned to ballistic missiles, and later the large intercontinental ballistic missiles (ICBMs) needed to carry newly developed nuclear warheads.

Korolev's team built the world's first ICBM, the R-7 rocket. The missile launched in the summer of 1957. On the October 4 of the same year, Korolev used the same vehicle to place Sputnik in orbit, starting the Space Age. This first satellite launch shocked both US scientists and the wider American public. Sputnik's simple radio signal, a beeping noise transmitted for three weeks, gave the impression of a Soviet lead in space and technology in general. The following month the same type of rocket carried a stray dog, Laika, into space, and less than four years later, Yuri Gagarin became the first human to orbit the Earth.

Having survived the worst years of the Soviet Union, Korolev's hidden work saw him leading a space program that sent the first probes to the Moon. His ambition was to land cosmonauts there too. He would, though, not live to see the USSR lose the Space Race: in 1965 he was diagnosed with colon cancer and died during surgery the following January.

Only after his death did the Soviet Union disclose his existence. *Pravda* ran an obituary, Korolev was interred with full honors in the Kremlin Wall in Red Square, and a large crater on the far side of the Moon bears his name.

Vostok leaving the Baikonur launch pad No. 1 *(left)*
Photograph – Soviet Union, April 12 1961

Korolev's Vostok spacecraft sets off for Earth orbit, carrying the Soviet cosmonaut Yuri Gagarin. It was the first time a human ever traveled into space.

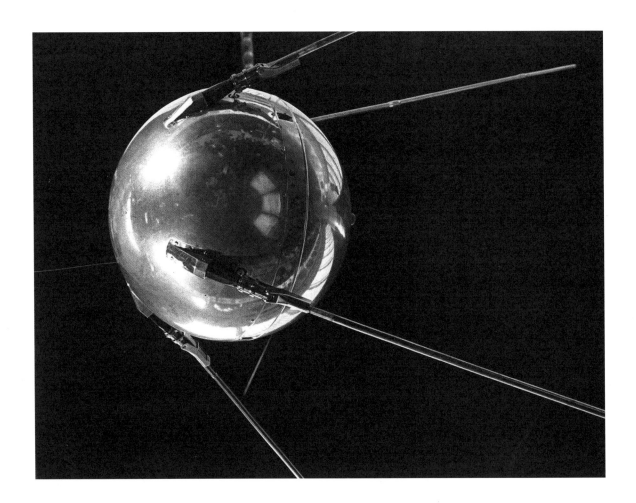

Sputnik, the first Soviet space satellite

Photograph – Valentin Cheredintsev, 1967

In October of 1957, Sputnik became the first human-made object to be put in space. A huge victory for the Soviet space program, it is regarded as the trigger of the Space Race. One of its aims was to test the method of placing an artificial satellite into Earth's orbit.

Totality (overleaf)

Photograph of installation – Katie Paterson, 2015

Paterson's mirrorball reflects more than 10,000 images of solar eclipses. They represent nearly every eclipse ever recorded, including drawings from hundreds of years ago. The installation explores the spectacle of the Moon and humanity's long-held fascination with it.

"Hail the Soviet People, Paving the Way to the Cosmos"
Chromolithograph – Vadim Volokov, 1959

In the early years of the Space Race, the Soviets appeared to be in the lead. Propaganda celebrated the space program's successes, while a censored press did not report any setbacks. In this poster from 1959, an oversized Moon looms large over the Spasskaya Tower of the Kremlin in Moscow.

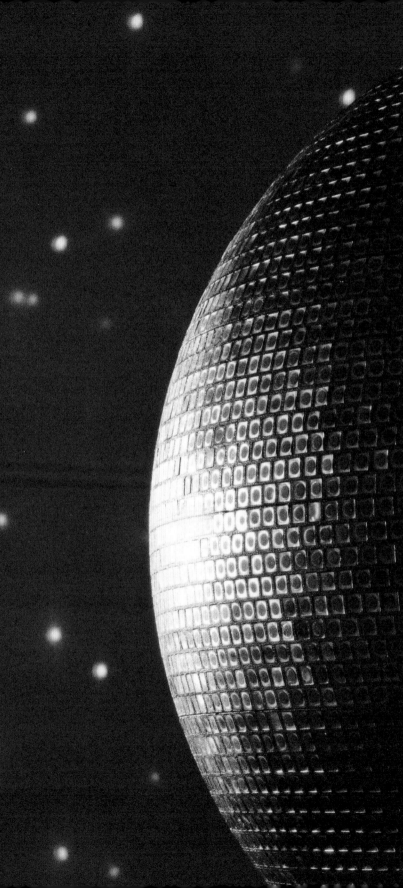

MARGARET HAMILTON

Software engineer Margaret Hamilton had a vital but unsung role in the Apollo program. Born in 1936 in Indiana, she studied mathematics, and at the age of 24 joined the Massachusetts Institute of Technology to become a software developer, working in the nascent field of computer science.

Hamilton initially saw the post as a way to support her husband while he studied law, but a year later MIT was asked to write the software (then a barely used word) for the Apollo guidance and navigation system. She seized the opportunity, leading the Software Engineering Division of the MIT Instrumentation Laboratory and becoming an author of the code that the Apollo missions used to travel to, land on, and return from the Moon.

In the 1960s, Hamilton was a working mother, and exceptionally rare in being a female computer programmer, an occupation that barely existed at the time. Even today, women make up less than a quarter of US employees in computing, and the proportion studying computer science fell from a third in the 1980s to less than a fifth today. Like many other employers in science and technology, NASA now makes more of an effort to hire women, and around half of prospective astronauts are female. The English-speaking world in particular faces a crisis of recruitment to science and technology, with, for example, women making up only one fifth of physics graduates in the US and UK. Expanding the base of applicants is a matter of necessity.

Despite the barriers, in interviews Hamilton describes the camaraderie she and her colleagues experienced; the sheer excitement and the addictive quality of the pioneering work they were doing. One key innovation from her team was asynchronous processing, in which the Apollo computers prioritized different functions to allow the systems to cope with multiple demands. When Apollo 11 made its final approach to the lunar surface in July 1969, two alarms, numbered 1201 and 1202, sounded. Mission Control had to make a go/no-go decision for landing. Engineers quickly realized that Hamilton's asynchronous code was doing its job: the computer was concentrating on the task in hand and ignoring less pressing work. Whenever it overloaded, the system cleared and restarted, eventually allowing the crew to bring the lunar module safely down in the Sea of Tranquillity.

In the 1970s, Hamilton left NASA for the private sector, founding two companies. In 2016 she received the Presidential Medal of Freedom from US President Barack Obama. Highlighting the belated recognition of the role women played in the Moon missions, Hamilton featured in the LEGO set "Women of NASA" in the same year, and her code was uploaded to the GitHub online platform, where modern-day developers share their work.

Margaret Hamilton working on the Apollo program *(right)*
Photograph – NASA/MIT Museum, c.1967

Were it not for Margaret Hamilton's code, Neil Armstrong and Buzz Aldrin would not have landed on the Moon in 1969. She is credited with pioneering the field of software engineering, as well as coining the term for this science itself.

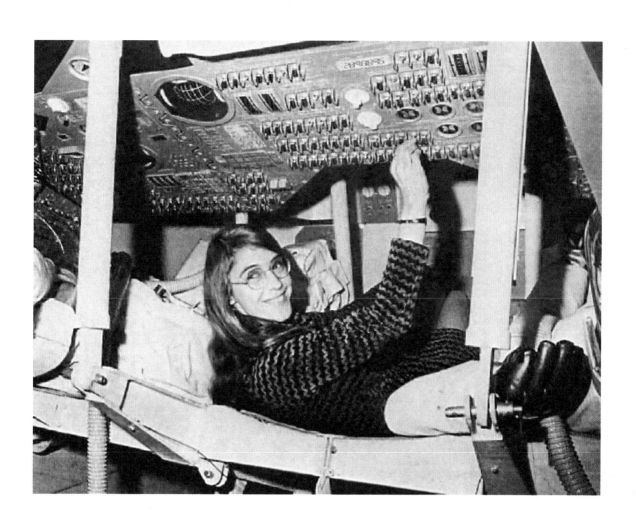

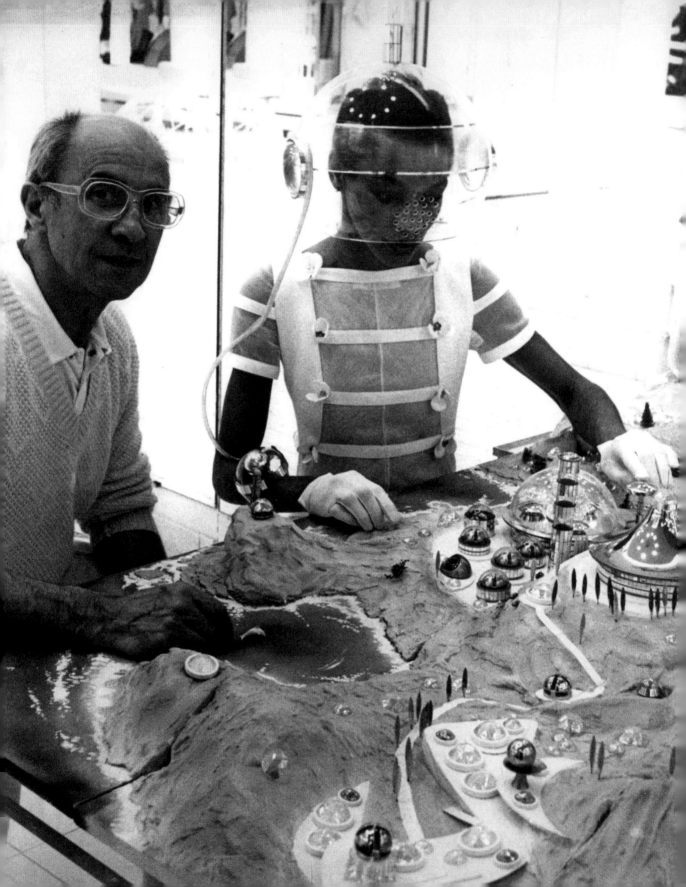

FASHION IN THE SPACE AGE

..................

The Space-Race era was not just politically and scientifically fascinating, it was also hugely influential on fashion and pop culture. Just as Russia and America were exploring new worlds, so were fashion designers and pop stars.

Fashion in the 1960s was inspired by the aesthetics of space travel, and ran with it. Space-Age fashion was fun, irreverent, architectural, and largely monochrome. It tapped into other trends, such as the emergence of the mini skirt and jumpsuits, and a general streamlining of the silhouette. A black-and-white palette, sharp outlines, and futuristic designs hailed in a new, experimental era in clothing and fashion.

The undisputed king of Space-Age style was French couturier André Courrèges, who from the early 1960s onward revolutionized fashion with his sculptural and elegant designs, often as white and shiny as space rockets. His iconic "Moon boots" are just one example of how he refashioned Apollo spacesuits and the aesthetics of space travel. Other designers were more literal, creating textile patterns that resembled the Moon's surface, celestial constellations, or the shapes of the Moon and other objects in space; as, for example, British milliner Edward Mann, who created helmet-shaped "capsule hats" with a pattern of simplified outlines of the Moon. In 1965, at the height of the race to the Moon there was even a space-themed Barbie doll available (see page 20). She sported a platinum blonde bob with a sharp fringe, and her slick silvery white spacesuit was notably less puffy than the real thing.

The rock and pop music scene lapped up space fashion. David Bowie masterfully developed the character of the fictional spaceman Major Tom in his 1969 song and album *Space Oddity*, and in the early 1970s created an alter ego who went by the name Ziggy Stardust. Bowie both dressed and performed the part of a space traveler, frequently wearing outlandish outfits by cutting-edge designers. Despite the visual and musical entertainment value, there was an undeniable undertone of alienation and isolation in Bowie's work, complementing the contradiction of excitement for the future and fear of destruction that marked the Cold-War era.

André Courrèges and model *(left)*
Photograph – Keystone Pictures USA, January 19, 1982

French fashion designer André Courrèges experimented with modern materials like plastics to create tailored, futuristic clothes inspired by the Space Age. His garments were often accessorized with refashioned items inspired directly from the designs of astronaut uniforms, such as spherical helmets, and boots.

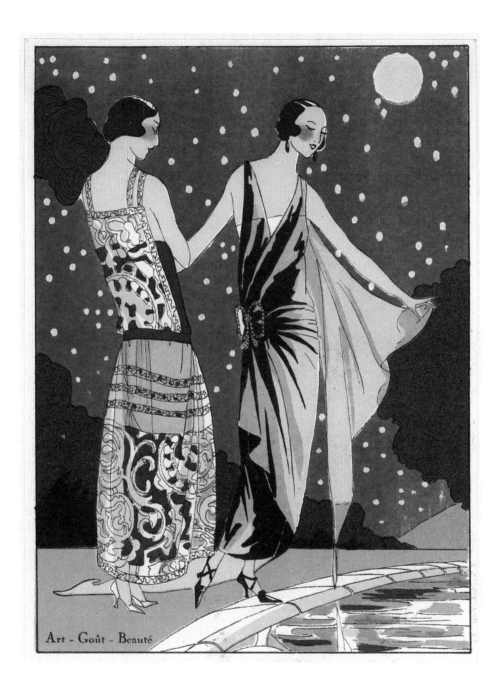

Fashion plate from *Art-Goût-Beauté*
Pochoir print – Unknown, 1923

A stylized starry sky and pale blue full Moon complement the elegant evening wear on show in this plate from luxury French magazine *Art-Goût-Beauté*. The glamorous fashion here is typical of the Art Deco period.

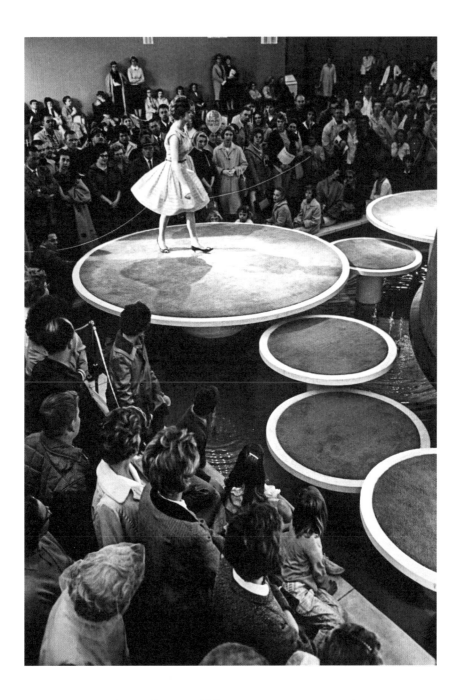

Fashion show from 1962's World Fair at Seattle, Washington, USA
Photograph – World History Archive, c.1962

The 1962 World Fair held in Seattle celebrated "Living in the Space Age." The race to the Moon heavily influenced the fashion of the time, perhaps more obvious in the stage set here than the garment.

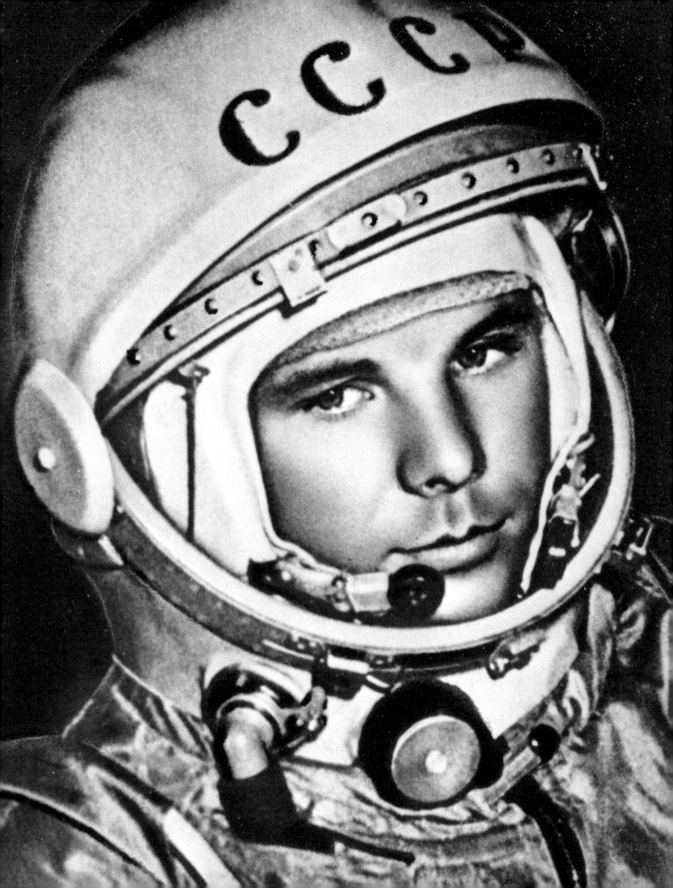

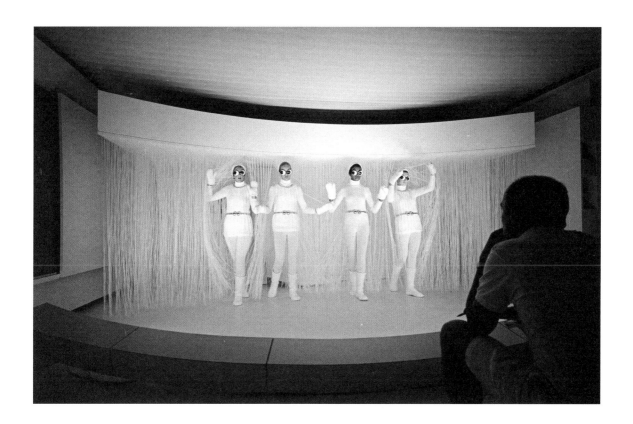

Cosmonaut Yuri Gagarin *(left)*
Photograph — Unknown, 1961

The image of Yuri Gagarin smiling in a space helmet became ubiquitous in Soviet propaganda and remains familiar to general audiences today. Tragically he died in a plane crash on a training flight just seven years after becoming the first human to travel in space. A year later, Neil Armstrong became the first man to step foot on the Moon.

André Courrèges' Winter collection, 1969-70
Photograph — Manuel Litran, July 28, 1969

André Courrèges' "little white dresses" and short hemlines were characteristic of his output during the 1960s. Here, a winter collection at the end of the decade translates this aesthetic into knitwear. The outfits are complete with white gloves, boots, and googles, as was customary, and with silver belts with Moon-like clasps.

Advert for E. & A. Mele & Ci. department store, Naples: "Novità per Uomo" ("New for Men")

Chromolithograph – Franz Laskoff, 1900

Advert for Blue Moon: "America's most beautiful silk stockings." *(right)*

Chromolithograph – Unknown artist, 1925

Above and right: Throughout the early 20th century, the Moon was a favorite motif in popular culture, adding a touch of eroticism and sophistication to a great variety of adverts.

Souvenir de Lausanne.

PAPER MOONS

The Moon is an object of such symbolic and physical magnitude that we sometimes forget to treat Earth's satellite with anything other than gravity. However, there was much humor in early fictional literature about the Moon. The first visit to the Moon on film, Georges Méliès' *Le Voyage dans la Lune* from 1902, was a satire with a good dose of slapstick (see pages 74–75).

The early twentieth century was certainly a time of interest in the Moon, as is reflected in popular culture. It was a key motif in many illustrated books of fairy and folk tales, while Christmas and Valentine cards with kitsch images of the Moon, often in combination with chubby babies, angelic children, or kittens, were extremely popular. It was also the heyday of the cheap picture postcard, which you would send to friends from places you had visited. Many postcard images of famous places and sights were available as moonlit scenes, with the Moon often added later to the photograph.

In America, a particular type of postcard was becoming popular. At fairs, carnivals, and other public events, temporary "paper moon" booths would be installed in which people could pose on a large Moon, usually made of cardboard or plywood, and have their picture taken. Most of the paper moons were sickle-shaped, as the shape was easy to sit or recline on. The backdrop was usually either completely black or a starry sky, while some more elaborate booths featured additional celestial objects or clouds, and a few even incorporated spacecrafts into the design, reminiscent of the theatrical sets of Méliès' film. Pictures taken in these moon booths were markedly different to portraits created in a photographer's studio. Many of them show romantic couples or friends or families on a day out together. What combines them is the informality and the underlying sense of fun.

The iconography of paper moon pictures eventually became so popular that it was widely used in advertising. A range of postcards with models striking more refined poses was produced in professional studios. Many of these were sold as greeting cards, and they were often of an erotic nature.

Paper moon booths remained a popular form of entertainment, and the Moon stayed in vogue as a motif for decades. In 1933, the Broadway song "It's Only a Paper Moon" was composed, popularized a few years later by Ella Fitzgerald and Nat King Cole. The song featured in Peter Bogdanovich's 1973 film *Paper Moon*, a comedy-drama set during the Great Depression. The marketing images for the film show the two main characters, played by Ryan and Tatum O'Neal, sitting on a white paper moon against a sky-blue background.

"Souvenir de Lausanne" *(left)*
Postcard – Switzerland, 1935

A Swiss postcard features the picturesque city of Lausanne, but the main subject is a jolly holidaymaker cycling along a tightrope attached to a sickle Moon. In the early 20th century, the Moon was a popular motif used to inject a sense of fun and whimsy into well-known tourist sights.

French paper-moon postcard
Postcard – Atelier Reutlinger, early 20th century

Moon postcards became so popular they began to be produced in professional studios such as that of Atelier Reutlinger in Paris. Typically the Moon was used to provide an element of fantasy within the staged photography.

The Kiss
Silverprint – Herbert Bayer, 1935

Bauhausler Herbert Bayer's experiments in photography often employed the technique of photomontage. Here a moonlit river provides the backdrop to a fragmented image of two lovers in an embrace, suggesting secret rendezvous.

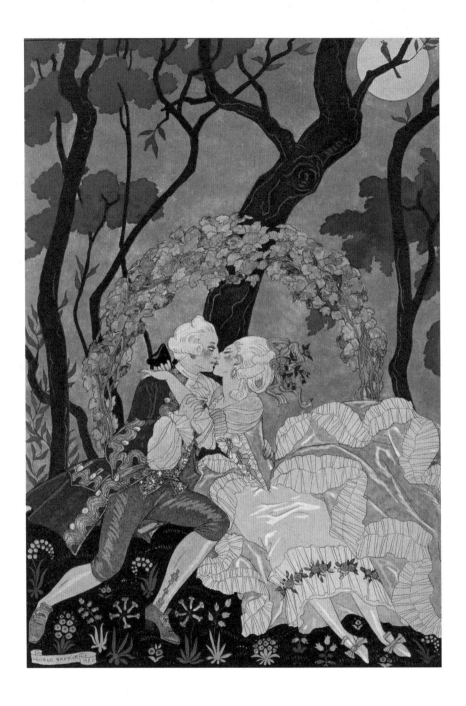

Illustration for "En Sourdine" from a 1928 edition of Paul Verlaine's *Fêtes galantes*
Pochoir print – Georges Barbier, 1920

The full Moon was frequently used as a mood-setter in romantic scenes. In famed French illustrator Georges Barbier's illustration here, the Moon lends the image a clandestine air, reinforced by the secluded forest setting.

Bow Moon
Color woodblock print
Utagawa Hiroshige, 19th century

In Hiroshige's traditional Japanese woodblock print, a crescent Moon hangs low in the early dawn sky between "huddled hills." The accompanying poem describes the fleeting gleam of the moonlight over forests and "hurrying" streams.

"Royal Palm Avenue by Moonlight in Tropical Florida"
Postcard – Unknown, c.1950

Miami Beach's iconic Palm Avenue looks just as inviting in the moonlight as it does in the sunshine. The Moon catches the eye, while artist's use of perspective draws it further into the image.

From *A Thousand and One Nights 1* (right)
Oil on canvas – Suad al-Attar, 1984

Another eye-catching Moon: Iraqi artist Suad al-Attar has painted a lush, enchanting forest scene. Her work is inspired by Middle Eastern art, and this dreamlike painting takes its name from the title of the famous Arabian folk tales.

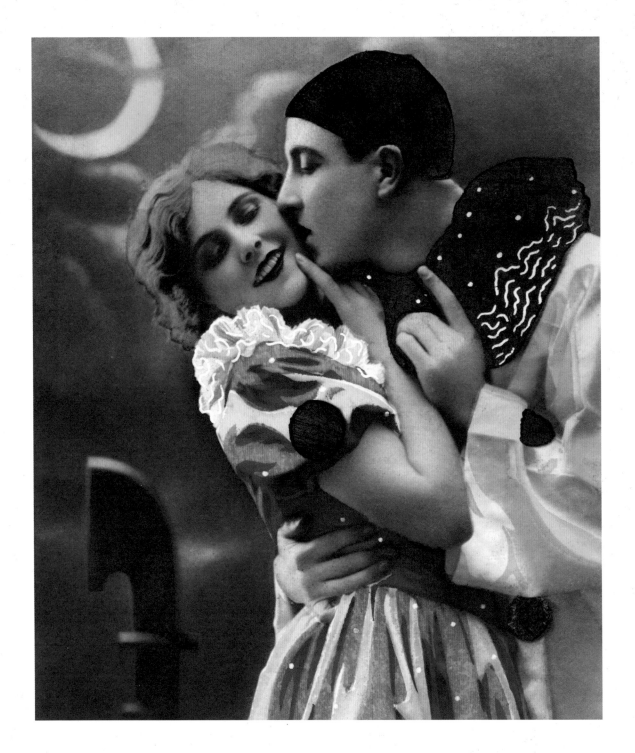

Couple at Venice Carnival

Hand-colored photograph – Unknown, c.1924

A kissing couple under moonlight, its yellow hues reflecting on the pair's festival costumes. The Venice Carnival is a huge celebration with masquerade balls, parades, and street performances, taking place in the run up to Lent.

Couples at a luxury tropical resort
Screenprint – Unknown, 1947

In contrast to the photographic travel postcards of the early 20th century, where the addition
of a Moon signaled fun and frivolity, this evening scene of dining couples at
a luxury resort conveys formality and sophistication.

Moonwalk
Screenprint – Andy Warhol, 1987

Famed Pop Artist Andy Warhol repurposes the iconic image of Buzz Aldrin from the Apollo 11 mission. Considering how the NASA imagery disseminated around the world, and remains vivid in many people's imaginations today, this was a fitting subject for Warhol whose work explored media and celebrity.

Cover of *Grand Hôtel*, issue XIX, "Luna e Lucciole" ("Moon and Fireflies")
Watercolor illustration – Walter Molino, 1964

This Italian magazine cover for a Women's weekly promises readers romance. It features just the publication's title above a moonlit scene of two lovers in the countryside.

THE WEREWOLF

..................

For humans, fear of the dark is a primal response, expedient to the extent that many of the things that might harm us, such as spiders, snakes, and other wild animals, are nocturnal. Besides the real dangers, there is also a long and rich history of imagined and mythological creatures that roam in the darkness, for example, ghosts and vampires. One popular myth with a particularly strong connection with the Moon is that of the werewolf: a hybrid creature of a (usually male) human and a wolf.

The origin of the werewolf myth is unknown but most likely it had its beginnings in early European culture; the "lycanthropes" of Greek and Roman classical antiquity, or the totemic wolf-warriors of early Germanic culture. In Ovid's *Metamorphoses*, one of the earliest texts to mention werewolves, Lycaon, along with his children, was turned into a wolf in punishment for serving the god Zeus the remains of a child. Elsewhere, the werewolf curse might be triggered by the donning of a cursed pelt.

Werewolf folklore developed significantly from the medieval period onward, in parallel to a growing religious hysteria around witchcraft. It was around this time that the idea of the curse being triggered by the light of the full Moon came to prominence, probably because of the belief that the full Moon caused mental disturbances and horrific, unnatural events. Between the fourteenth and seventeenth centuries, most of the literature around werewolves dealt with killers accused of particularly brutal crimes. Today we can see alternative explanations in mental-health problems and possibly rabies, at the time not understood and met with a fear inflamed by popular superstition.

The myth of the werewolf was hugely popular in nineteenth-century gothic literature, and found a new lease of life in the horror films of the twentieth century, when ever-improving special-effects technology provided us with spectacular shapeshifting scenes. A particular high point in werewolf history was the early 1980s, with the brutal transformation scene of *An American Werewolf in London* (1981) and Michael Jackson's yellow-eyed wolf in his 1982 "Thriller" music video. In times and places where dangerous wild animals are scarce if not missing altogether, the continuing popularity of the werewolf myth reveals our thirst for terror—and the enduring fascination with stories about humans cursed to become a brutal beast.

Poster for *La Nuit du Loup-Garou (The Curse of the Werewolf)* *(right)*
Chromolithograph – Guy Gerard Noel, 1961

The *Curse of the Werewolf* was released in 1961 by Hammer Film Productions, best known for their cult horror films of the 1960s and '70s. The movie stars Oliver Reed as the titular beast, fated to transform under a full Moon and commit acts of savagery and murder. Love is the only antidote to his curse, recalling the classic horror trope of good versus evil.

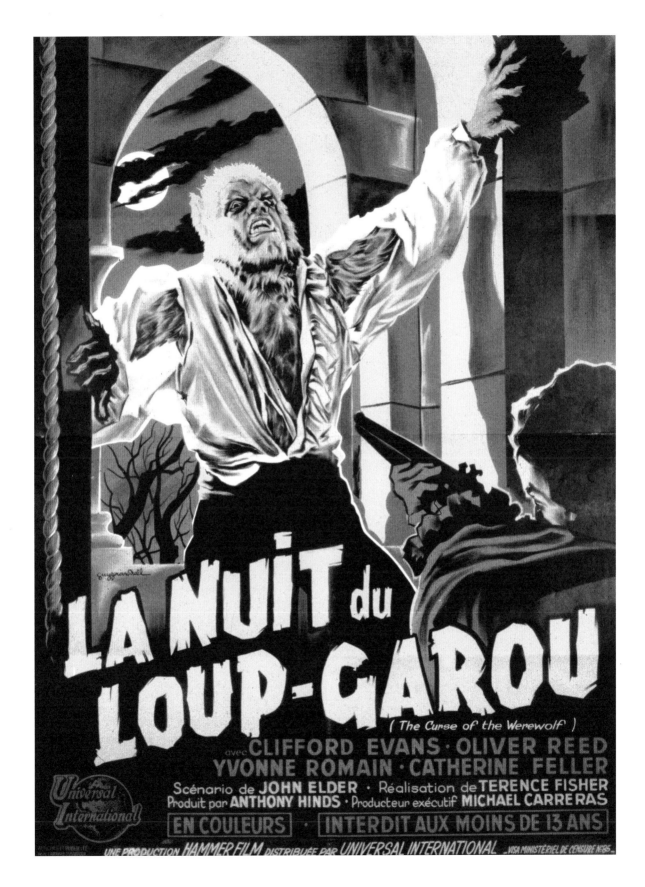

**Werewolf costume for the *Ballet de la Nuit*
by Jean-Baptiste Lully** *(left)*

Watercolor on paper – French, c.1653

Staged in honour of Louis XIV of France, also known as the Sun King, the *Ballet de la Nuit* was an impressive twelve-hour performance that featured mythical gods and goddesses, such as Diana, the lunar deity, and Apollo, the Sun god (played by the king himself). Other characters included Endymion, the mortal shepherd beloved of the Moon, and a werewolf, whose ingenious costume is pictured here.

The Sleeping Gypsy

Oil on canvas – Henri Rousseau, 1897

A beast of the night comes in the form of a lion, who has picked up on the scent of a sleeping mandolin player. Describing the painting, Rousseau noted how the lion does not attack the woman, and he credited the moonlight with contributing a poetic effect.

Poster (above) and still (right) from the film
An American Werewolf in London
Poster, color print / Film still – Universal, 1981

The werewolf is a symbol of brutality and violence, conjured up by the spell of a full Moon. Landis's 1981 film is a notable edition to the cannon of 20th-century werewolf movies and has since become a cult classic.

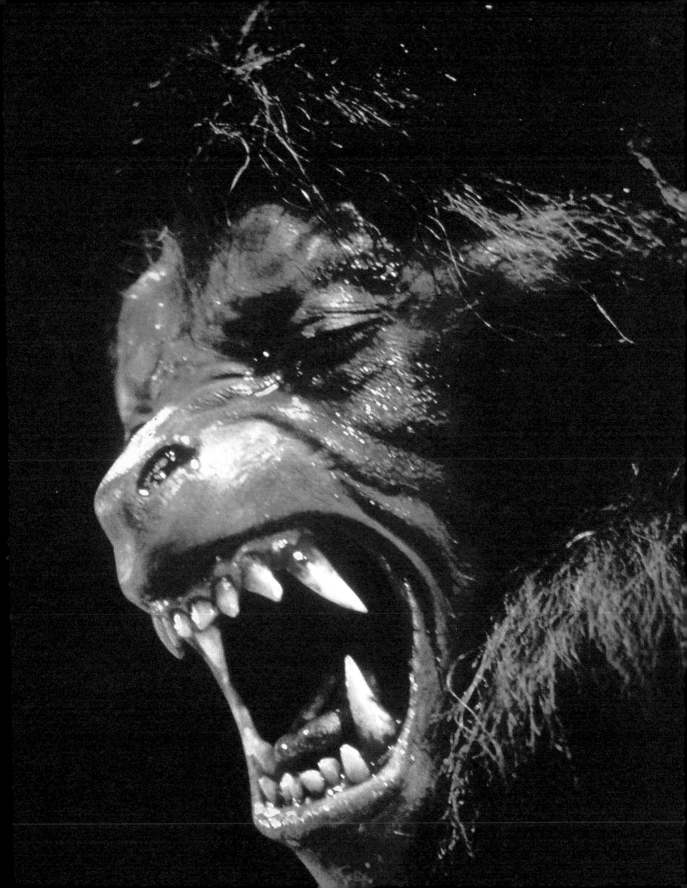

LUNACY

Among the many enduring fallacies about the Moon is the idea that it can affect mental health. The terms lunacy or lunatic directly link luna—the Moon—to mental illness, suggesting that Earth's satellite is responsible for anything from foolishness to forms of perceived madness or insanity. The belief that the phases of the Moon, particularly the full Moon, trigger erratic behavior and intermittent health problems, such as seizures, epilepsy, and nervous breakdowns, can be traced back to at least ancient Greece and Rome. The Moon's known influence on bodies of water led to the belief that it could also draw the moisture in the brain, resulting in altered states of mind.

Later, when good health, both mental and physical, was thought to be dependent on the balance of the body's four humors (blood, phlegm, black bile, and yellow bile), the waxing and waning of the Moon was thought to change the composition of these fluids, causing uncharacteristic or episodically deranged behaviors. Nothing much changed from the medieval period, when the full Moon acquired its link with werewolfism (itself possibly a crude explanation of mental disorder), to the nineteenth century, when, in Britain, the Lunacy Act of 1842 was still positing a direct link between the Moon's phases and changes in a person's mental health. Psychiatric institutions were referred to as "lunatic asylums," like Bethlem Royal Hospital in London, which first admitted mentally ill patients in 1407. Throughout the eighteenth and nineteenth centuries, these establishments continued to grow in popularity despite the frequently inhumane treatment of their patients, who were sometimes beaten during certain phases of the Moon to prevent the possible lunar triggering of violent behavior.

A posthumously famous patient of one such institution was none other than the painter Vincent van Gogh, who in May 1889 had checked himself in to the Saint-Paul-de-Mausole asylum in France, following a mental breakdown. Conditions in this asylum were considerably better than most, and Van Gogh was able to paint there. Despite the deteriorating state of his health, he produced there one of his best-known and loved paintings, *The Starry Night*, which features a prominent, yellow, waning sickle Moon against an inky blue, swirling night sky.

The Starry Night (right)
Oil on canvas – Vincent van Gogh, 1889

Van Gogh's famed starry night was painted during his stay at the Saint-Paul asylum. The painting features the "morning star" Venus and a golden crescent Moon. In a letter to his brother, the artist described how he found the night "more alive and richly colored than the day."

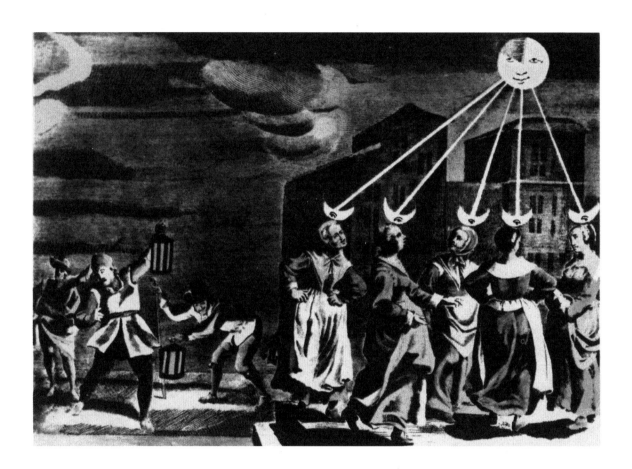

"The influence of the Moon on the feminine mind"
Color woodblock print – French, 17th century

The erroneous belief that the Moon can have an effect on the mind has persisted for a surprisingly long time. Here, it acts specifically on the female mind. The feminine cycle is often connected to the Moon's phases, which in this illustration directly beam down in separate crescents onto the heads of a group of women.

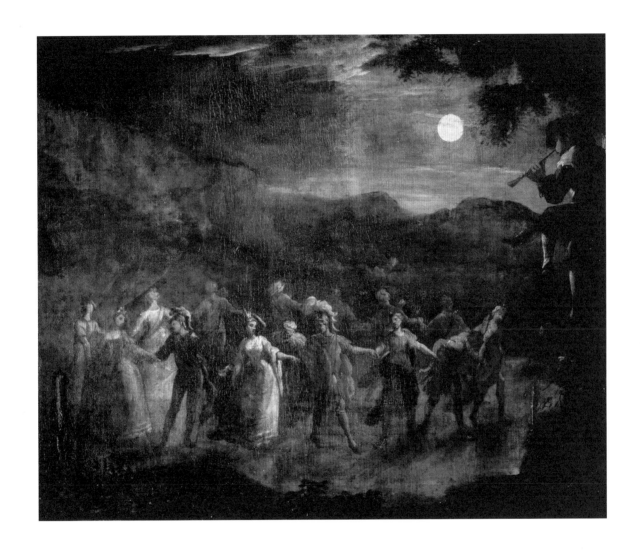

Fairies Dancing by Moonlight
Oil on canvas – Francis Hayman, c.1740

Artist Francis Hayman had a background in painting for theatre, which included scenery as well as book illustrations of Shakespeare's plays. The influence of the stage can be seen here in composition and subject. Fairies are often depicted reveling in moonlit woodlands; dancing and playing instruments.

Moonlight Fairies in a Wood (left)
Pen and ink, watercolor, and gouache on paper –
Arthur Rackham, 20th century

Renowned English book illustrator Arthur Rackham was largely known for his fantasy works for children's literature. In this secluded woodland, a full Moon hanging low in the sky lights up a clearing where two fairies sit, one playing a musical instrument.

Dead Souls
Oil on canvas — Peter Nicolai Arbo, 1866

Arbo was a Norwegian painter, heavily inspired by Norse mythology. Here he depicts the mythical Wild Hunt, where dead souls surge across the night's sky. The sight of the hunt was thought to be a bad omen.

On the Tees, near Barnard Castle (left)
Gouache and watercolor on paper – John Atkinson Grimshaw, c.1866

John Atkinson Grimshaw was a Victorian-era painter, working at a time when many artists were seeking to paint mood and atmosphere—the Moon often featured in such works as a symbol of melancholy or foreboding. Grimshaw was admired for his moonlit nocturnes; his mastery of light can be witnessed in this eerie landscape.

Moonlight, Wood Island Light
Oil on canvas – Winslow Homer, 1894

Working at around a similar time to Grimshaw, American artist Homer was best known for his dramatic seascapes where his subject was the power of the ocean itself. In his painting above, the Moon is obscured by hazy clouds but it beautifully illuminates the foreground rocks and a curling wave suspended in motion.

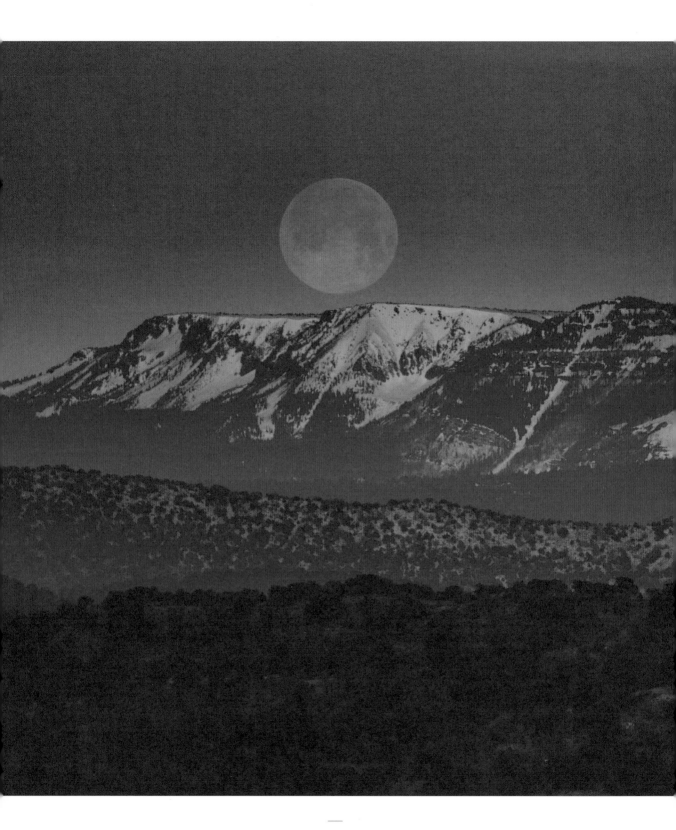

SUPERMOONS

In astronomy, things are rarely symmetrical. Planets like the Earth and satellites like the Moon are not quite spherical. The paths they travel, their orbits, are slightly stretched circles or ellipses. These orbits, in turn, are tilted in a third deviation from flawlessness, and the effects combine to give an ever-changing appearance and location in the sky for planets and moons.

Johannes Kepler described this for the first time more than 400 years ago—surprisingly it makes it easier to predict where the Sun, Moon, and planets are at a given time than if they moved in circular orbits. The same calculations allow astronomers to work out the changing distance of the Moon from the Earth.

Each (lunar) month the Moon completes an elliptical orbit around the Earth, its appearance changing from invisible at new Moon to the bright disc of full Moon, and back again. Depending on the time of year, the Moon appears higher or lower in the sky at a different point in the month, and the elliptical path means its distance from the Earth varies by up to 31,000 miles (50,000 kilometers).

The nearest point to the Earth, the perigee, can be a little over 221,500 miles (356,000 kilometers) at its closest. When the perigee coincides with full Moon, the result is a somewhat larger and brighter lunar disc sometimes described as a "supermoon." This can be overstated, as a perigee Moon is only about 14 percent bigger than at apogee (when it is farthest away from the Earth), but experienced observers do notice a significant difference in size. The increased brightness is a subtler change, as the human eye is incredibly good at compensating for changes in light levels (just think of how we adjust from sunlight to a moderately lit room at night). The only other physical effect is a slight increase in the tidal range of the seas, a result of the increased gravitational pull when the Moon is closer to the Earth.

Much more obvious is the so-called "Moon illusion." When the lunar disc is low on the horizon, it looks dramatically larger than when it hangs high in the sky. This effect is very visible, and surprisingly its explanation is still debated. The Greek philosopher Aristotle described the illusion as long ago as the fourth century BCE, believing that the Earth's atmosphere somehow acted as a lens to magnify the Moon. More recent ideas include "size constancy," where we perceive the Moon to be farther away when low on the horizon, so assume it to be larger, but another theory argues that we perceive the Moon to be closer in the same position. In any case, a photographed image soon demonstrates that the size of the Moon is essentially the same no matter how high it is in the sky.

Moonset at 6.48 a.m. (left)
Photograph – Andrea Reiman, 2017

Photographers can exaggerate the effects of the "Moon illusion" (when it appears larger in the sky the closer it is to the horizon) using a telephoto lens, which makes objects in the distance appear bigger. This is known as the "telephoto compression effect" and, used well, it can create dramatic, seemingly unreal images of the lunar disc.

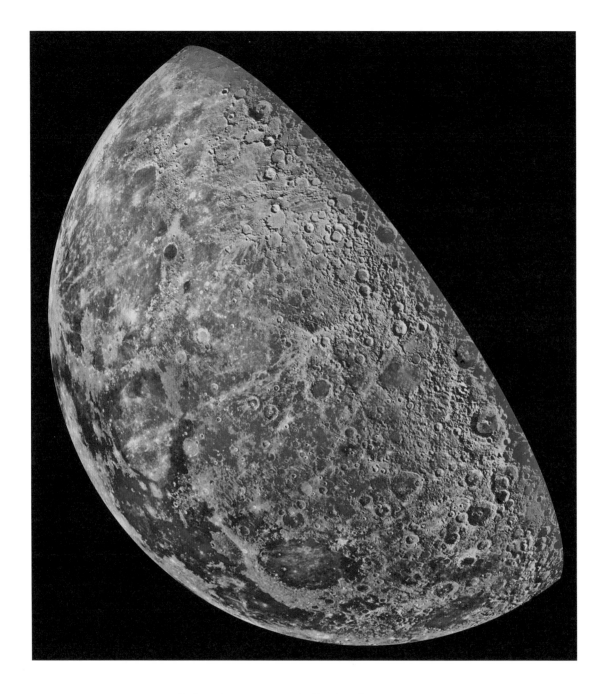

Geological variations across the Moon's northern hemisphere
False-color mosaic of 53 images through three spectral filters
NASA Galileo spacecraft, 1992–96

This false-color mosaic shows the Moon's northern hemisphere. In the lower left region, the dark blue area is the Mare Tranquillitatis (where Apollo 11's Eagle landed). The pink areas indicate highlands, while the brightest blues show the most recent impacts.

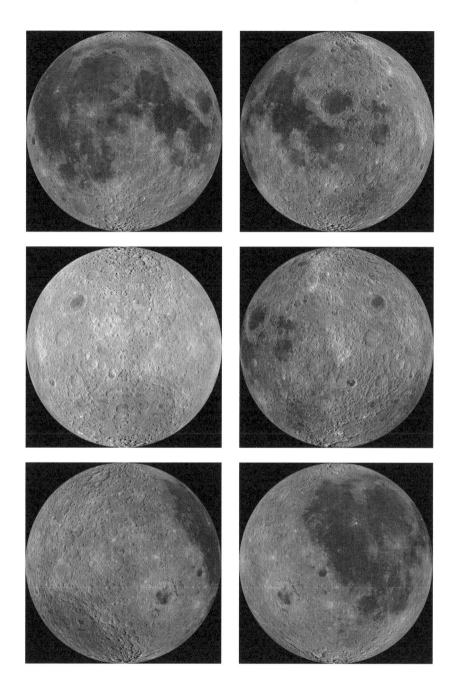

The far side of the Moon—and all the way around

Photographs – NASA/Lunar Reconnaissance Orbiter Camera, 2011

The far side of the Moon only became visible to us in 1959, when it was first photographed by the Soviet Luna 3 spacecraft. It revealed a different landscape to that of the near side, which is always facing Earth. Most notably, there are fewer and smaller maria. It could be due to the far side's thicker crust, meaning the ancient volcanic eruptions that resulted in the Moon's "seas" were less likely.

PHASES OF THE MOON

Although two fifths of its surface will remain forever unseen from the Earth, each month sees a change in the Moon's appearance as it moves around our planet. Over a period of about 29.5 days (with some variation due to the shape of the lunar and terrestrial orbits), the Moon completes a cycle of phases. This synodic month is the length of time between one new Moon and the next (or one full Moon and the next).

The Moon is called "new" when it is between the Earth and the Sun. Unless a solar eclipse takes place, making the lunar disc visible in silhouette, the Moon will be invisible to the eye. The unseen far side of the Moon will be fully illuminated at midday, but the side facing the Earth will be in lunar night, with little light reaching it except what might be reflected from Earth.

A day or two later, the Moon has traveled far enough for a thin crescent to be illuminated by sunlight, visible briefly after sunset, in the western sky. This "first sighting" governs the Islamic calendar and marks the beginning of each month. While traditionally the physical sight was important, in the modern world, Muslim worshippers tend to be happy with theoretical, if extremely accurate, predictions—not least in the often-cloudy skies of northern Europe.

The crescent waxes (grows thicker) each night, with more of the Earth-facing hemisphere lit up, and the Moon sets later in the evening. Often, the part of the disc still experiencing lunar night is illuminated too, but by sunlight reflected from the Earth—the so-called "earthshine." Through a telescope, the terminator—the line between day and night—traces the outline of mountains and craters. From our perspective, it moves eastward as the Moon rotates, and more of the visible surface is lit by the Sun. Near the terminator, mountains and craters walls cast long shadows, throwing these features into relief.

First quarter, about seven days in, sees half of the Moon's visible disc lit up. In the following days, the Moon is gibbous, then, fourteen days after new Moon, it is full, and visible all night. Full Moons look bright, with few shadows, but typically the lunar surface reflects only about 13 percent of the light falling on it—similar to asphalt on a road. At this point, craters and mountains are washed out in a telescope, but bright white rays mark the path of debris ejected from young impact craters.

Seven days on from full Moon, last quarter sees the waning half-Moon largely visible after midnight, and again craters and mountains are prominent, with the shadows in the opposite direction to the first part of the month. About a week later, the crescent Moon becomes new again, and the cycle repeats.

"Phases of the Moon": plate 19 of the 1708 edition of *Harmonia Macrocosmica* (right)
Hand-colored copperplate engraving – Andreas Cellarius, 1708

Andreas Cellarius's *Harmonia Macrocosmica* is a beautiful and ambitious atlas combining all known cosmological theories into one single volume. It spans 1,500 years of knowledge and speculation, dating as far back as ancient Greece.

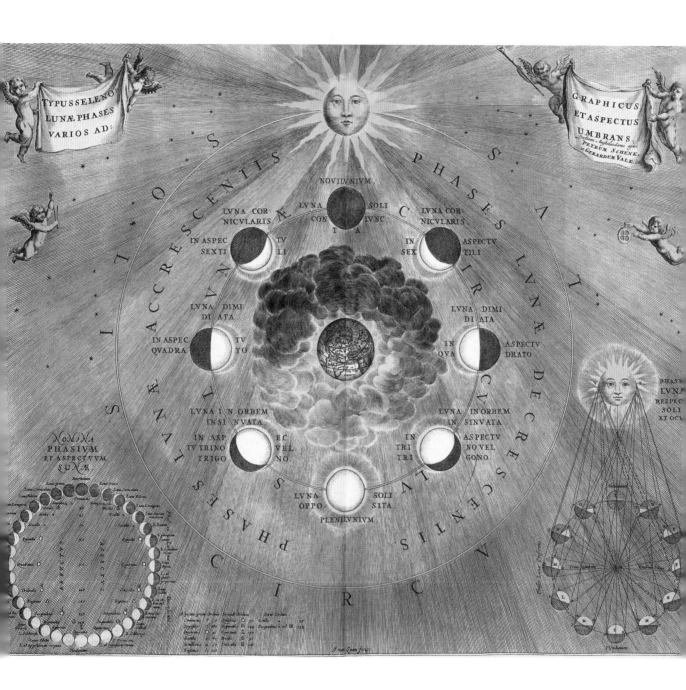

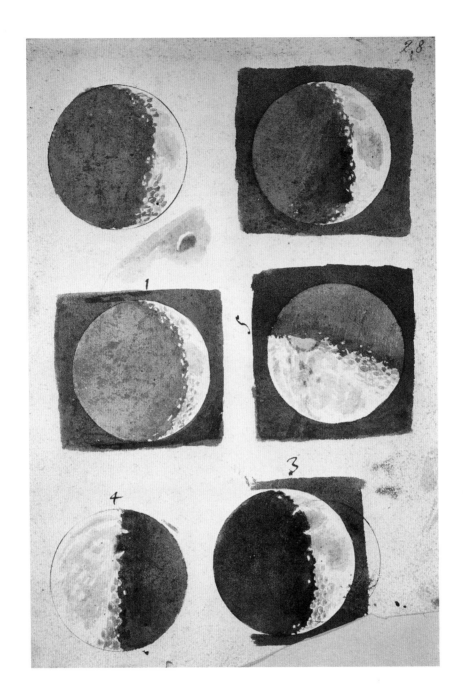

Phases of the Moon, from *Sidereus Nuncius (Starry Messenger)*

Manuscript – Galileo Galilei, 1610

Barring Thomas Harriot's drawing (see pages 172–173) Galileo's *Starry Messenger* was the first scientific work ever published about the Moon that was based on observations through a telescope.

Pflanzen im Mondschein (Plants in the Moonlight)
Ink and watercolor on paper – Paul Klee, 1929

The Moon appears many times over in Paul Klee's art, notably in his famous 1933 painting *Fire at Full Moon*.
Here, a crescent Moon shimmers in a delicate moonshine-blue sky, lighting the strange, anthropomorphic plants.

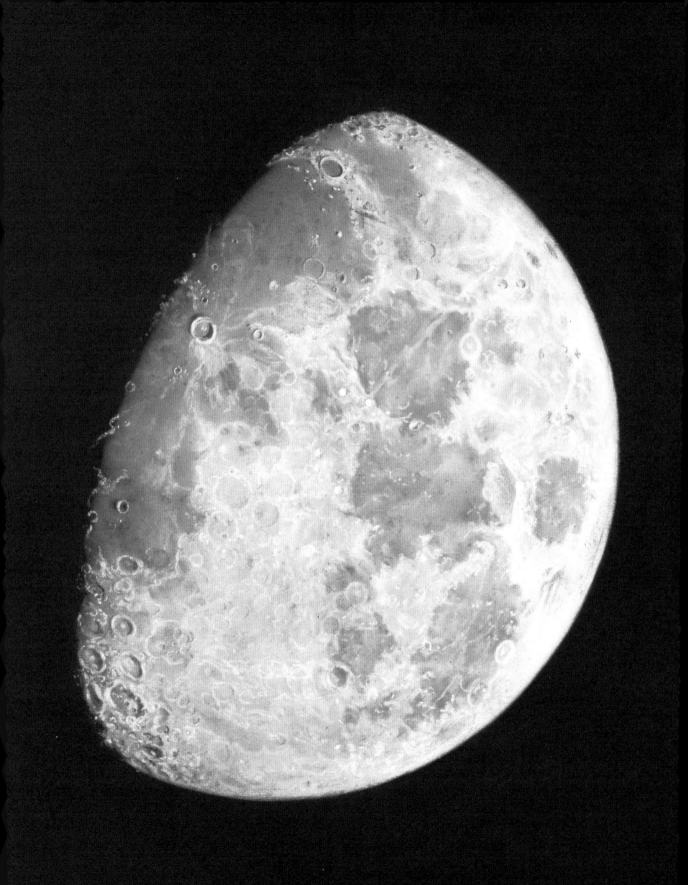

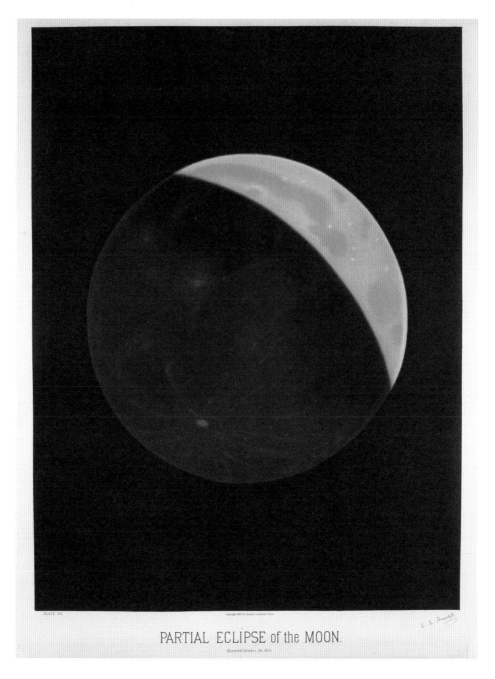

PARTIAL ECLIPSE of the MOON.

Face of the Moon (left)
Pastel on board – John Russell, 1793–97

Russell's effervescent waxing Moon is beautifully rendered in pastel, detailing the contours of the Moon's maria and craters.

"Partial eclipse of the moon. Observed October 24, 1874,"
Plate VII of *The Trouvelot Astronomical Drawings*
Chromolithograph – E. L. Trouvelot, 1881-82

Trouvelot created approximately 7,000 astronomical drawings in his lifetime. He is best know for his fifteen pastel drawings published as *The Trouvelot Astronomical Drawings*, of which the partial eclipse above is one.

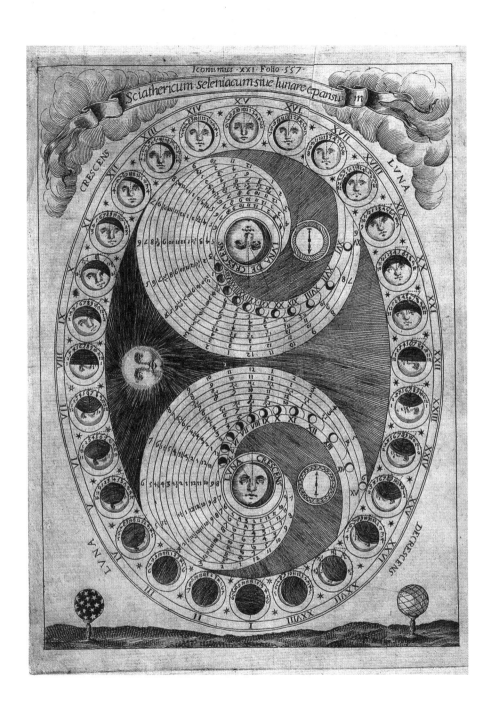

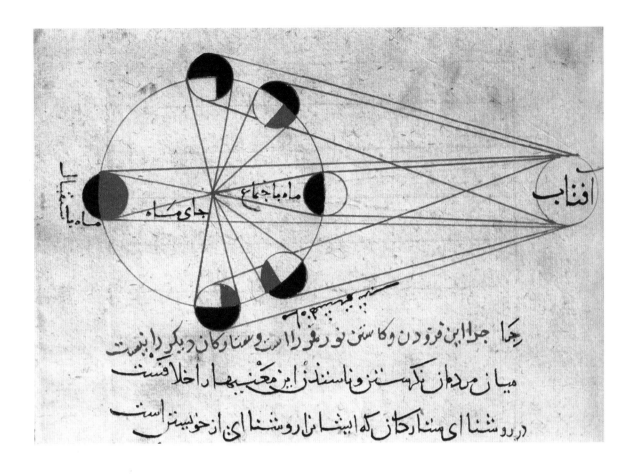

"Sciathericum seleniacum sive lunare expansivium"
("Moondial, or the Process of Lunation")
from *Ars Magna Lucis et Umbrae* by Athanasius Kircher
Engraving – P. Miotte, 1646

This plate from Athanasius Kircher's *Ars Magna Lucis et Umbrae (The Great Art of Light and Shadows)* shows the phases of the Moon in detail. Around the edge are 28 anthropomorphized phases, while the inner spirals show the hours in which the Moon appears in the sky, for the waning phases (top) and waxing phases (bottom).

Astronomical illustration explaining the different phases of the moon
Drawing – Al-Biruni, 11th century

Al-Biruni was an Iranian scholar and polymath, working during the period known as the Islamic Golden Age, a time of significant development in the field of astronomy, among other sciences. Al-Biruni studied the motions of the Sun, Moon, and planets, and wrote hundreds of books devoted to astronomy and mathematics.

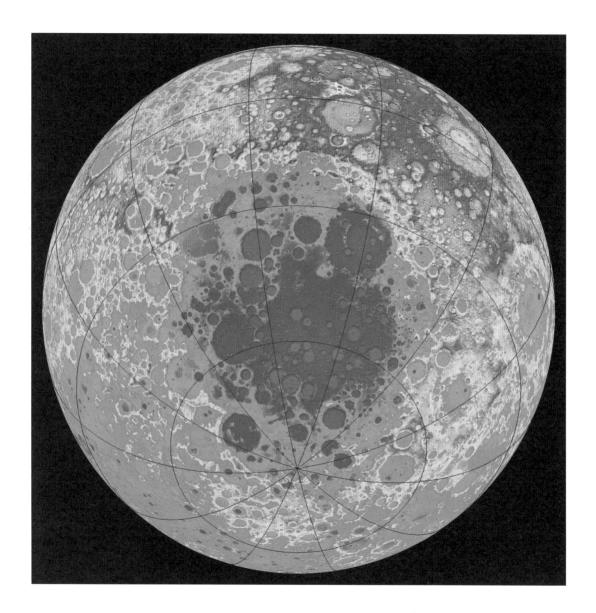

Topographical map of the Moon's South Pole, Aitken Basin

Color-shaded relief — NASA, 2014

The South Pole-Aitken basin, situated on the far side of the Moon,
is its largest impact crater, and it's recognized as the one of the largest
and oldest in the solar system. The purple and dark blue area represents its low center.

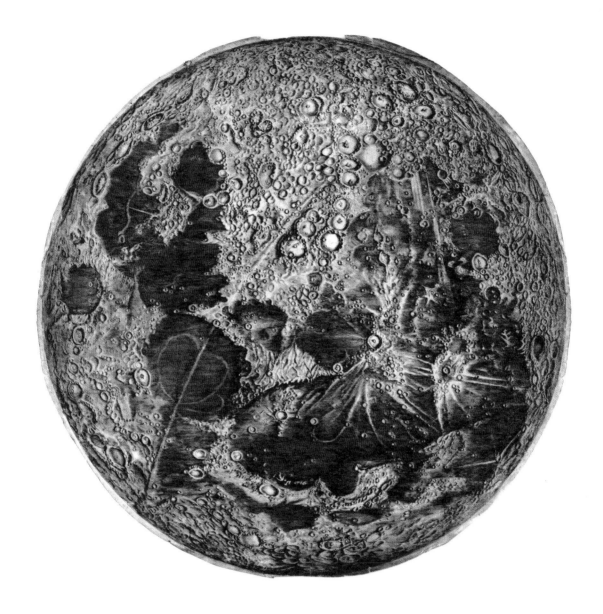

Moon Map
Engraving – Giovanni Domenico Cassini, 1679

Cassini is credited with creating one of the first scientific maps of the Moon, detailing mountains, craters, and maria. However he also included a tiny image of a woman, her head in profile jutting out of the craters at the bottom of the map, just off center, as well as a heart shape in the lower left quarter.

**Microscopic view of a thin section of a Moon rock
collected by the Apollo 12 astronauts**
Photomicrograph – NASA, 1969

Apollo 12 was the second mission to land on the Moon. Astronauts Charles Conrad and Alan Bean
collected Moon rocks and soil samples that have helped scientists understand the geology of the lunar surface.

Microscopic view of crystals in a cavity in a fragment of Moon rock collected by the Apollo 14 astronauts
Photomicrograph — NASA, 1971

After the aborted mission of Apollo 13, Apollo 14 became the third mission to land on the Moon. Astronauts Alan Shepard and Edgar Mitchell collected just over 90 pounds (40kg) of Moon rocks during two lunar EVAs (extra-vehicular activities).

LUNAR LAVA TUBES: FUTURE HABITATS?

Evidence of ancient lava flows on the Moon is visible even in moderate-sized telescopes from Earth. Channels known as "sinuous rilles" were recorded as early as the eighteenth century and mark places where magma (liquid rock) once erupted out from the lunar interior, before carving out a path on the surface as the hot liquid forced its way through the rock. Some of these channels may form underground tunnels with roofs of solid rock dozens of feet thick, and themselves be several hundred yards (or meters) in diameter.

These lava tubes have been the subject of speculation since the early 1960s. What makes them so interesting and important is their potential as future habitats. If the channels drained after their formation, as similar features do on Earth, then the large hollow tubes left behind could be a key part of a future lunar base.

The Moon is a dangerous environment. Inhabitants will initially need to bring all their supplies from Earth to cope with the challenge of a world without food, where the only abundant water is locked up in frozen polar craters, and where the atmosphere is vanishingly thin. They and their equipment will also face solar and cosmic radiation, temperatures that fluctuate from -279 to 261 degrees Fahrenheit (-173 to 127 degrees Celsius), and impacts from small meteorites. A lava tube would be a natural shield against these hazards and might even make it affordable enough for a public and private sector partnership to take the risk of starting the first off-world construction project.

"Collapse pits" in lunar images are strong evidence that empty lava tubes really do exist. The pits suggest meteorites smashed holes in the tube roofs, exposing voids beneath. In images of the Marius Hills, a region in the Ocean of Storms (Oceanus Procellarum), the Japanese Kaguya spacecraft, and NASA's Lunar Reconnaissance Orbiter Camera (LROC) found a pit 210 feet (65 meters) wide—apparently a skylight in a tube hundreds of yards across and more than 260 feet (80 meters) deep. Follow-up radar observations confirmed the presence of tubes in the same region for future missions to explore in more detail.

Thurston lava tube, Hawaii *(right)*
Photograph – Douglas Peebles, 2014

Scientists are hopeful that the Moon also features lava tubes like those present on Earth, which could provide the basis for future lunar habitats.

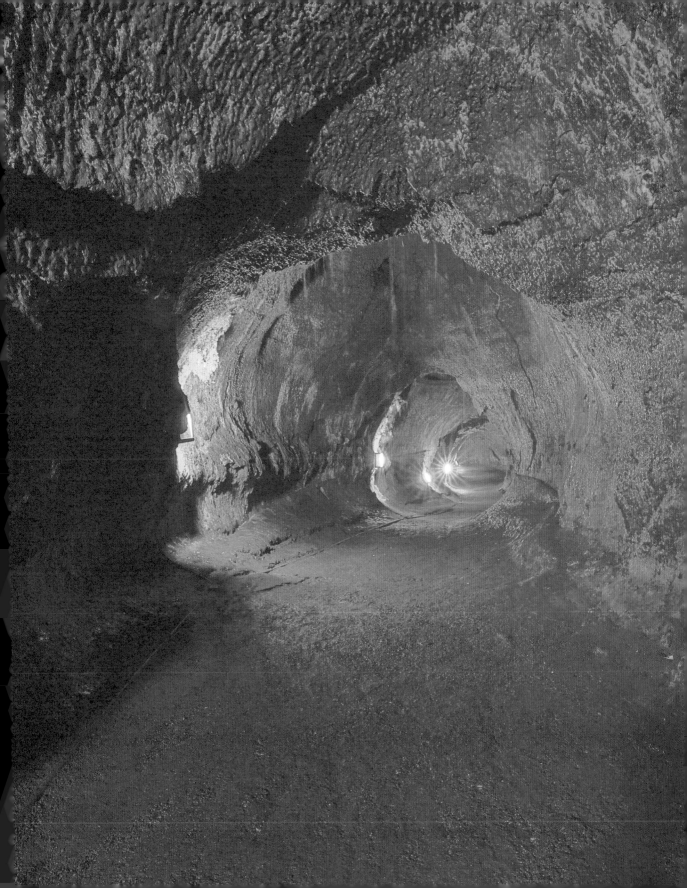

**Microscopic view of a thin section of a Moon rock
collected by the Apollo 12 astronauts**
Photomicrograph – NASA, 1969

It's hard to believe this colorful mosaic is an image of a Moon rock. A thin section of rock has been photographed
through a microscope in cross-polarized light, creating this stunning effect.

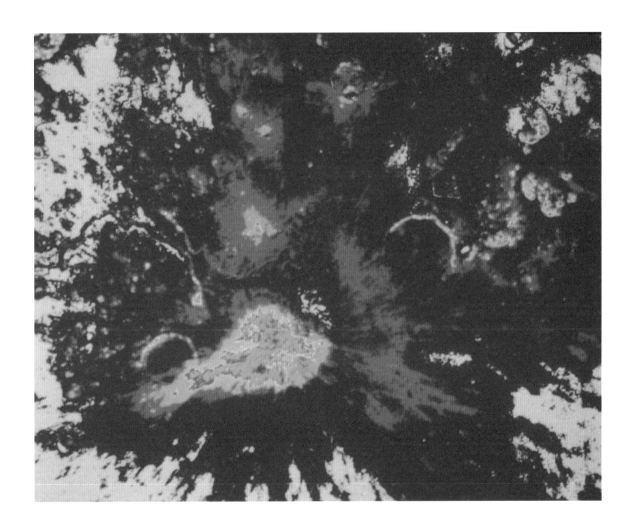

Iron map of the Aristarchus plateau

Color-coded geological map – NASA, 1994

The Aristarchus plateau is one of the most interesting features of the lunar landscape, particularly for those interested in returning to the Moon. The area is rich in pyroclastic deposits associated with volcanic eruptions, containing useful elements such as hydrogen, oxygen, iron, and titanium. The map above shows the region's iron content.

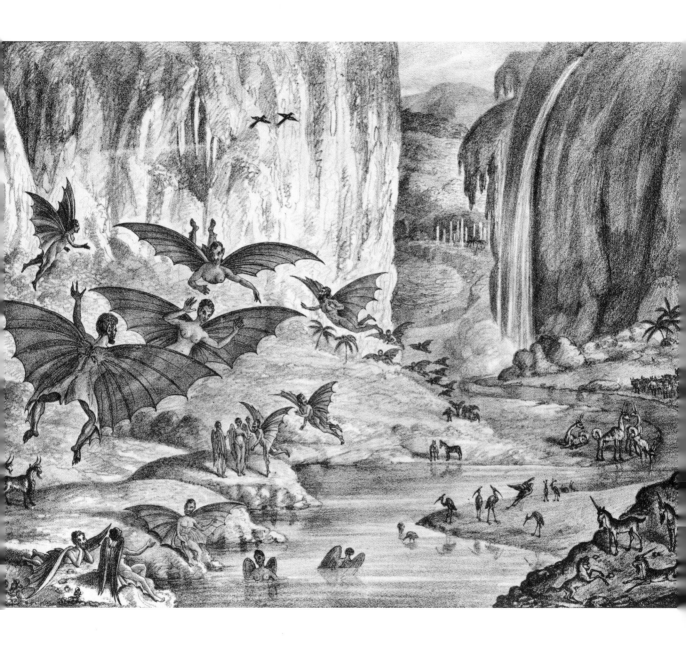

THE GREAT MOON HOAX

..................

In August 1835, the *New York Sun* published a series of hoax articles describing the discovery of life on the Moon. The newspaper claimed the sensational findings were the work of the astronomer Sir John Herschel, who at the time was based at the Cape of Good Hope in South Africa—conveniently too far away to be aware of the *Sun*'s reports.

Newly appointed editor Richard Adams Locke later confessed to the hoax, which may have been inspired by Herschel's pioneering father Sir William Herschel, also an astronomer, who did include descriptions of woods, forests, and fields he believed he saw in his own observations of the Moon in the late eighteenth century. Locke may also have been influenced by a short story by Edgar Allan Poe, published earlier the same year, describing a Dutch explorer who traveled to the Moon in a hot-air balloon and encountered "ugly little people."

Locke saw the hoax as a vehicle for satirizing writers who seemed certain about extraterrestrial life on the Moon and elsewhere. He reserved particular scorn for the astronomy writer Thomas Dick who had suggested sending a signal to lunar inhabitants by constructing a vast structure in Siberia, big enough to be seen from the Moon, in the hope that beings there would send a reply.

According to the *Sun* articles, Sir John had discovered "planets in other solar systems," and "solved or corrected nearly every leading problem of mathematical astronomy." But these achievements were nothing compared with his work on the Moon. The descriptions are elaborate. Running for a week, six articles described flowers, trees, lakes, huge crystals, flocks of birds, and herds of deer and sheep, all of which the younger Herschel had apparently seen through a giant telescope with a lens 24 feet (seven meters) in diameter. (This is comparable to the largest telescopes used in the present day, but these all use mirrors, as it would be near impossible to make a working lens on this scale.) The penultimate article even discussed "man bats," intelligent humanoid creatures with wings, apparently engaged in conversation, and the remains of ruined temples.

Herschel became aware of the hoax later in 1835, initially taking it in good humor. As time passed, however, he complained to his aunt, the astronomer Caroline Herschel, about being pestered by letters from people who took it seriously—something all too familiar to researchers who challenge pseudoscience today.

"Lunar Animals and Other Objects" *(left)*
Lithograph – Benjamin Day for the *New York Sun*, 1935

"Man bats," unicorns, and other supposed extraterrestrial lifeforms abound in a thriving valley in this artist's interpretation of faked findings on the Moon.

ISLAM AND THE MOON

.....................

The Moon and other celestial bodies, such as stars and the Sun, feature heavily in symbolic representations of religious and political groups. Objects and shapes that are universal, ever-present, and of compelling beauty lend themselves to the visual expression of beliefs and other forms of belonging, which explains the frequent use of stars as a motif in world flags.

More than any other religion, Islam has become associated with the crescent or sickle Moon, often in combination with a five-pointed star placed between or balanced by the tips of the crescent Moon. We see the Moon, with or without the star, topping the minarets and domes of many Islamic buildings, and it features on the flags of several of Islamic countries. Crucially, the religious festival of Ramadan, a month of fasting, begins at the new Moon in the ninth month of the Islamic year and ends with the feast of Eid al-Fitr at the next new Moon. Since Islam follows a lunar calendar, Ramadan begins eleven days earlier each year and fasting is experienced in different seasons, with many Muslims quite literally gazing at the sky on the day of Eid al-Fitr, the "breaking of the fast."

However, the story of the Moon and Islamic culture is not straightforward, and today the Moon is not a standard or internationally accepted symbol of the Muslim world. It also hasn't been associated with it for as long as we may think. The first official use of the Moon as a symbol of Islamic culture was in 1453, after the Turkish conquest of Constantinople (now known as Istanbul), which effectively ended the Christian Byzantine Empire. The choice of the crescent Moon and a star for the Turkish flag "Ay Yildiz" (literally: "moon star") may have its origin in an Ottoman myth, first recorded in the same century as the Fall of Constantinople. According to legend, the thirteenth-century founder of the Ottoman Empire, Osman I, had a prophetic dream in which he saw a full Moon rising from a holy man's chest before setting on his own chest, out of which grew a tree—symbolizing the new empire he would make.

Some twentieth-century scholars have suggested that Allah may have been a Moon god in pre-Islamic times, but the theory has been widely criticized. A more likely explanation for the auspicious use of celestial imagery in Muslim symbolism is that the map of the skies was an important guide to navigation on both sea and land, and a natural timekeeper, an important anchor for humans before artificial light and modern technology.

East London Mosque, Whitechapel Road, East London (right)
Finial – John Gill Associates (Architects), 1983

The crescent Moon, a symbol of Islam, sits atop a spire on a minaret of this East London mosque. A second crescent Moon adorns the top of its dome.

Crescent Moon pattern on the floor of Siena's Duomo
Mosaic – Italian, 14th–16th centuries

The marble floor of the Siena Duomo is one of its main attractions. In addition to this crescent Moon mosaic, it features over 50 panels depicting historical and biblical scenes.

Blue Birds (Les Peintres Témoins de Leur Temps) (right)
Chromolithograph – Georges Braque, 1961

Georges Braque's painting of two birds flying in the night's sky is an example of the simplified forms and bold use of color favoured by the Fauvists. The stars and crescent Moon are nearly crude, but the effect is pleasing.

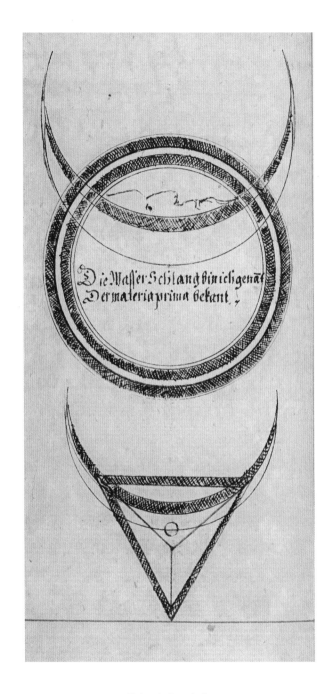

Alchemical symbols

Ink on paper – German, c.1610

This illustration features geometric symbols containing lunar crests.
The text reads: "I am the Water Snake, to the first matter known."

The ancient Egyptian Moon god Khonsu

Color print – L. J. J. Dubois, 1823–25

Khonsu, the ancient Egyptian Moon god, was often depicted in the form of a man with a falcon head, crowned with a Sun disc and crescent Moon. His name means "traveler," thought to reference the Moon's journeys across the night's sky.

The Chinese Moon goddess, Chang'e
Colored woodblock print
Inner Mongolia, c.13th–14th century

In Chinese mythology, Chang'e is a lunar deity who lives in the Moon. She is worshipped on the night of the full Moon during the eighth lunar month of every year as part of the Mid-Autumn Festival, where mooncakes are offered up. China named their first lunar probe after the goddess.

Fashion plate from *Art-Goût-Beauté*
Pochoir print – Unknown, 1925

The pochoir stenciling technique used here as well as the illustration on page 108, from the same fashion magazine, was popular during the Art Deco period in France and recalls the aesthetic of traditional Japanese and Chinese woodblock prints, as seen opposite and on page 109, respectively.

Illustration from *Songs for Little People* by Norman Gale
Lithograph – Helen Stratton, 1896

**Illustration from *Der Kleine Häwelmann
(The Little Häwelmann)* by Theodor Storm**
Color print – Else Wenz-Vietor, 1926

Above and left: The Moon is a popular motif in children's books, a symbol of magic and mystery. In Stratton's illustration, left, a bright full Moon illuminates a room full of little fairies. It plays a more central role in the narrative of Storm's fairy tale, where an exuberant little boy tests the man in the Moon's patience during a night time adventure (see page 222).

THOMAS HARRIOT'S MOON MAP FROM 1609

In 1609, English astronomer Thomas Harriot made the first drawing of a Moon through a telescope, four months earlier than Galileo's more famous work, later that year. Born in Oxford in 1560, in adult life he moved to London, where his interests in astronomy, navigation, and mathematics led to work as Sir Walter Raleigh's assistant, and he accompanied the explorer to Virginia in an expedition to set up the Roanoke Colony in 1585.

Under the patronage of Henry Percy, the ninth Earl of Northumberland, Harriot received land and lived a comfortable life at Syon House in what is now west London. His patron was not so fortunate and spent sixteen years imprisoned in the Tower of London for suspicion of involvement in the failed Gunpowder Plot to assassinate King James I. (Harriot was imprisoned too, but only for three weeks.)

In 1608, lens-maker Hans Lippershey applied to the States General of the Netherlands for a patent for a simple telescope. The new invention, described as "Dutch trunkes, cylinders of perspectives," was sold in major European cities. Harriot soon acquired a telescope, and on July 26 1609, became the first person to use one to look at the Moon.

The resulting sketch is crude by modern standards, but clearly shows the terminator (the line between night and day) and shading in the sunlit portion of the image. Telescopes, and his drawings, quickly improved, and early in the 1610s he created a map of prominent lunar features that would not be bettered for decades. As early telescopes had a narrow field of view, it was impossible to see the whole lunar disc in one look, so mapping the Moon needed some patience and skill.

Harriot and his work were celebrated as part of the International Year of Astronomy in 2009, which marked 400 years of use of the telescope to study the night sky. Though Galileo rightly deserves recognition as a more significant, and multi-talented, scientist, Harriot's contributions should not be forgotten.

Drawing of a five-day-old crescent Moon (right)
Ink on paper – Thomas Harriot, July 26th, 1609

Thomas Harriot's drawing of crescent Moon, the first to ever be made through observation with a telescope, preceded even Galileo's *Starry Messenger* (see page 146).

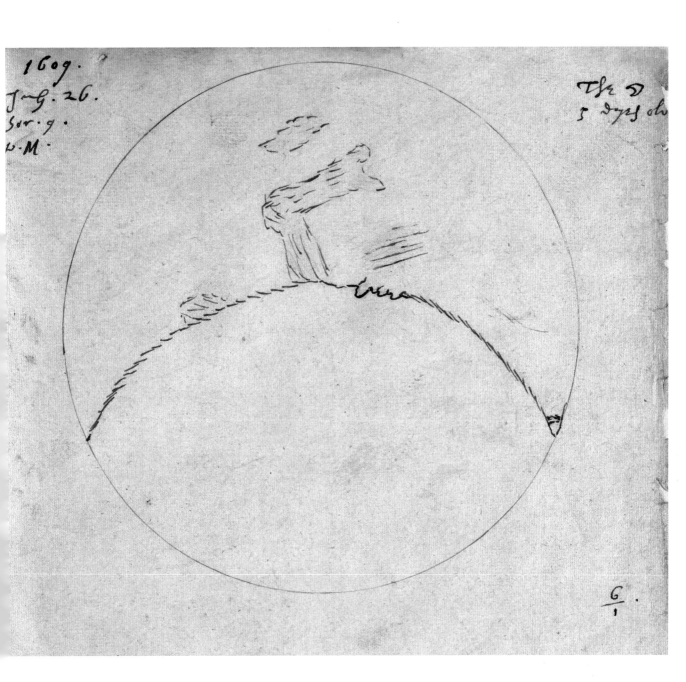

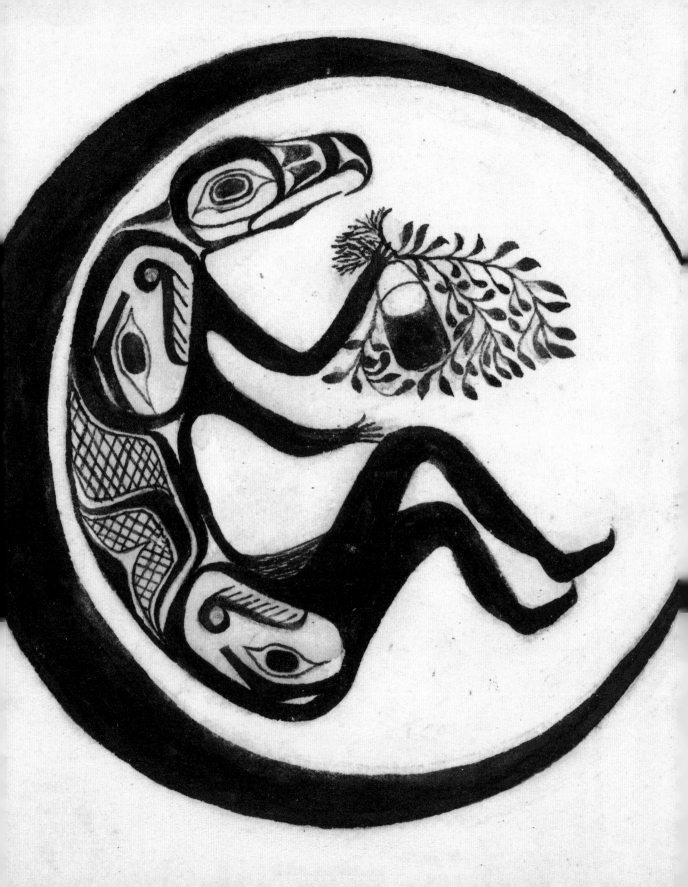

NOT (JUST) THE MAN IN THE MOON

"Pareidolia" describes the human instinct to find images and patterns in random formations—like seeing animals in clouds, and religious figures in burned toast. Before the invention of telescopes, all we could do was use our eyes to make sense of the intriguing shape-shifting celestial object above us, and one of the most common images that we have identified in the pattern of the full Moon is that of a human face. In most Western cultures (in the Northern Hemisphere) this is the face of a man, with his mouth wide-open as if in awe of the universe he is observing. Two of the largest "seas," the Mare Imbrium and Mare Tranquillitatis, form the eyes and Mare Nubium his mouth.

In Western cultures in general, human figures dominate the Moon's features. Other imagery includes a hunter carrying some form of weapon on his shoulders (visible in the Northern Hemisphere, or the head-and-shoulders profile of a well-coiffed woman. What we saw, or wanted to see, in the Moon's face has inspired countless images in mythology, art, and literature, and the complete personification of the Moon as a man, despite the many associations with the female sphere, is a frequent and popular motif.

Yet, other cultures have seen very different shapes and images in the Moon. In Asia the most common earthly creature identified in the Moon's disc is a seated or curled-up rabbit or hare. The hare is an important symbol of immortality and rejuvenation in Asian tradition and religion, probably beginning in Buddhist culture. In China a mid-autumn harvest festival celebrates the Moon and Moon goddess Chang'e. Women make small pale biscuits showing the Moon and a hare (the Moon rabbit; Chang'e's pet after whom, incidentally, China's Jade Rabbit rover is named), usually depicted making an elixir that ensures Chang'e's immortality. In Japanese prints we often see white hares or rabbits gathering under a white full Moon, or silhouetted against it. One of the reincarnations of the Buddha was a hare, and linguistically, in Sanskrit, the words for hare and Moon are almost identical. Images of hares and rabbits in connection with the Moon are also prominent in Mayan and Aztec art. According to one legend, a hare offered to sacrifice himself to the Aztec god Quetzalcoatl to save him from starvation. As a reward, the hare was lifted to the Moon and back, so that everyone on Earth could see the figure of the creature.

The advent of telescopes and space travel may have changed how we look at the Moon, but they haven't eliminated those familiar faces and figures we can identify simply through observation with the naked eye.

The Man in the Moon, Koong, of Haida mythology, from Franz R. and Kathryn M. Stenzel's collection of Western American art *(left)*
Ink on paper – Johnny Kit Elswa, 1883

The Haida are indigenous people of the Pacific Northwest Coast of North America. In Haida mythology, a man named Koong is stolen by the moon while drawing water from a brook with a bucket. He tries to resist the Moon's rays, and grabs onto a bush, but the Moon is too strong. Koong, along with his bucket and bush, are said to be visible at full Moons, and it is Koong who causes the rains when he decides to tip over his pail occasionally.

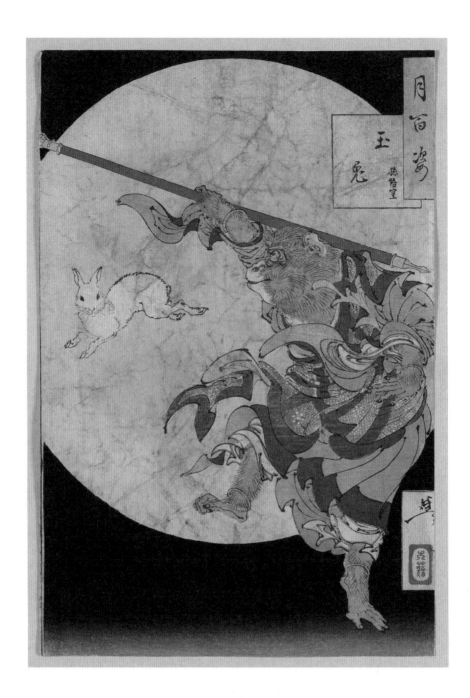

Sun Wukong, the Monkey King, and the Moon Rabbit
Color woodblock print – Yoshitoshi Taiso, c.1885–90

A white hare or rabbit is often associated with the Moon in Asian cultures as a symbol of immortality. In Chinese mythology, it is the pet of Chang'e, the Moon goddess.

Romanian stamps *(right)*
Postage stamps – Romania, 1957

Romanian stamps commemorating Laika, the first animal to orbit the Earth.

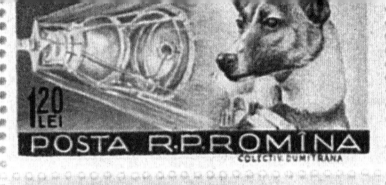

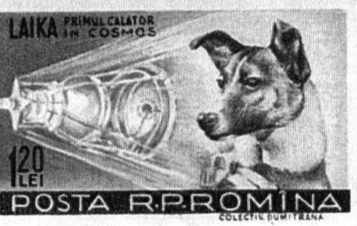

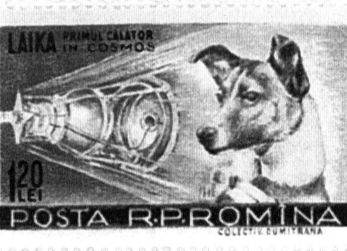

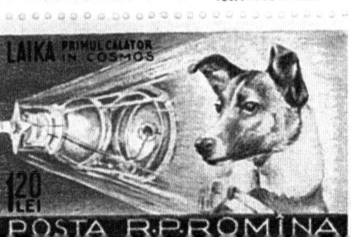

THE NAMES OF THE MOON

Aside from poetry, in which the Moon frequently proves its aptness for metaphor and is referred to by a great variety of epithets, we tend to think of Earth's moon just as "the Moon." Yet we're likely to recognize at least a few more unusual and descriptive names, such as "Blood Moon" and "Harvest Moon."

Many of the names we are most familiar with today were invented by Native Americans, later adopted by European settlers. These hunter tribes had a deep connection to the world around them, and the lunar calendar they used to mark the yearly cycle names the full Moon of each month according to the behaviors of animals or the growth of flora or crops. These poetic names vary from one tribe to another, according to their individual cultures and their geographical and ecological situation—for a tribe favoring a fish-based diet, their August Moon might be named Sturgeon Moon, while in another it might be Green Corn Moon.

Common names are: Cold Moon for December, Wolf or Spirit Moon for January; Snow, Hunger, or Bear Moon for February, followed by Pink, Flower, and Strawberry Moons in spring and early summer. Buck, Thunder, Sturgeon, and Berry are names for the high summer Moons. The Corn or Harvest Moon occurs in late September or early October and is the full Moon closest to the start of the autumnal equinox in the Northern Hemisphere.

As a sign of the changing season and a symbol of abundance, the Harvest Moon has inspired many artists. In landscape painting it is often depicted as an orange or red disc, but this coloration is caused only by the Moon's position close to the horizon, so the full Moon of any month can appear in this hue—however, it may be particularly noticeable in the early autumn due to the timing of the sunset and moonrise. Harvest Moon is followed by the Hunter's Moon or Blood Moon. (The latter does not refer to a reddish color but probably the warm blood of the hunters' prey.)

But what about the Blue Moon? One of the most familiar names of the Moon has nothing to do with color. It is the name for an additional full Moon that occurs in a calendar year every two or three years, because the length of a lunar cycle is shorter than the average calendar month. It is also the name often given to a second full moon in a calendar month—but this is an inaccurate definition originating with amateur astronomer James Hugh Pruett, writing for the popular *American Sky & Telescope* magazine in 1946. Both definitions chime with the old colloquial phrase "once in a blue moon" for something that happens very rarely or is quite absurd. Black Moon, on the other hand, is an additional new Moon in a calendar year, or the absence of a full Moon in a calendar month, which can only occur in February.

Mond über Landschaft (Moon Above Landscape) *(right)*
Oil on canvas – Paula Modersohn-Becker, c.1900

Modersohn-Becker's *Mond über Landschaft* is a clear example of painters taking inspiration from the full, autumnal Harvest Moon. Here it appears bright and blazing orange in striking contrast to the muted tones of the sky and hills. It sits low in the sky, which explains the vivid color, and looms large (see pages 140–141).

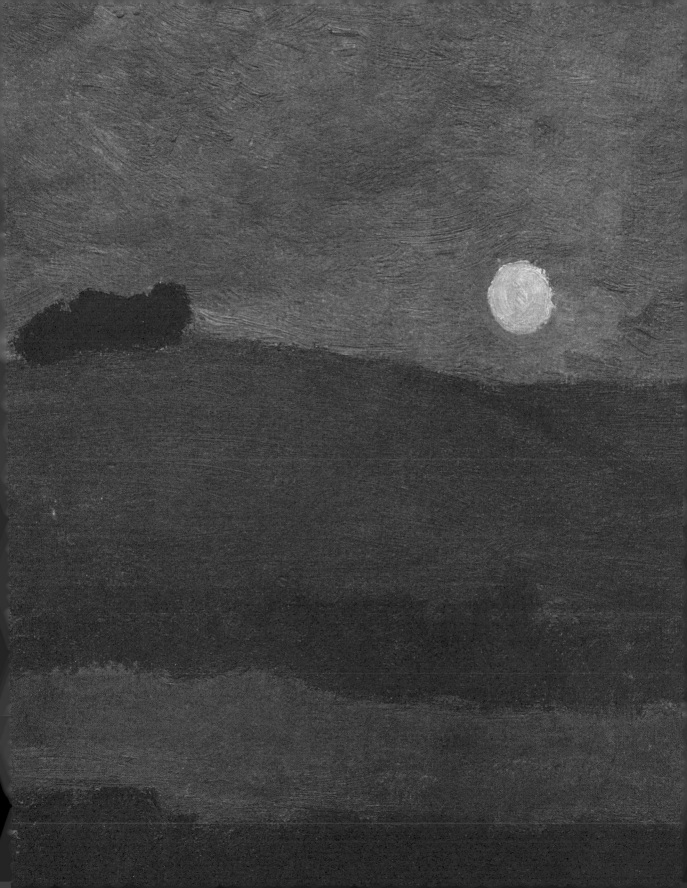

Fishing by Moonlight

Oil on canvas – Aert van der Neer, c.1665

Dutch painter Van der Neer specialized in atmospheric moonlit seascapes. Here his pale yellow full Moon delicately illuminates the fishing nets in the scene below. It's a restful image, the water is still and fishermen quietly go about their work. Tranquility is a recurring theme in moonlit paintings of landscapes and seascapes.

Park Row, Leeds (right)

Oil on canvas – John Atkinson Grimshaw, 1882

Park Row, Leeds is a example of one of Grimshaw's renowned urban nocturnes, where lighting and mood are the main focus. Two carriages in the distance are the only signs of activity in the quiet city streets. Grimshaw often painted very tranquil, poetic scenes of the docks and town centers of industrial cities in Northern England.

Vesuvius

Oil on canvas – Joseph Wright of Derby, c.1773–78

The Sublime paintings of the 18th century focused on the power of nature, how it can be unpredictable and beyond human control. Derby's seemingly peaceful scene, with calm waters, is softly lit in green hues from the Moon. But the red-tinged silhouette of Vesuvius looms in the background, alluding to its potential for violence and destruction. This is one of more than 30 paintings the artist made of the volcano.

Moonlight over the Faroe Islands, Denmark
Photograph – Michael Dam, 2017

Dam's image of the Faroe Islands in Denmark is another powerful and atmospheric seascape that highlights the magnificence of nature. Although the Moon is out of sight, it illuminates dark clouds, rough seas, and imposing mountains. Recalling similar themes to the Sublime paintings centuries before, contrasts the bright, stormy moonlight with saturated, moody colors and a heavy vignette.

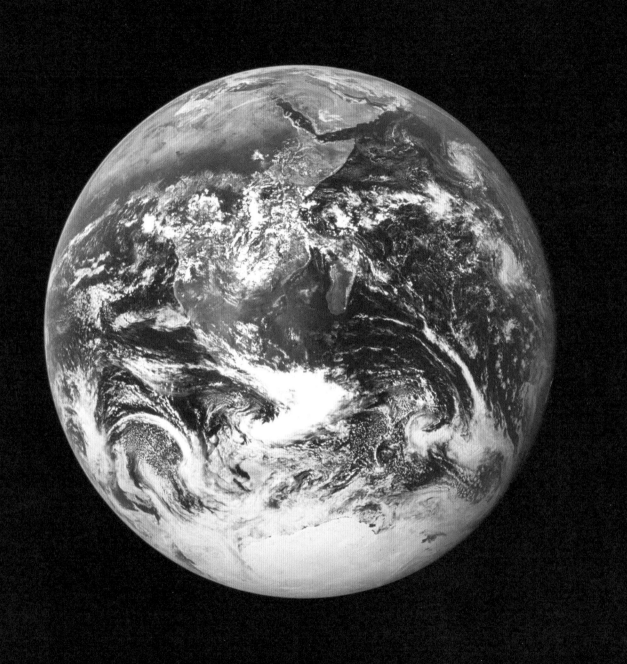

THE
BLUE
MARBLE

A view of an entire hemisphere of the Earth, the *Blue Marble* image is a photograph from Apollo 17, taken en route to the Moon in the final mission of the program.

Astronauts Eugene Cernan, Ronald Evans, and Harrison Schmitt had a view of the Earth's South Pole, and the brilliant-white Antarctic ice cap, clouds, and storms over the Indian, Atlantic, and Southern Oceans, the deserts, grasslands, and rainforests of Africa, the arid Arabian Peninsula, and the Mediterranean Sea. This image makes it easy to imagine the "overview effect," describing the shift in perspective—not only physical but also cognitive—that astronauts have experienced when seeing our world from space. Since 1972, no astronaut has been farther than a few hundred kilometers from our home planet, but they still describe experiencing a world where national boundaries are essentially invisible, and a new sense of the challenges faced by humanity.

For the Apollo crews, the Earth receded over a few days, shrinking to appear four times the size of the Moon in our sky. From (only) 250,000 miles (400,000 kilometers), the colors of the Earth contrast the blackness of space and the grays of the Moon's surface. If human explorers ever travel the far greater distance to Mars, the Earth-Moon system, with all its beauty, would soon be no more than two small, if bright, dots, much like the other planets of the solar system, and the background stars.

The *Blue Marble* represents the Earth in many other settings. Science-fiction writers, environmental activists, finance and IT companies, and even pseudoscientists (remarkably including flat-Earth proponents) have all exploited it. While no person has since gone far enough into space to repeat the Apollo 17 photograph, several unmanned space missions have captured a similar view, some with the explicit goal of reminding us of the fragility of our planet.

Blue Marble *(left)*
Photograph – NASA, by the crew of Apollo 17, December 7, 1972

This iconic image of our planet is one of the most reproduced and widely distributed images ever taken. The globe is almost fully illuminated as the Sun was behind the astronauts of Apollo 17 when they took the photograph. You can see the continent of Africa, mainland Asia, and the south polar ice cap along the bottom. However in the original, the ice cap was orientated at the top. NASA flipped the image so that it would be more familiar to us.

THE MOON AND FATE

In his much-loved poem "Aedh Wishes for the Cloths of Heaven" (1899) the Irish poet William Butler Yeats describes "the heaven's embroidered cloths, Enwrought with golden and silver light, The blue and the dim and the dark cloths, Of night and light and the half-light." The metaphor of a spun or woven nocturnal tapestry in the sky, with the Moon its luminous center, is strongly linked to the feminine and the cycle of birth, life, and death. The waxing, waning, disappearing, and reappearing Moon has long been interpreted as a spinning wheel, spooling and unspooling the threads of human fate.

In Ancient Greece the phases of the Moon and human life, were personified by a trio of female "Fates," the Moirai. These were more ancient than the gods and goddesses, and in the Orphic hymns they are described as "daughters of darkling night"—usually they are literally the daughters of Nyx (the night) or other primordial gods. They hold power over both deities and mortals: Clotho witnesses birth and spins the thread of life, Lachesis weaves the cloth of life with the thread, while Atropos ends life by cutting the thread with her shears. Although sometimes referred to as one figure, the Moirai are usually depicted as a trio, holding spindles, spinning wheels, and shears, spinning the web of human fate and destiny. Their dark, underworldly origin and connection with the Moon are often reflected in their nocturnal, moonlit settings or white garments. The spinning wheel, whose circular shape resembles the Moon, became the metaphorical wheel of fortune.

The concept of three-part female lunar deities that create, measure, and end life has persisted into other cultures. The Roman equivalent of the Moirai was the Parcae (Nona, Decima, and Morta), and in Nordic and Scandinavian mythology, the Norns Urd, Skuld, and Verdandi represent past, present, and future. Like the Moirai, the Norns are older than the gods; they dwell in the well of fate at the roots of Yggdrasil, the sacred world-tree, whose roots they water with liquid drawn from the spring.

Along with their primordial origins, the Fate goddesses also have in common the respect of the ruling gods (in later Greek mythology, the Moirai become the daughters of Zeus and Themis rather than Nyx, indicating an elevated station), and the ambivalence of the humans under their dominion. While the Fates are connected with birth, they are equally associated with death, and with the knowledge they have and power they hold over an individual's destiny, and so, a bit like the Moon itself, while there is nothing evil about the Fates, we may be justified in fearing what they represent.

Lune, from *Le Tarot Astrologique* *(right)*
Tarot card – Georges Muchery, 1927

In Muchery's deck of tarot cards, the Moon once again takes the guise of a woman.
Here is a more modern interpretation than the tarot card on page 19.

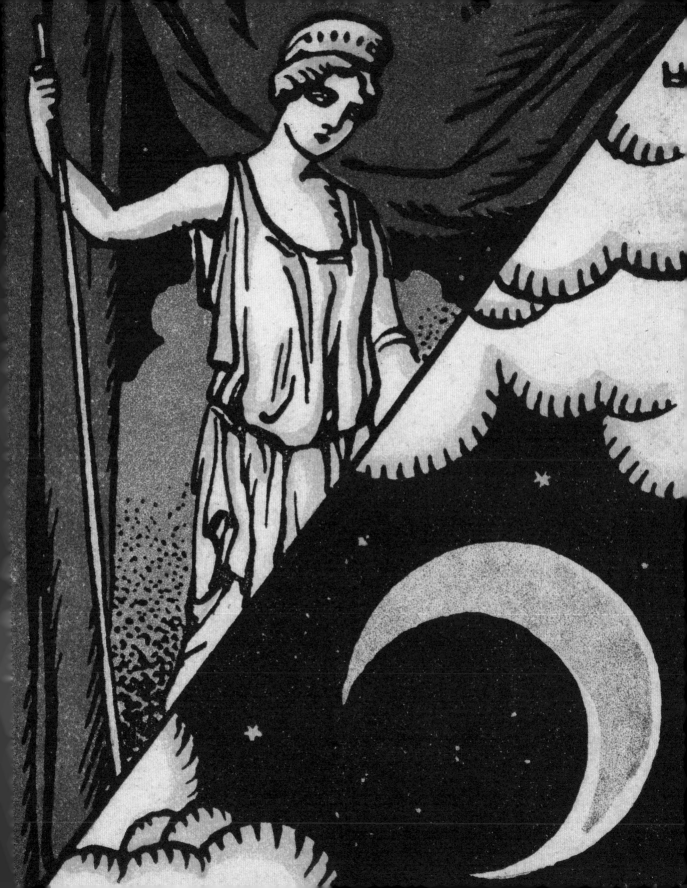

Museum of the Moon at Piscine Saint-Georges, Rennes, France

Installation – Luke Jerram with Les Tombées de la Nuit, 2017

Jerram's Moon is 23 feet (seven meters) in diameter and inflated with helium. It features accurate details from NASA imagery printed in high-resolution that are lit up from the inside. The installation invited visitors to take a moonlit swim and delight at the lunar spectacle up close.

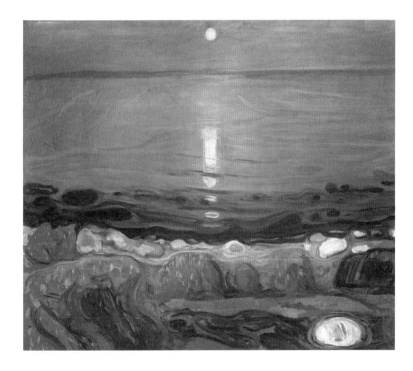

Summer Night on the Beach
Oil on canvas – Edvard Munch, 1895

The Moon and the rich light that it provides captivated the artist Van Gogh (page 133), while Edvard Munch exploited its ability to convey melancholy mood and emotion. Here, he uses a soft but vivid palette to capture the moonlight, giving the image a glowing and even positive feel.

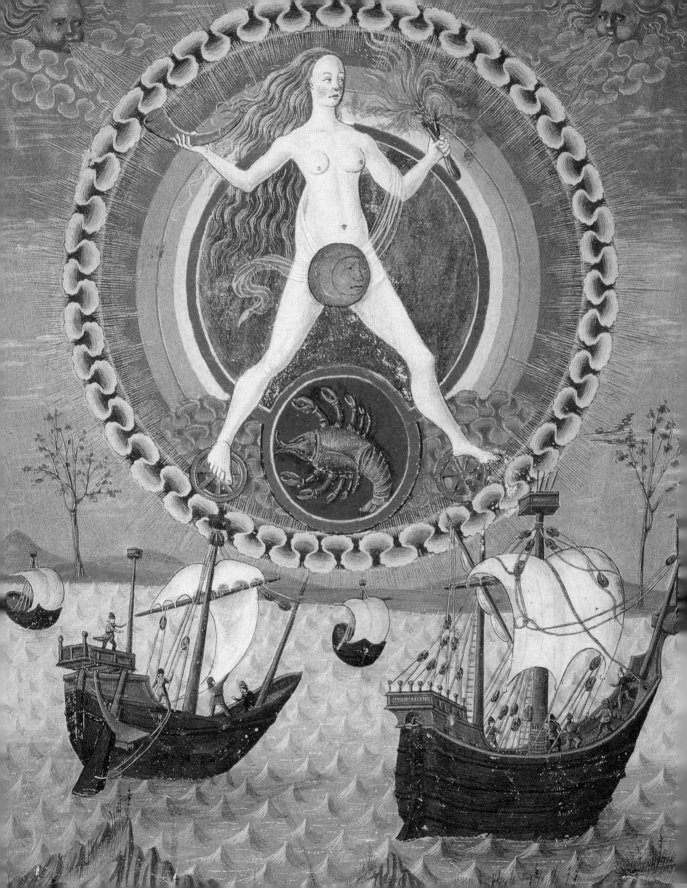

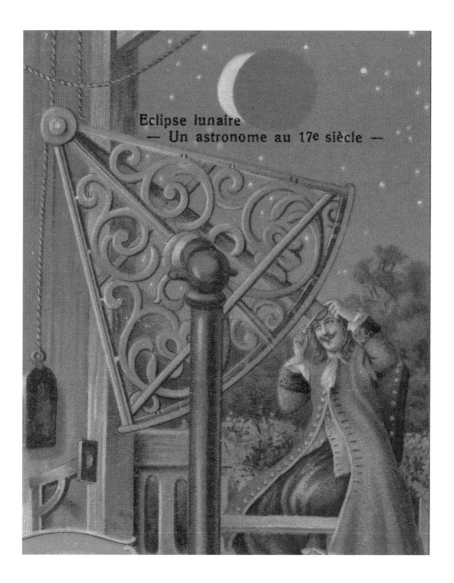

"Luna," folio 12v of *De Sphaera* *(left)*
Tempera and gold on parchment
Probably Cristoforo de Predis, 1470

The Moon was a vital navigational tool for sailors, as well as having significance in relation to tides. Luna's importance is celebrated here. Depicted as a goddess, winds blow above her in the top right and left corners. The crustacean emblem resembles that found on Luna's chariot on page 14.

"Eclipse lunaire: Un astronome au 17e siècle"
("Lunar eclipse: A 17th-century astronomer")
Advertising card, chromolithograph
The Liebig Company, 1925

A 17th-century astronomer carefully observes the phenomenon of a lunar eclipse with an ornate telescope.

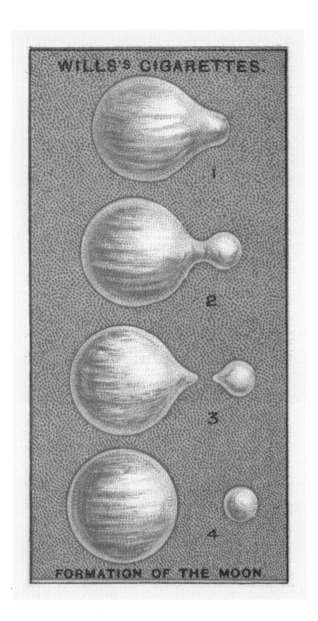

"Formation of the Moon"
Cigarette card, chromolithograph
Wills's Cigarettes, 20th century

Primordial Earth and Moon (right)
Acrylic on wood
Richard Bizley, 20th century

Above and right: Current thinking proposes that the Earth and Moon began as a single entity until a Mars-sized asteroid collided with the proto-Earth, and the Moon formed from some of the debris.. In contrast to the violence of this impact, the illustration above shows the Moon smoothly just slipping out of the Earth, like a dainty raindrop. The image on the right is a far more dramatic depiction of two worlds' surfaces.

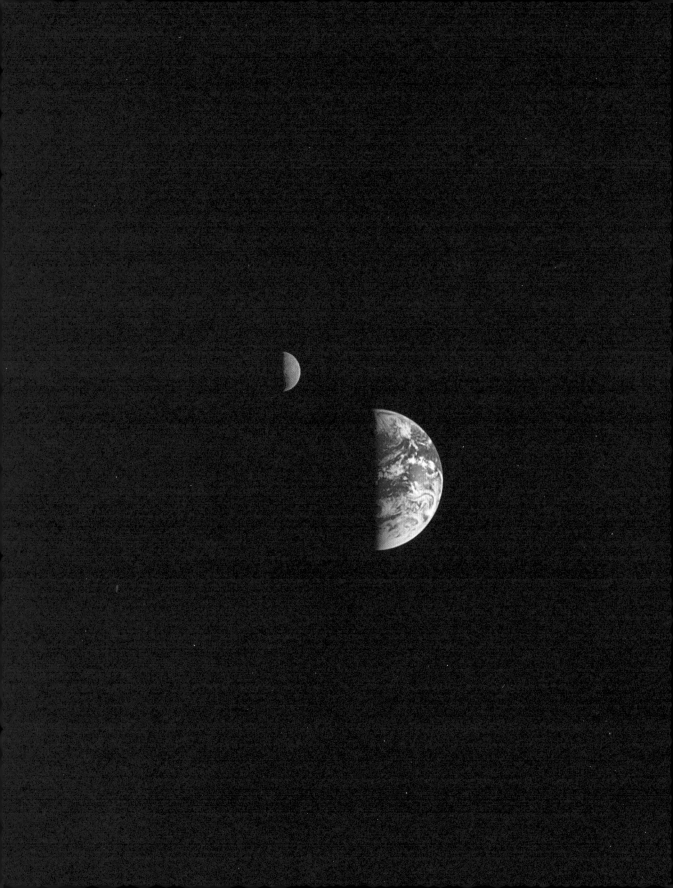

THE MOON GETS FARTHER AWAY

Today it is 238,900 miles away (384,400 kilometers), but the Moon is thought to have started out between 12,000–19,000 miles (20,000–30,000 kilometers) from the Earth, after its violent formation. The early Earth was no place for watching the sky, but if a time traveler could find a solid rock to stand on, the Moon would dominate the view. If that explorer stretched out her arm in front of her face, the Moon would look about as big as her fist, and the lunar gravitational pull on the Earth would be hundreds of times stronger than today.

Both worlds would have been very different in their appearance, with molten surfaces pockmarked with scars of impacting bodies. But when the Earth had cooled sufficiently for large oceans to be sustained, the mass of water became a third factor in the relationship between the two worlds. A given place on Earth experiences two low and two high tides each day as the planet rotates, resulting from the gravitational pull of both the Moon and the Sun. The former is more important, as its closeness to the Earth compensates for its tiny mass compared with our nearest star.

The Earth rotates much more quickly than the Moon moves around it, so the raised bulge of water at high tide pulls the Moon ahead somewhat, slowly increasing its speed, and making it move farther away. At the same time, the rotation of the Earth slows down, lengthening the day by a few thousandths of a second each century (a value measured with the most accurate atomic clocks).

Firing laser beams at reflectors left on the lunar surface by three of the Apollo crews, and timing how long it takes for the beam to return to Earth, measures this increase in lunar distance. The average distance to the Moon is increasing by an inch and a half (3.8 centimeters) each year, and evidence from ancient rocks suggests this is faster than in the past. In any case, the drift away will continue into the far future, long after the Earth becomes uninhabitable, when oceans boil away as the Sun slowly expands. Earth's increasing distance to the Moon will also make total solar eclipses impossible, as the apparent size of the lunar disk will be too small to cover the Sun.

Assuming the Earth and Moon are not consumed into the atmosphere of the Sun when it expands to be a red giant star in the final stage of its life, the terrestrial day will eventually match the lunar month. The two now-dead worlds will then keep the same face to each other, as they trace out their orbit around the tiny remnant of our star.

**The Moon orbiting the Earth, taken from
3.9 million miles (6.2 million kilometers)** *(left)*
Composite photograph – NASA, Galileo spacecraft, 1992

The Moon is locked into orbit with our planet by gravity, while the speed of the
Earth's rotation also pulls the Moon along. Here the visible halves of the two celestial
bodies mirror each other, recalling their combined history and connectedness.

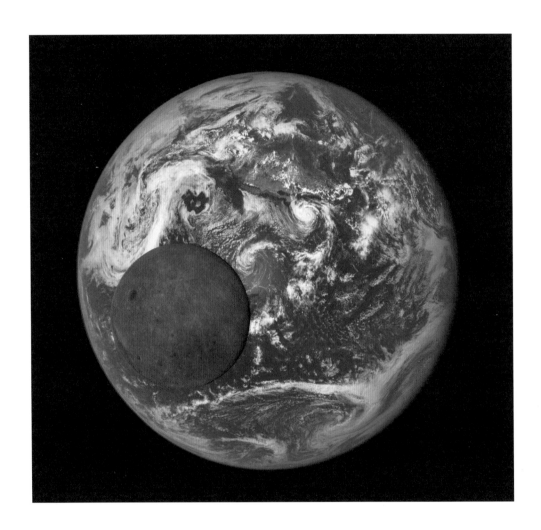

Moon crossing the face of the Earth
Animation still
NASA, Deep Space Climate Observatory (DSCOVR) satellite, July 16, 2015

Taken in orbit one million miles (1.6 million km) away from Earth by NASA's imaging camera
on board the DSCOVR satellite, this incredible view shows the far side of the Moon
(the side never visible to Earth) as the Moon crosses in front of the planet.

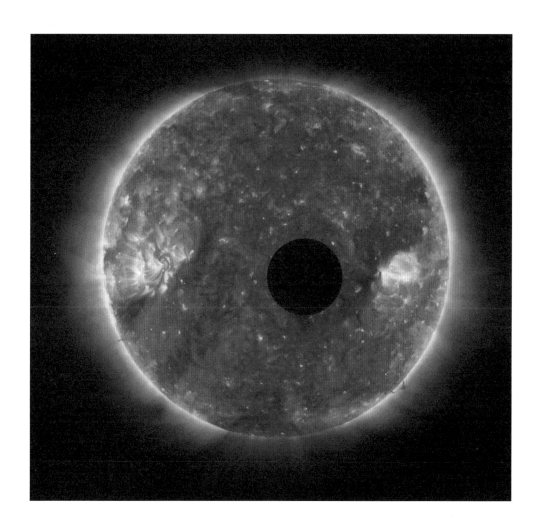

Moon passing in front of the Sun
Composite photograph
NASA, STEREO-B spacecraft, February 25, 2007

This image was captured by the STEREO-B (Solar Terrestrial Relations Observatory)
spacecraft that was launched with the mission of studying the Sun and monitoring its corona
(see pages 44–47). Here the Moon is seen as it passes across the fiery giant.

MOON BASE

There is something compelling about the dream of a lunar settlement. A popular theme in science fiction novels and cinema, like *2001: A Space Odyssey* (1968) and the much more recent *Moon* (2009), authors and directors alike enjoy depicting a comfortable interior in a habitat in an otherwise harsh lunar landscape.

In the era of Apollo, the establishment of a permanent base seemed inevitable, not least as a stepping stone for a voyage on to Mars. The prospects of both receded even as plans were put together, however, and were seemingly always 20 years in the future. Insomuch as the Space Race was a proxy for the Cold War, the superpowers have since found other ways to express their rivalry.

Half a century after the Apollo 11 landing, there is renewed interest in returning to the Moon, and serious discussion on how a Moon base could be built, and what it would be for. Constructing a settlement would be hard and dangerous work. As well as the conventional risks of a construction project, any task would be complicated by working in a near-vacuum, and if a burst of radioactive particles were to head from the Sun to the Earth-Moon system in a "coronal mass ejection," or a near-Earth asteroid were to crash onto the lunar surface, astronauts there would have little to shield them.

Any base must be designed to cope with a more extreme environment than anything found on Earth. Even deep in the Antarctic, explorers can at least freely breathe the air outside and are protected from the hazards of space by the thick terrestrial atmosphere. A Moon base in contrast would need shielding from asteroid impacts, radiation, and huge changes in temperature. On the surface, this will likely mean covering the base with regolith (lunar soil), or constructing it underground, taking advantage of hollow lava tubes, akin to living in a cave on Earth.

Proponents of a Moon base argue strongly for using resources in situ—effectively, living off the land. Deposits of water in the regolith at the lunar poles could be used for drinking, manufacturing rocket fuel, or extracting oxygen to breathe. For an energy supply, some locations at the poles have near permanent sunlight, where solar power could be ideal. Lab experiments suggest that the most abundant material—rocks and dust on the surface—could be made into lunar concrete or "lunarcrete," saving precious weight on supply missions from Earth.

Space exploration books from every decade since the 1950s typically have illustrations of lunar rovers and astronauts digging for materials, with the domes of crew quarters and a spaceport in the background. A Moon base is not a new idea, but just perhaps one the authors, and almost certainly our children, will live to see.

Lunar base concept *(right)*
Architectural concept artwork – ESA/Foster + Partners, 2013

As part of a consortium set up by the European Space Agency, architects ESA/Foster + Partners are exploring the possibilities of building a Moon base. Here is their concept artwork for a multi-dome lunar base in the process of being constructed. The domes would be assembled using 3D-printing technology and covered with a protective layer of regolith.

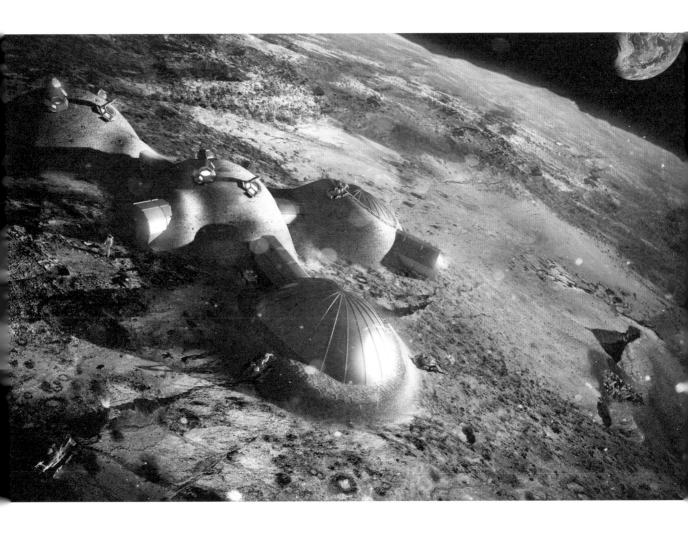

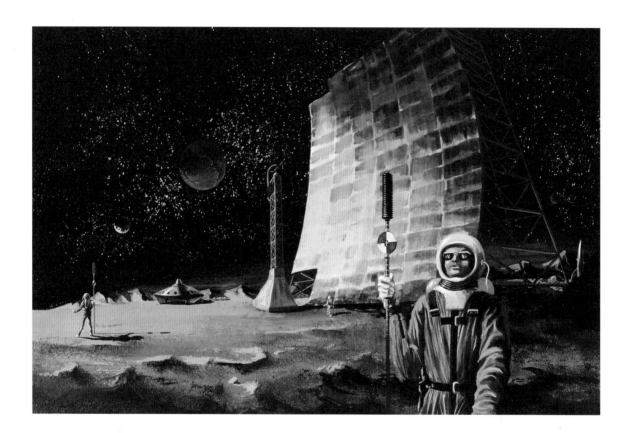

Explorers on Earth's Moon

Watercolor on paper – Ron Dembosky, c.1960s

During the Apollo era, the possibility of a Moon base seemed a lot more tangible. A recurring idea is to harness solar power for energy—some areas at the poles are in nearly constant sunlight. Here an astronaut wears sunglasses to protect his eyes, almost appearing as though on vacation.

Family playing on the Moon (right)

Chromolithograph – Unknown, c.1960s

It was an easy stretch of the imagination to go from lunar base to tourist destination in the '60s. This illustration shows a family of four making the most of the Moon's low-gravity conditions, playing ball and leapfrog. It is not so dissimilar to private sector ambitions to develop commercial trips to Mars today.

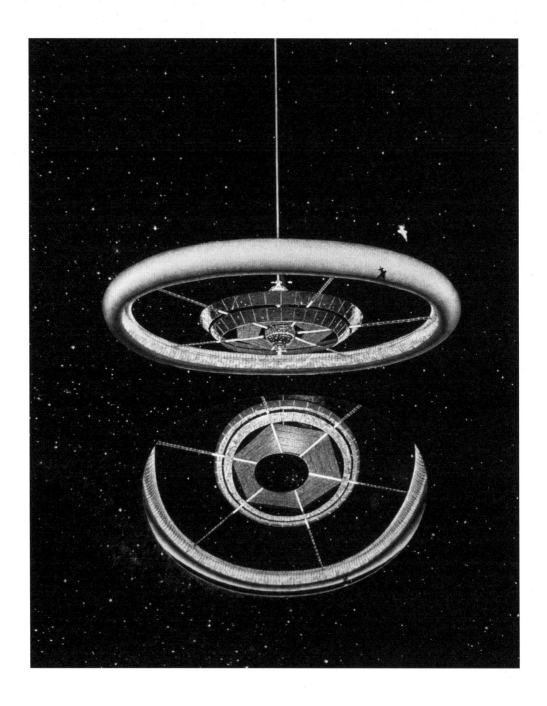

External and internal (right) view of a Stanford Torus; space colony concept

Oil on board – Donald E. Davis for NASA, 1975 / 1976

This concept for a space colony was proposed as part of a NASA summer design program held at Stanford University in 1975. The ring of the hub is just over one mile (1.8 kilometers) in diameter; a spacecraft can be seen flying past it for scale. The interior would house a population similar to that of a dense suburb.

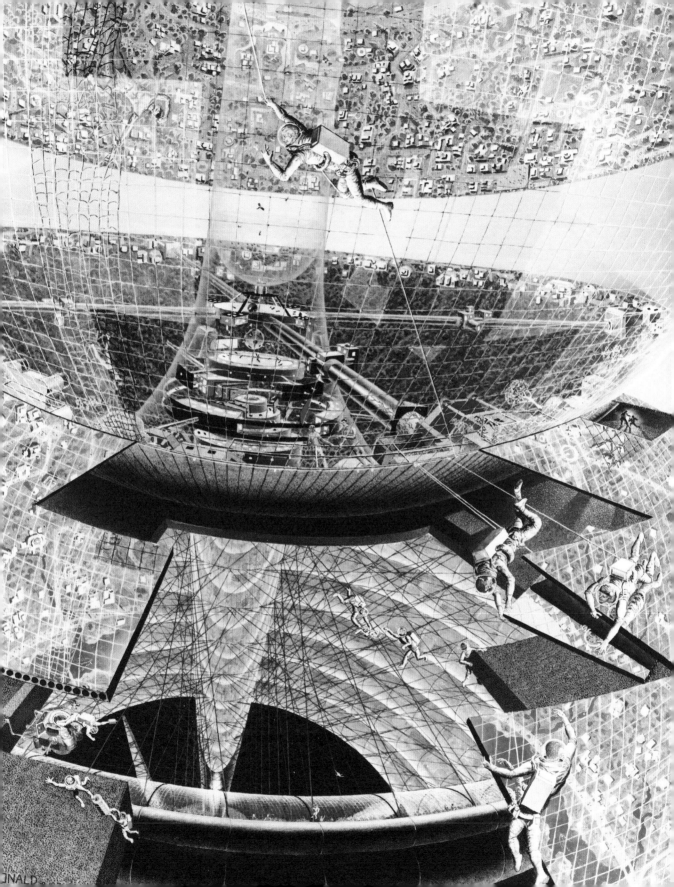

BEGINNING

HOW THE MOON WAS MADE

.....................

The Moon, perhaps reflected in a sea or lake, or with clouds scudding by, often symbolizes calm—literally serenity—divorced from our hectic terrestrial lives. Yet this nearest satellite and the world we inhabit have a shared and violent history.

More than 4.5 billion years ago, the Sun and planets that make up the bulk of our solar system formed from a cloud of gas and dust collapsing under the force of gravity. In the center, our parent star came into being as that matter became dense and hot, reaching a point where hydrogen fused into helium. This fusion—seen more destructively in nuclear weapons—releases colossal amounts of energy, and powers the solar engine throughout its life.

The cloud around the Sun was now a disc, its dust grains sticking together to make up clumps. Over a few million years, collisions and gravity glued these into boulders. Collisions between these rocks could have different outcomes: the most violent might shatter them into smaller fragments, adding to the general debris; slower impacts, however, could cause larger objects to be made. Approximately two or three million years after the Sun formed, the cores of the current planets were in place, gaining material to make the precursors of the worlds we see today.

Most planets have natural satellites too. Gas giants like Jupiter and Saturn have dozens, some large enough to have volcanoes and ice-covered oceans, and others far smaller. But, with the exception of the far smaller dwarf planet Pluto and its half-size companion Charon, the Earth and Moon stand out: Our companion is fully one-quarter the size of our planet.

One historical idea about the origin of this system was that the two worlds formed side by side, the Earth capturing the Moon. Another proposed that the proto-Earth spun so quickly that the Moon was a part of its material that was flung off, leaving the bulk behind to form the Earth. From the 1970s, planetary scientists pieced together a new model based on analysis of the samples returned by the Apollo missions. In this version, an object the size of Mars (given the name Theia) had collided with the Earth. At least the outermost layer of each planet was completely vaporized, and ejected into space, leaving heavier molten cores, and mantle rock above, to melt together. In a few months, some of the cloud of debris around the merged planets accreted to create a new satellite—the Moon—in a process probably completed within a century of the collision.

Beginning
Robert Massey

Lunar rocks returned to Earth by Apollo astronauts and Soviet probes hint at this common ancestry. The material of the lunar surface is similar to the interior of the Earth, as is the proportion of different masses of oxygen atoms (the isotope ratio). Though both worlds were affected by later events, this similarity may imply a direct hit between Theia and the proto-Earth, an event of extraordinary violence almost impossible in today's solar system.

Immediately after the collision, both the Earth and the Moon were unrecognisable molten worlds. It took 100 million years for the surfaces to cool enough for the first terrestrial oceans to develop, and fossil evidence suggests that life only emerged 200 million years after that.

The Moon also started out much closer to the Earth, perhaps 12,000–19,000 miles (20,000–30,000 kilometers) away, compared with nearly 250,000 miles (400,000 kilometers) today. The early Earth rotated more quickly, taking only six hours to spin on its axis. Once oceans were established, a complex interplay between the two bodies, and the tides of the sea, transferred energy to the Moon, causing it to move farther away, and slowing down the rotation of the Earth to lengthen the day. Today the result is a continuing drift away from the Earth of one and a half inches (3.8 centimeters) a year, and a day 24 hours long. Such a large satellite has benefits for life on Earth: it stabilizes the angle of the Earth's axis of rotation, which in turn prevents more dramatic (natural) changes in climate.

The gravitational field of the Earth had another effect on the Moon; eventually locking one of its faces toward us. It takes about 27.3 days for the Moon to complete one orbit around the Earth, based on its position as measured against the stars. The Moon rotates at the same rate, so its day is the same length. Because the lunar orbit isn't a perfect circle, is tilted, and we have a slightly different perspective from moonrse to moonset, over time we get to see about 59 percent of the Moon in total, with the combined effect described as libration—but the remaining 41 percent is forever out of sight from the Earth.

Tracing the earliest history of Earth requires scientific detective work: most of the evidence is concealed by overlying rock, buried beneath desert sands, or smothered by vegetation. The Moon is different. With no atmosphere of any significance, the majority of the surface is baked and frozen every month, but no wind ever blows and no rain ever falls. This landscape is a fossil record of more than four billion years of history, a vivid reminder of the violent events that characterized its earliest epoch.

Craters are the most obvious lunar features, visible in even the smallest telescopes. Many of these probably formed in the "Late Heavy Bombardment" starting around four billion years ago—when collisions with asteroid-sized objects were many times more frequent than they are today—just before the solar system settled into its present shape. Without the protection of an atmosphere, lunar impacts continue today, though large events are rare. Craters range in size from microscopic pits to the 1,500-mile-wide (2,500-kilometer) South Pole-Aitken basin found on the far side of the Moon—one of the largest craters in the solar system. Depending on the circumstances of their formation, craters vary in appearance. The biggest often have central mountains, caused by a rebound of the surface after the impact. Others have terraces, are themselves cratered, or have smooth floors where now-frozen lava once flowed. The youngest, like Copernicus and Tycho, have ray systems where lighter-colored debris rained down onto darker surroundings.

Beginning
Robert Massey

Some of the most dramatic events on the Moon were the great impacts that created huge basins. Liquid magma eventually smoothed over the Moon's surface, mostly on the side facing the Earth where the crust was thinner and the magma could more easily break through the surface. The magma cooled to leave behind those darker regions originally described as "seas" or "maria" that are visible to the naked eye. The most famous of these, the Mare Tranquillitatis (Sea of Tranquility), was the landing site for Apollo 11, and stretches nearly 560 miles (900 kilometers). Like most of the other nearside maria, it is easily visible without a telescope (for Northern-Hemisphere observers it appears at the top right of the lunar disc at full Moon). The thicker crust on the far side gives it a completely different appearance, and maria are found in only a few places.

The parts of the surface that seem whiter to the eye are the lunar highlands. This more rugged terrain includes genuine mountains, with some peaks more than 2.5 miles (4 kilometers) higher than the "average" lunar terrain, and more than 6 miles (10 kilometers) above their surroundings. These heights and ranges are found at the edges of the impact basins, and formed rapidly and violently, unlike the slow pushing up of mountains on Earth.

To an extent, larger (solid) planets retain liquid cores and major geological activity for longer than smaller worlds. Across much of the Earth, volcanoes and earthquakes remind us of a dynamic interior. Quakes on the Moon are smaller, though long-lasting, and often resulting from surface events such as landslides and meteorite impacts. For at least the first billion years of its history, geological processes were, however, important in shaping the Moon. As well as molten rock filling in the maria, there are lava tubes akin to their terrestrial equivalents. Hot liquid rock cut long scars, some of which are uncovered (so-called "rilles") and some are cylinders beneath the surface. Domes kilometers across mark the sites where the lava oozed out, wrinkled ridges where it cooled and shrank, and faults like the "straight wall" show where blocks of rock shifted. The proximity of the Moon makes all of these visible in small telescopes, and its landscape easy to imagine.

By any measure, the Moon is a robustly harsh environment, with temperatures that range from 250 degrees Fahrenheit (120 degrees Celsius) during the day to -240 degrees (-150 degrees Celsius) at night. The depths of some of the craters near its South Pole, in the Aitken basin, almost never see sunlight, so have permanently cold floors. This frigidity traps water as ice mixed in the surface soil, probably delivered by colliding asteroids and comets throughout lunar history.

We have a better understanding of the natural history of the Moon than ever before, its violent beginnings and how it developed into the relatively quiet world we see today. Should humankind ever return to the Moon, this knowledge of its landscape, its natural hazards, and its natural resources, will provide the shape and basis of any new missions in the decades ahead.

BELIEVING

HOW THE MOON HAS FASCINATED US THROUGH HISTORY

..................

In one of the most atmospheric poems in the English language, Ted Hughes's "Full Moon and Little Frieda," a very young girl, just learning to say a few words, though not yet full sentences, looks at a rural evening landscape and suddenly and repeatedly cries out: "Moon!" Her excitement is pure, innocent, and utterly human. The little girl's eyes are drawn to that bright disc in the sky, our nearest heavenly body, and she is utterly enthralled by it, like many humans before her. When Hughes's daughter, Frieda, suddenly saw the Moon in the early 1960s, delighting her father and moving him to write a poem full of warm, rich, nocturnal imagery, she was unaware that she had tapped into something universal—our fascination with and dependence on a heavenly body that is a timekeeper, anchor, and source of inspiration.

The Moon draws us in, captivates us, is tantalizingly visible, and seemingly approachable. By contrast, the Sun—though it dominates the sky and makes life on Earth possible—cannot be looked at with the naked eye, apart from for a few moments at the beginning and the end of a day. But we revel in watching the Moon; we can even make out its pockmarked surface, the shadows of its hills and valleys. We perhaps feel a special connection through its relative familiarity. On a clear night, especially when the Moon is in its first or third quarter and the shadows of its mountain ranges and craters are more pronounced, the human eye can read some of its surface structure, even without a telescope. We recognize formations that remind us of our home planet: we have mountains, valleys, even craters on Earth, so the Moon's surface is perhaps not so unlike the ground we tread on here at home. When we started mapping the Moon, we chose names that mirrored our own planet: Mare Imbrium (The Sea of Rains), Mare Nubium (The Sea of Clouds), Montes Apenninus (The Apennine Mountains), and so on. With its seas, mountains, and valleys, we look at the Moon as into a pale mirror, and see a reflection of ourselves.

There is a clarity to the Moon that no other star or planet visible from Earth has. We see the Moon's clear outline, often sharply silhouetted against the night sky. Our eyes, hands, pens, and brushes can follow its outline, pattern, and shadows. The Moon provides a visual certainty that has long since inspired human imagination and creativity. And yet the Moon is full of contradictions. It is seemingly benign—a source of light in the darkness, our constant companion,

Believing
Alexandra Loske

steadying the spinning Earth in its orbit, pulling at our seas, and thus giving our oceans a fruitful and predictable rhythm. Yet it is also always changing, appearing and disappearing, waxing and waning. Its color may change from silvery white to blue, orange, yellow, purple, and even blood-red due to dust in the atmosphere and the height of the Moon above the horizon. The Moon's apparent size changes, too, as its orbit is not a perfect circle but an ellipse, meaning that its distance from the Earth varies significantly. Before the reasons for these changes were understood, how would they have been interpreted?

From the beginning of human creative activity, the heavens played an important role in art, myth, folklore, traditions, and belief systems. The Moon's changing shape also offered a rudimentary form of timekeeping in the earliest cultures: in pre-historic caves, carvings, drawings, and markings have been found on bones and rock that possibly depict lunations, the phases of the Moon. Approximately 15,000 years ago, for example, Cro-magnon men drew linear patterns of dots and squares on the walls of the Lascaux Cave in France, which are believed to depict the Moon's phases. If these patterns are indeed early lunar calendars, they reflect an early human awareness of time and cyclical phases of life, death, and rebirth. Around the fifth millennium BCE, Mesopotamian and Assyrian cultures, too, observed and recorded the Moon's movements. The bronze and gold sky disc of Nebra, which was created around 1600 BCE and found recently in Germany, possibly shows a sickle and a full Moon. It was most probably used as both a simple map of the sky and a ritualistic object.

While these observations of the Moon's appearance and journey across the heaven eventually led to the first lunar calendar systems, its regular waning and disappearance led to it being associated with death, crime, danger, and illness in many cultures. For example, the Moon is often included in medieval or Renaissance images of the death of Christ. Indeed, one of the first realistic images of a waning gibbous daytime Moon can be spotted in Jan van Eyck's *The Crucifixion* from c.1440, hovering malevolently over Calvary as Jesus is pierced by a lance. Even more alarming than the shape-shifting of the Moon are occasions when it momentarily blocks out the light of the life-giving Sun, eclipsing it partially or even fully. Such extreme phenomena were in many cultures considered to be of spiritual significance or given deep symbolic or prophetic meaning. The word "eclipse" itself derives from Greek and means "abandonment" or "omission," and in this context appears to refer to the missing light of celestial objects generally, or Earth and humanity being abandoned by their guiding lights the Sun and the Moon.

The Moon itself turning dark in an eclipse filled the ancient Chinese with horror and fear of death, and they believed a dragon was in the process of eating the Moon. In many ancient cultures, rituals took place to frighten similar dark forces away. Often these rituals would include noise and wild gestures. The Chinese banged on mirrors to scare off the Moon-eating away, alluding to the silver appearance of the Moon, while in Africa certain tribes would throw sand in the air. The Romans opted for throwing or waving burning torches in an attempt to reignite the Moon's fire. In earlier Babylonian culture, altars were erected and noisy processions organized to prevent being abandoned by the Moon or Sun, during which pots would be banged, loud instruments would be played, and much

Believing
Alexandra Loske

shouting would take place. The idea of the Moon being eaten was often associated with wild and dangerous beasts. In Nordic and some Eastern European cultures, the equivalent to this was bloodthirsty wolves or other dog-like creatures, and the reddish color of the Moon during an eclipse was often interpreted as the Moon bleeding to death while being eaten by the monsters. In Christianity, too, the temporary disappearance of heavenly light is a prominent symbol, based on the creation myth that clearly associates light with life, which banishes the darkness. The Second Coming of Christ, for example, is, in the Gospel of Matthew preceded by a description of cosmic disorder and loss of light through an eclipse: "But immediately after the tribulation of those days the Sun shall be darkened, and the Moon shall not give her light, and the stars shall fall from heaven, and the powers of the heavens shall be shaken." It is perhaps not surprising that eclipses have in some recorded instances literally changed the course of history. Thucydides tells the story of Nicias, the superstitious leader of the Athenian army, who, in 413 BCE, decided to postpone an attack on the Syracusans, because of a lunar eclipse he had just witnessed. His opponents ignored the heavenly sign and attacked first, winning the battle.

The Moon, often paired with the Sun, is one of the oldest and most frequently employed symbols in human culture. It doesn't take a great leap of imagination to comprehend the wonder ancient peoples must have experienced as they observed the heavens, or to understand how these bodies came to be revered as deities, given both their prominence in the sky and their enormous impact on the cycles and currents of life on Earth.

While we find stylized geometrical depictions of the Moon as a cosmic object in Persian, Egyptian, Chinese, Indian, Greek, and Roman culture, countless representations of the Moon as anthropomorphized deities developed alongside these maps, shapes, and diagrams. The Mesopotamian Moon god Nanna (or Sin) is one of the earliest recorded personifications of the Moon, being mentioned in the Sumerian poem "Inanna's Descent," dating from about 1750 BCE. In Mesopotamian culture Nanna is the father of the Sun, and he is often depicted with the attribute of a sickle Moon and associated with the bull. Then there is the complexity and richness of ancient Egyptian Moon deities, such as Khonsu, the "traveler" who represents the path of the Moon across the sky; Thoth, the god of time; and the pair Isis and Osiris. Their meaning and symbolism vary slightly, but their lives often reflect lunar cycles, and their emblems are, of course, almost always images of the Moon. Osiris, for example, often balances a full Moon contained in a crescent Moon on his head.

In Greek and Roman culture, a similarly complex scheme of Moon deities developed, but here the Moon was almost exclusively represented by women, with a strong association of the lunar cycle with the menstrual cycle. Phoebe, Hecate, Diana, Artemis, and Selene are all lunar goddesses in various incarnations, and are often associated with nature, hunting, the night, magic, virginity, childbirth, and femininity in general. Their depictions often come in the form of young, beautiful, strong, naked or semi-naked women, with matching Moon attributes and emblems. There are dozens of examples of lunar deities in other cultures, too many to mention here, but most allude to aspects of time in general, the cycle of life, and the night. Christianity inherited and

Believing
Alexandra Loske

reused much of the symbolism of preceding belief systems and used ancient myths and folklore to suit its image of belief and holiness. We see the Moon again predominantly as a symbol of virginal femininity —especially in the Roman Catholic Church, the Virgin Mary is often depicted with a crescent Moon under her feet.

The myths, stories, and symbolism triggered by our fascination with the Moon have been evolving through the millennia. Moon imagery is used far beyond a religious context. It is found in pre-Christian times, in pagan contexts, and in folklore, with a wide range of positive, negative, and contradictory associations. As a mood-setter, light source, indicator of significant events, and an object of desire, it features greatly in Gothic imagination and fiction, as well as in modern-age fairy tales, many of which have much older origins in folklore. In the great period of fairy book illustration of the late nineteenth and early twentieth centuries, we see many artists revelling in the possibilities of the Moon and the illuminated night sky as a compositional element, especially in northern European circles, such as those of Kay Nielsen or Edmund Dulac. In their illustrations, the Moon often serves as a beautiful and serene focal point that adds a mysterious and shimmering quality to a scene or indicates a significant moment in the narrative. In these tales, women often also resemble the Moon or share its attributes. In the magical story *The Dreamer of Dreams* (1915), written by Marie, Queen of Romania and illustrated by Dulac, for example, the moment a beautiful Nordic Ice-Maiden enters the scene is described thus: "All the splendor of the night, the dazzling brilliancy, the vast snow-field, the glory of the moon, the myriad stars, all paled before the beauty of the woman that now approached. Everything about her was white, glistening and shining; so shining that the human eye could hardly bear the radiance."

The Moon is a cultural motif as constant as the Moon itself, and it changes just as constantly. The poet William Butler Yeats, who wrote so evocatively about "the heaven's embroidered cloths" noted that "the Moon is the most changeable of symbols, and not merely because it is the symbol of change. As mistress of the waters she governs the life of instinct and the generation of things…" It is a celestial object that, like no other, has been a source for the creation of countless myths and analogies. The symbolism surrounding the secretive nature of this extraordinary mirror in the sky is only matched by its rival and partner, the Sun. We are in awe of the Moon, it inspires us with its serene beauty and perceived predictability, yet sometimes frightens us with its unpredictability and disappearing acts. Its subtle, glowing light and its role as timekeeper makes it our eternal companion, and it serves as one of the most universal objects of study, desire, fantasy, and hope, but also of fear and uncertainty. It suits many contexts, many stories, and is a rich visual and conceptual source. It is also perhaps one of our primal instincts to look at the Moon, to name it, explore it, reach for it—on a physical and scientific, as well as on a spiritual, level. Almost every human who ever lived has looked at the Moon. Humans were, are, and will always be like little Frieda in her father's poem, instinctively drawn to that most mesmerising object in the sky. This is what makes that footprint of the first human on the Moon's barren surface such a potent image. In 1969 we disturbed that secret stillness and left our mark, which only we are likely to disturb again.

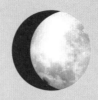

EXPLORING

A BRIEF HISTORY OF OBSERVING THE MOON

........................

The Moon is the brightest and closest object in our night sky, and looking at it is part of our shared human heritage. Most of the time it is the only nightly body that appears as anything more than a point of light. It appears to grow and change its shape as it moves from new to full, before shrinking again, and moves significantly in the sky from one night to the next. That monthly cycle of phases is a natural timekeeper, and understanding the movement of the Moon around the Earth is a starting point for comprehending the structure of the wider solar system.

Our nearest neighboring world is also one of just a handful of celestial objects with features visible to the eye alone. Prehistoric archaeological structures acknowledge its importance, and humanity must have discussed its nature from soon after spoken language emerged. The earliest observers exploited the calendar cycle, recognising the movement of the Moon in the sky in ancient sites around the world (most famously Stonehenge) and various cultures saw the Moon as a deity.

One of the more remarkable prehistoric discoveries is what appears to be a 5,000-year-old map of the Moon carved onto a wall of the Knowth passage tomb in Ireland. Its pattern of marks aligns with the lunar maria, the darker features on the Moon visible to the eye. This map, and the Nebra Sky Disc, a 3,500-year-old bronze-and-gold artifact depicting stars and the crescent Moon (see pages 70–71), are, like the Neolithic monuments, a visible demonstration of the importance of the Moon to ancient peoples.

Astronomers in ancient China and Babylonia made the first attempts to develop systems for calculating the positions of the Moon and other celestial objects. Observatories were set up as long ago as 2300 BCE in China and the following millennium in Babylonia, in part to keep track of time, and in part for astrology. Babylonian observers first recorded the Saros cycle, which describes the motion of the Moon over a period of 223 months. Both civilizations recognized that lunar and solar eclipses took place on a regular cycle, predicting their occurrence with some success. Babylonian culture saw eclipses as hinting at the death of a king: predicting them must have been a matter of state importance as well as a scientific triumph.

In classical antiquity, the ancient Greeks were the first to consider scientific ideas about the nature of the Moon, as well as predicting its position in the sky. In the earliest

Exploring
Robert Massey

of a series of revolutionary steps, Greek philosophers suggested that the Moon shines by reflecting sunlight, and deduced that lunar eclipses result from the Moon moving into the Earth's shadow. The mathematical skills and sheer ingenuity of later Greek figures such as Aristarchus of Samos, working in the third century BCE, then led to the first reasonable estimates for the scale of the nearby universe, including the size of the Moon and its distance from the Earth. Aristarchus devised the first Sun-centered or heliocentric model of the solar system, but the Earth-centered or geocentric model refined by Plato, Aristotle, and Ptolemy prevailed.

In the Ptolemaic system described in the second century CE, the Moon was held in place in the nearest of the celestial spheres rotating around an unmoving Earth. Though the plausibility of this model depended on adding complicated loops (so-called epicycles) to circular orbits to explain the movement of the Moon and planets in the sky, it correlates with early Christian doctrine, putatively including those Bible verses interpreted to mean that the Earth could not move.

The thinking of Ptolemy and Aristotle shaped most natural science until the Renaissance. Aristotle saw the Moon as reflecting the perfection of the heavens—but corrupted by the terrestrial realm, which explained the spots visible to the eye. The writer Plutarch, who also speculated about lunar inhabitants, took a different view and believed the spots to be shadows of deep crevasses, but Aristotle's ideas won through.

In the early Middle Ages, European scientific thinking made little progress. Some of the best work in astronomy, before the invention of the telescope, took place instead in the newly emergent Islamic world, where scholars built on the legacy of the Greeks. Islam uses a calendar system based on the observation of the lunar crescent after new Moon, which defines the beginning of each month. At significant points in the Islamic year, like the month of Ramadan, the sighting of the crescent Moon has added importance and it defines dates like the Eid festival. Inspired by the need to predict these dates, and by a general enthusiasm to study the night sky as encouraged by the Qur'an, Muslim astronomers were diligent observers.

From the ninth century onward in the Middle East, central Asia, North Africa, and what became Spain, instruments such as quadrants and astrolabes were used for measuring the positions of objects in the sky, and for timekeeping and navigation. Using such devices, Islamic astronomers improved measurements of the distance from the Earth to the Moon and the size of the Moon. The peak of Islamic astronomy is represented by one of the finest pre-telescopic observatories in the world, sited at Samarkand in what is now Uzbekistan. Built by the astronomer and Timurid ruler Ulugh Beg, it is one of the largest quadrants ever constructed and it measured the positions of the Moon, planets, and stars with unprecedented accuracy. The work of Beg and others later helped Western astronomers in their quest to understand the movement of the Moon and planets through space.

Over several thousand years astronomical knowledge thus flowed from the East and Middle East, through ancient Greece and the medieval Islamic world, arriving in Europe in the late Middle Ages. (Entirely independently, astronomy, and the cycles of the Moon, were part of Mesoamerican culture too.) European astronomy books from that time include richly illustrated models of the solar system and diagrams showing the phases of the Moon, all still within

Exploring
Robert Massey

the then prevailing geocentric system. The fifteenth and sixteenth centuries also saw the first representations of features on the Moon in fine art, at least those visible to the unaided eye.

The Netherlandish artist Jan van Eyck recorded it as seen during the day in three of his paintings between 1420 and 1437, most famously the *Ghent Altarpiece*; Leonardo da Vinci made pen and ink sketches of the Moon between 1505 and 1508; and at the beginning of the sixteenth century, William Gilbert, an astronomer and the physician to Elizabeth I, drew a somewhat crude map of the Moon with his unaided eye. The blotches in Gilbert's drawing of the full Moon, recognizable and familiar, are at the limit of what can be seen without a telescope.

Astronomy, and our understanding of the Moon, was now set for radical change. In 1543, the Earth-centered understanding of the universe underwent a paradigm shift with the publication of *De revolutionibus orbium coelestium (On the Revolutions of the Celestial Spheres)* by Polish astronomer Nicolaus Copernicus, which advocated for a heliocentric cosmos. In Copernicus's model, planets and the Moon still moved in circular orbits, but Earth was no longer the center of the universe. Scientists including Johannes Kepler, Galileo Galilei, and, later, Isaac Newton refined the model to include a theory of motion, gravitation, and elliptical orbits, and for most purposes it remains in place to this day. This idea was nothing less than revolutionary. It challenged Church doctrine, diminished the status of the Earth forever, and eventually allowed scientists to understand the mechanics and evolution of the Earth-Moon system.

The "Copernican revolution," as it has come to be known, was bolstered by the invention of the telescope, one of the seminal events of the seventeenth century. This invention turned the study of the night sky into a modern science. The four centuries since have seen more progress in our understanding of the Moon than the previous four millennia: long before the Space Age, telescopes made it possible to see the landscape of the lunar surface in detail.

Though there are claims of earlier versions, the Dutch optician Hans Lippershey first patented the design of a simple telescope—a so-called "Dutch trunke"—in 1608. This innovation, placing two lenses in a tube, allowed observers to see objects in more detail, and in astronomy, to see stars invisible to the naked eye. Within a year, the still little-known English astronomer Thomas Harriot had made the first technology-assisted drawing of the Moon from Syon House in what became west London. In the next decade, Harriot, under the patronage of the Earl of Northumberland, went on to draw Moon maps that would not be bettered for several decades. He and others did well to overcome the narrow field of view and poor optics of the first telescopes.

The following year, in northern Italy, Galileo Galilei published drawings of lunar features reminiscent of modern photographs. He benefited from artistic training, he recorded his results, and his field of interest was not confined to astronomy: he also investigated gravitation, the motion of objects, mathematics, and engineering. Galileo's high profile and willingness to uphold the Copernican model brought him into conflict with the Catholic Church and its geocentric orthodoxy. Galileo was eventually threatened with torture and placed under house arrest, but his ideas survived and spread.

Slowly improving lenses and mirrors, and better telescopes, led to correspondingly better lunar charts, as astronomers sought to build a detailed knowledge of the

Exploring
Robert Massey

lunar surface, though their efforts took time. Johannes Hevelius, working in Gdansk, spent four years mapping the Moon, publishing *Selenographia, sive Lunae descriptio (Selenography, or A Description of the Moon)* in 1647. He was the first astronomer to draw the effect of libration, where Earth-based observers are over time able to see a small part of the far side of the Moon.

In the same century, Giovanni Domenico Cassini, one of the founders of the Paris Observatory, created what has been described as the first "scientific" map of the Moon, charting the mountains, craters, ray systems, and maria. In what seems to have been an act of whimsy, he famously included one embellishment—the head of a mystery woman that may have been his wife, as well as a subtle heart shape. Cassini's contemporary, Giovanni Riccioli, gave modern names for lunar features still in use today.

For nearly 300 years, astronomers continued in this tradition, making and relying on drawings of the Moon and its features. In the absence of photography, let alone electronic imaging, this was the only way of recording what they saw on the lunar surface.

Creating a map of the whole of that surface is a challenging task (as anyone who looks through a medium-sized telescope at the Moon will realize), so many observers concentrate on particular craters, mountain ranges, or other features over a small area. Even the most careful observers, though, could make claims that seem fanciful today. William Herschel, who is best known for discovering Uranus (and was the first president of the Royal Astronomical Society), recorded his observations of the Moon from 1775 to 1807. Using a modest telescope from his home in Bath, England, and then a much larger one in Slough, he noted what he thought were active volcanoes, and even vegetation, describing a wood near the crater Gassendi. Based on this, Herschel believed the Moon to certainly be inhabited.

This probably shaped one of the more entertaining episodes in lunar astronomy, involving William's son, John, who set up an observatory near Cape Town. Unknown to him, in August 1835, the *Sun*, a New York newspaper, ran a series of articles describing new discoveries on the Moon. The outlandish claims included a 300-mile (480-kilometer) long piece of quartz, lakes and oceans, and humanoid winged creatures that walked upright. The younger Herschel himself heard about the hoax later that year, and was reportedly amused to begin with, but two years later complained to his aunt Caroline (a well-known astronomer in her own right) about the letters he had received.

Though various efforts were made to standardize their work, the approach taken by observers who drew the lunar surface could be very different. This changed radically with the invention of photography in the 1820s. Though the earliest photographic techniques were laborious, by 1839 Louis Daguerre took the first shot of the crescent Moon, and a year later John William Draper repeated this with the full Moon. Photography eventually allowed scientists to record features of the Moon at some speed and created a permanent and reasonably objective record.

Two decades later, astronomers also began to decipher the composition of the lunar surface using the new science of spectroscopy. Here, prisms, and later gratings, are combined with a telescope. They disperse the light from the Sun, Moon, stars, and planets into a rainbow, and dark lines set against these colors reveal the presence of chemical elements and more complex minerals. Two scientists working in London, Margaret and William Huggins, used this technique to confirm that the Moon had no significant

Exploring
Robert Massey

atmosphere. Another indication of this is the way stars simply blink out when the dark limb of the Moon moves in front of them—with an atmosphere there would be a gradual fading—and the almost complete absence of change in lunar surface features.

In the same era it became possible too, to detect heat from the lunar surface. In 1856, Charles Piazzi Smyth, Astronomer Royal for Scotland, first detected infrared from the Moon. Infrared gives a good indication of temperature, and a decade later Laurence Parson, the first Earl of Rosse, working in Ireland, showed that the surface of the Moon warmed and cooled as a result of the Sun, rather than being a source of heat in its own right. Improved infrared techniques later identified hot spots on the surface that remain warmer than their surroundings in the lunar night, and scientists developed a greater understanding of the properties of lunar soil and how it holds heat.

In the twentieth century observatories began to employ staff, and universities expanded their research activity. By the 1960s, and the announcement of the Apollo program, ground-based lunar observing started to be superseded by space probes. There were, though, still major efforts to chart the Moon from the ground: One notable response came from Ewen Whitaker, who drew one of the first accurate charts of the lunar South Pole, later moving to NASA to identify potential landing sites.

Unpaid amateurs, who a century earlier made up almost the entire astronomical community, continued to contribute. Authors like Sir Patrick Moore, who published his classic *Guide to the Moon* in 1953, helped popularize the study of the Moon, which remains a key target for amateur astronomers today. Moore and others studied reports of so-called "transient lunar phenomena," where mainly amateur astronomers observed changes in color or glows on the lunar surface. The findings of these studies are still controversial, and may be caused by gas escaping from underground, interaction between the surface and solar radiation, or impact events—or they may result from changes in the Earth's atmosphere rather than anything on the Moon.

Observing the Moon from the ground is much less of a priority now than in the past. The giant telescopes built in the last two decades, like the Very Large Telescope in Chile, are designed with more distant targets in mind, like galaxies in the early universe, and are rarely used on objects closer to home. Sometimes, though, these are tried out on the Moon to explore the level of detail in their images. The VLT image of the Taruntius region, made in 2002, shows features 425 feet (130 meters) across and remains one of the sharpest made from the Earth. (This is still nowhere good enough to see the Apollo landers and counter the hoaxers who say that the program was faked, but the spacecraft are clearly visible in images from lunar orbit.)

No ground-based observatories today can compete with the images sent from spacecraft near the Moon, though the Moon remains a favorite for anyone looking through a telescope for the first time (if you haven't done this yourself, the authors strongly recommend it). Nonetheless, the centuries of work before the Space Age, looking at the Moon with the eye, measuring its position with instruments, and mapping it with telescopes, have a huge legacy. That work turned an object in the sky from a god, into a world, a timekeeper, and a tool for navigation. The features of our neighbor became apparent—craters, mountains, ridges, and domes—making it a destination for space missions and a place human beings could visit.

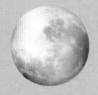

ROMANTICIZING

THE MOON AS IMAGE; SYMBOLIC AND SUBLIME

Think of a great image of the Moon in science and you may well think of one of the photographs taken on the Apollo missions in the 1960s. Think of a picture of the Moon in science fiction and many people would associate this with a twentieth-century film still or a garishly colored book jacket. But think of the Moon in art, especially in Europe, and you would probably think of a nocturnal landscape by painters such as J. M. W. Turner, Caspar David Friedrich, Philip James de Loutherbourg or Joseph Wright of Derby. In the late eighteenth and early nineteenth centuries we find a deluge of striking images of the Moon in painting, more so than in any other period. The German painter Caspar David Friedrich painted dozens of pictures, some of them now the best-known of the period, of human figures—solitary or in small groups—with their back to the viewer, looking quietly at the Moon in its wider setting. Turner dipped many a watercolor and oil painting in blue moonlight, cherishing the mysterious atmosphere it creates.

These moonscapes are not always serene. In the same period we find many images of dramatic and frightening scenes of natural and human disaster, such as shipwrecks, avalanches, destructive storms, or simply vast mountains thrown into eerie relief by bright moonlight. The same is true for poetry and novels of that time, where the Moon is used almost like a prop, a staple ingredient to create mood, to indicate danger, doom, or simply to light a scene in a dramatic fashion. Coincidentally, a piece of music that is, more than any other classical piece, associated with the Moon was composed when Turner, Friedrich, and others were happily churning out moonscapes: Ludwig van Beethoven's Piano Sonata No. 14—better known as Moonlight Sonata—a melancholy, aching composition of three movements, was composed in 1801. It wasn't the composer himself who associated it with the Moon, but a poet friend who, years later, said that the famous first movement of the piece reminded him of moonlight reflected on Lake Lucerne.

What was the reason for the obsession with the Moon at that time? Much of it can be explained by prevailing attitudes and aesthetics of the Romantic age, when, after a long period that focused more on the sciences, research, and all things that could be measured and classified, writers and artists were becoming more concerned with sensations, feeling, and how the human figure fits into the greater

Romanticizing
Alexandra Loske

spiritual and physical context of the world. It is therefore not surprising that landscapes, and especially dramatic nocturnes, were used to express feelings and to create a mood, both in literature and the visual arts. The eighteenth century was the Age of Enlightenment and Reason. It gave us maps, clocks, atlases, taxonomical classification systems, new instruments, academies, and even a flying machine in the shape of a helium balloon. We had nearly explored the whole of the Earth, and we were now trying to make sense of it all. And this is why the point of view shifted to a more personal and more human perspective. If you look at the ground from the great height of an airborne balloon, the human figure soon diminishes to ant-like proportions, and in fact the whole human world, which seemed so big and important from ground-level, becomes worryingly tiny. In many ways, the Romantic movement's style and choice of imagery constituted a creative reaction to the strictly objective science-focused earlier eighteenth century.

The appeal of the Moon to painters in particular is connected to the rise of landscape painting as a genre. For centuries, portraiture and grand-manner history paintings dominated in the art world, but by the later eighteenth century it was acceptable to paint what you saw—the actual landscape you were surrounded by—and it soon became a fashionable pastime to travel in a leisurely manner, to Italy on a Grand Tour if you were wealthy enough, and record what you saw. Italian landscapes and classical imagery had dominated European culture for a long time, with elegant white architecture and ornament set in sun-drenched visions of light. But on the way to Rome the intrepid eighteenth- and nineteenth-century traveler had to overcome a major obstacle: the Alps. It was here that, geographically, the Picturesque met the Sublime.

For many artists, nature was a mighty force, a source of what had been labeled the Sublime earlier in the eighteenth century. The Sublime was the opposite of measurable, predictable beauty. It was that which was beyond human control and rationalization; those formations and events that leave us awestruck, fearful, and amazed. For the painter or poet then, an eclipse, a moonrise over the sea, or the Moon dramatically lighting large cloud formations over the Alps would be translated into a picture or a poem with sublime elements, where the Moon was not charted and analyzed but used as a key element to create that sense of awe. Early examples of the sublime Moon can be found in almost every painting by Joseph Wright of Derby, who was particularly interested in the contrast between light and dark. Slightly later, the best examples were perhaps those painted by Turner, often in a mountainous setting or in seascapes. This interest in the Sublime is still apparent in the later nineteenth century, but often with moral undertones, such as in the imposing biblical paintings of John Martin, which, as if they were not themselves epic enough, were sometimes displayed in galleries with dramatic light shows. In this context, the Moon is a scene- and mood-setter; like stage lighting in the modern theater, it helps to underline emotional content, and emphasizes and dramatizes plot turns. Ultimately, it helps to entertain the audience.

Perhaps surprisingly, the Romantic imagination was also, to a significant degree, informed by hard science, despite many depictions of the Moon and the sky appearing visionary and subjective. Artists and poets, just like the scientists, were busy observing nature and cosmic phenomena carefully. To many, it was important to work from nature and in nature (*en plein air*), and they produced remarkably accurate studies of natural phenomena,

Romanticizing
Alexandra Loske

including clouds, rainbows, sunrises, and Moon phases. A good example of the Romantics combining science with subjectivity is the German playwright and poet Johann Wolfgang von Goethe, who became so interested in the Moon that he obtained a copy of Johann H. Schroeter's magnificent book *Selenotopographische Fragmente* (1791), and even invited friends to Moon-watching parties at his house, proudly announcing that he had already set up three telescopes. This did not stop him writing poems in which the Moon is invariably a symbol of love, erotic desire, voyeurism, and sometimes even old age and death. His own amateur sketches of moonscapes are a combination of science and love: they are observations of nature, but also deeply melancholic, and were given as a token of affection to his close friend Charlotte von Stein. The Moon in these delicate drawings became the couple's very personal symbolic language of love and friendship.

The association of the Moon with love and romance has persisted since antiquity, despite its other, paradoxical link with death. Perhaps the association of the Moon with the night is pertinent; it lights the darkness with a familiar and friendly face, providing a more secretive and conducive glow than the harsh light of the Sun. Perhaps it is the connection between femininity and the Moon—in Greek and Roman religious symbolism, the Moon is typically represented by virginal goddesses, such as Artemis, Diana, Hecate—and even the Virgin Mary when Christian theology replaced the ancient religions. Romantic writers were apt to use the imagery of the Moon in their descriptions of beautiful women, or to compare them. Perhaps it is even the link to madness, which the Moon was once thought to cause, lubricating desires and removing inhibitions.

Whichever way, the erotic potency of the Moon as a motif was known to painters and writers for centuries: in Shakespeare's *The Merchant of Venice*, Lorenzo enthuses to Jessica about the moonlight and its sensual qualities: "How sweet the moonlight sleeps upon this bank!/Here will we sit and let the sounds of music/Creep in our ears: soft stillness and the night/Become the touches of sweet harmony," while Romeo declares in love for Juliet at night "by yonder blessèd moon." Juliet is wisely somewhat sceptical about this, reminding her lover of the inconstant and unreliable nature of the Moon.

From love trysts under cover of the night, it is only a small step to notions of the illicit, forbidden, dangerous, and unpredictable, all of which are elements of the concept of the Sublime. The Moon shows its dual face when, in Gothic novels, murders and supernatural events frequently happen by the light of the Moon or against the backdrop of nocturnal storms, thunder, and lightning. Mary Shelley was reportedly inspired to write *Frankenstein; or, The Modern Prometheus* (1818) when she woke up one night and contemplated the moonlight flooding into her room.

While Romantics artists and writers embraced the erotic associations of the Moon, its more morbid aspects clearly excited them, leading them toward themes of danger and doom. Mary Shelley's husband, the poet Percy Bysshe Shelley, for instance, makes the connection between the Moon and death in "The Waning Moon" (published 1824) and even alludes to insanity: "And, like a dying lady lean and pale/Who totters forth, wrapp'd in a gauzy veil,/Out of her chamber, led by the insane/And feeble wanderings of her fading brain,/The moon arose up in the murky east/A white and shapeless mass."

Romanticizing
Alexandra Loske

The Moon itself continued to be used as a symbol of both love and doom in many aspects of culture in the post-Romantic age. In Victorian painting it frequently shines on scenes of desolation and figures that have fallen from grace, or are about to. There are also many examples of the Moon adding melancholy and mood in a similar fashion, as in Turner's nocturnes. Artists like John Atkinson Grimshaw used the Moon to create eerily empty urban nocturnes in the later nineteenth century, while J. A. M. Whistler managed to dissolve views of industrial and built-up London in washes of moonlight that he called "Symphonies." These artists didn't shy away from depicting the Moon in an urban context, just like many early and mid-twentieth century artists after them, such as Paul Nash and John Piper, who are sometimes described as "modern Romantics."

Away from high art, the Moon gained its own momentum in popular culture as a simple and easily recognizable symbol of love, affection, and sometimes naughtiness. With the advent of picture postcards and the popularization of photography, we see the Moon in sickly sweet colored designs for Valentine and Christmas cards, as well as ordinary postcards (see pages 114–115). Small children were often put on cardboard Moons, reminiscent of putti sitting on clouds in Old Master paintings, and images of kissing or flirting couples precariously balanced on sickle Moons were extremely popular. Naturally, the more attractive aspects of the Moon were also utilized in advertising, where it was sometimes used to evoke a geographically exotic setting, usually for goods imported from foreign countries, such as coffee, spices, or tobacco. Elements of eroticism are never far away in these postcards and posters from the late nineteenth and early twentieth century, as is evident in the rather daring image of a woman in stockings, reclining in a seductive manner on a sickle Moon in a 1920s advert by the American Blue Moon Silk Hosiery Company (see page 113).

In the Romantic period, the Moon shone both on lovers and killers, on romance and crime, on scenes of beauty and destruction. It was, and still is, employed to express melancholy and contemplation, but perhaps its symbolic potency became diminished by exposure to the mainstream, or perhaps we wanted to restore it to its less threatening and emotionally charged position of our benign companion. From the nineteenth century onward, it served as an easily readable, light-hearted, effective symbol in popular art and advertising.

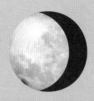

REACHING

OUR LONG TRADITION OF IMAGINARY JOURNEYS TO THE MOON

The desire to reach our nearest heavenly body, to explore and perhaps even conquer and colonize it, is a surprisingly long-held dream. The idea recurs with regularity in fiction, non-fiction, and satire, and often the boundaries between the genres are blurred. What combines all these texts is the ambition of reaching beyond our terrestrial limits, to conquer heaven, and—eventually—other worlds. One of the most intriguing questions for scientists, philosophers, and storytellers was whether there was any kind of civilization on the Moon. Are there extraterrestrial life-forms that may question our position in the universe, propose danger? At the very least, they offer superb material for stories.

We now think of imagined cosmic voyages as a popular subject of nineteenth- or twentieth-century science fiction in literature and film, with a focus on technology. However, there is a long and steady tradition of hypothesizing about the landscape and inhabitants of the Moon, going back thousands of years. A vision of a civilized Moon is mentioned in fragments of Orphic poetry dating from the fifth century BCE: "And he devised another world, immense, which the Immortals call Selene and the inhabitants of Earth Mene, a world which has many mountains, cities, many mansions."

In the first century CE, the Greek scholar Plutarch wrote a fictional dialogue in which eight speakers, including mathematicians, philosophers, and travelers, discuss the appearance and structure of the lunar surface, as well as the possibility of lunar life-forms. Incidentally, the title of the essay "Concerning the Face Which Appears in the Orb of the Moon" introduces the "face in the Moon" in written culture. This is the first anthropomorphic image of the Moon's face in literature, although the text also notes that any figures in the Moon may be an optical illusion. Plutarch provides us with some beautiful metaphors, such as the Moon as a "glassy body," or "a mirror that reflects the great ocean."

By comparison, the other significant text concerning the Moon from classical antiquity is the entirely fantastical lunar journey described by Lucian of Samosata. This second-century work was possibly written as a satirical response to "writers of old." It is the first detailed account of an imagined voyage to the Moon, and was included in a series of tales entitled *Vera Historia (True Stories)*—which are quite the opposite of true. In fact, the author calls himself a liar in the prologue and later notes that his readers "should on no

Reaching
Alexandra Loske

account believe in [these stories]." As is the case with most early lunar science fiction, the author portrays the Moon as inhabited by a range of bizarre creatures, some half-animal and half-plant, and goes into considerable detail about their strange methods of reproduction.

The invention of the telescope in the early seventeenth century subtly changed how writers envisaged the Moon's surface, although it didn't make theories and stories about its possible inhabitants less fanciful. The German scientist Johannes Kepler is a curious case in this respect. He had a lifelong interest in astronomy, astrology, and mathematics and published a number of important scientific works. But also wrote an intriguing story of a lunar voyage that mixes rigorous science with high fantasy: his *Somnium (The Dream)*. In Kepler's story, the Moon is reached with the help of a friendly daemon. By using fiction Kepler was able to describe his account of the geography of the Moon, with mountains and craters, then only theoretical; to present a view of the cosmos from the perspective of the Moon's surface, supporting Copernican theory; and to suggest the dangers of space travel, including solar radiation, freezing temperatures, and the lack of oxygen. Written in 1608, many aspects of Kepler's story were surprisingly prescient.

Before the age of aviation and space exploration, a major theme of lunar fiction was the means of traveling in space. Lucian's travelers reach the Moon accidentally, with the help of a sustained whirlwind, while Kepler had his folklorish daemons. In other pre-Space-Age literature there is no shortage of flocks of birds carrying protagonists into space, homemade kites attached to the traveler's body, or complicated winged flying machines, some of which bear a resemblance to hot-air balloons, which were invented in the late eighteenth century.

The late-eighteenth-century novel *Baron Münchhausen's Narrative of his Marvelous Travels and Campaigns in Russia* by German author Rudolf Erich Raspe (published in 1785) is an overblown first-person account of the big-headed nobleman Münchhausen's achievements and adventures, including a ride on a cannonball, travels underwater, and not just one, but two journeys to the Moon. He first reaches the Moon by climbing up a Turkish bean plant, which he hooks on to the sickle Moon (see page 53). His second journey is via a boat which is lifted up by a storm so powerful that it carries him to his destination. The Moon is inhabited by human-like figures sporting detachable eyes and heads, as well as bellies that double-up as handbags. These inhabitants don't die but dissolve into thin air when they are old. Intended as a social satire, this hilarious book was quickly translated into English and became an international success. It is just likely that Münchhausen's vision of the Moon and its inhabitants inspired the descriptions of the Great Moon Hoax of 1835 (see pages 160–161).

A generation after the Great Moon Hoax, the French writer Jules Verne wrote two of the most popular stories of Moon exploration in history: *From the Earth to the Moon (De la terre à la lune)* in 1865 and its 1870 sequel *Around the Moon (Autour de la Lune)*. Verne sends his protagonists to the Moon in a powerful cannon, a premonition of the Saturn V rocket that would take humans to the Moon a hundred years later. Verne's Moon novels have never been out of print and have spawned countless film adaptations, inspiring Georges Méliès to make *Le Voyage dans la Lune (A Trip to the Moon)*. Méliès' image of the rocket landing in the eye of the Moon, depicted as a large anthropomorphized face, and has become one of the best-known images of the Moon in popular culture (see pages 74–75). Verne also left

Reaching
Alexandra Loske

a mark on music: in 1875 Jacques Offenbach composed an opera, *Le voyage dans la lune*, inspired by Verne's stories.

Méliès' film was only the beginning of science fiction on the silver screen. In 1929, a generation after Méliès, Fritz Lang produced a film that put a woman at the center of space travel: *Woman in the Moon (Frau im Mond)*. It is essentially a melodrama set on the Moon, with the spacecraft named after the love interest Friede. The design of the rocket was deemed so realistic that a few years later the film was banned by the Nazis, who thought it was too similar to the secret V-2 rocket they were developing. The lunar landscape in Lang's film, on the other hand, is still delightfully and unrealistically ragged, with many a spiky mountain range, as was common in literature and film until close-up lunar photography in the 1950s and 1960s.

The other great name in modern science fiction is the British author H. G. Wells, who was writing and publishing at the turn of the twentieth century, a time when there was a renewed interest in the exploration of space. The age of terrestrial discoveries had come to a close; Earth had been almost completely charted and mapped, so where else to go but beyond Earth, into space? Wells also witnessed the rise of motorized transport, commercial air travel, and new means of communication, such as the telephone. Writers, scientists, inventors, and politicians, were turning their attention to worlds farther away, and began imagining powerful machines that could take us to the Moon.

Wells wrote many tales of time and space travel, including the Mars-focused *The War of the Worlds* (1897), which was famously adapted for radio broadcast by Orson Welles in 1938. Wells's story of a journey to the Moon, *The First Men in the Moon*, was published in serialized form between 1900 and 1901. His protagonists reach the Moon by means of an impressive homemade spaceship, and when Wells discusses aspects such as zero gravity, weightlessness, and thin atmosphere, it all sounds intriguingly plausible and scientific. Wells was not shy about populating his Moon with curious beasts and plants. His name for the rather unwelcoming natives of the Moon, Selenites, the same chosen by Méliès in his *Voyage dans la Lune*, is a literary nod to the Greek Moon goddess Selene.

Although the means of lunar voyages was evolving, ever closer to the rocket technology that would eventually take men to the Moon in real life, the magic of lunar travel by means of wings, birds, wind, and flying machines remained popular in children's literature. In a short story written by Theodor Storm in 1849 for his son, *Der kleine Häwelmann* (see page 171), a young boy rides around in his cot, escapes through the window of his room, and eventually reaches the (male) Moon and naughtily runs over his nose. The Moon is so angered that he turns off his lights and throws the little boy into the sea. In another fairy tale, *Little Peter's Journey to the Moon (Peterchens Mondfahrt)* (see page 72), written by Gerdt von Bassewitz in 1915, two young children go on a nocturnal journey to the Milky Way and eventually the Moon. They ride to the Moon on the back of the Great Bear (Ursa Major), are catapulted onto Moon mountains via a "Moon cannon" and fight an aggressive "Moon man."

To this day, the Moon remains a much-loved object of mystery and fiction in children's literature, animated films, poetry, and music, but, perhaps not surprisingly, it has not often been the focus of science fiction stories since we reached it in 1969. We lost irrevocably some of the mystery of it when we finally conquered it, and our imagination turned elsewhere—to Mars and farther beyond. As a metaphysical symbol, however, it has lost none of its potency.

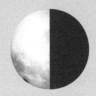

TRAVELING

FROM THE SPACE RACE TO THE APOLLO ERA AND BEYOND

In the final days of the Second World War, the Soviet Union and the United States both realized the potential of the terrifying V-2 rockets that bombarded the UK, northern France, and the low countries at long range from 1944 onward. Both powers then sought the missile expertise (and people) of the Third Reich for their own military programs.

Once the war ended, the West and the East bloc countries faced each other. The Cold War—which would see a confrontation between the capitalist and communist systems for more than 40 years—began in earnest, each bloc prioritizing the development of military technology. The US enjoyed a brief monopoly in the possession of nuclear weapons, from the first (and so far only) use in warfare against the cities of Hiroshima and Nagasaki in 1945, until the Soviet test of an atomic bomb in 1949. Both superpowers at first relied on conventional bomber planes, but understood the importance of rocket delivery systems—missiles—that could take nuclear weapons to their targets in less than an hour. German rocket engineers were brought to the US and USSR to use their knowledge for rocket development, culminating in the ICBMs (intercontinental ballistic missiles) that defined the nuclear fears of the Cold-War period.

Alongside the arms race, more peaceful programs were being developed. Wernher von Braun, the German scientist who had created the V-2 for the Nazis—notoriously using slave labor at his Peenemünde rocket site—came to the US. Quickly, and perhaps cynically, he became an American citizen and advocate of democracy. There, the passion for space exploration he had harbored since his youth culminated in the Saturn rockets that would eventually carry astronauts to the Moon.

The push to "conquer space" took center stage in United States policy-making after the surprise of the Soviet Union's Sputnik launch on October 4, 1957. This small (23 inches or 58 centimeters diameter) sphere went into orbit, transmitting a simple beep picked up by radio hams around the world. Meanwhile, the US satellite project was looking decidedly shaky after its first attempt ended in a launch failure, dubbed "flopnik" by a scathing press.

Just one month later, Sputnik II carried the first living creature into orbit: Laika, a stray dog from the Moscow streets. Though Soviet propaganda at the time claimed she lived for a week, dying painlessly in orbit, in 2002, a Russian historian revealed that the cosmonaut dog died

Traveling
Robert Massey

from overheating and stress just a few hours after blast off—she had never been expected to survive. A subsequent mission repeated the experiment with a canine pair, Strelka and Belka, and in a happier ending returned them safely to Earth.

The Ukrainian Sergei Korolev, then an unknown figure in the West, led the Soviet space effort. Born in 1906, Korolev trained as an aeronautical engineer, and spent six years in the Gulag after his arrest in 1938 in one of Stalin's purges. After his release, he designed the first Soviet long-range missiles, became Chief Designer of their space program, and pushed for lunar exploration and for cosmonauts to travel to the Moon. Korolev died in 1966 after an operation for his cancer, after which his identity was made public.

By the time the US put its first satellite, Explorer 1, into orbit, in April 1958, the Soviet lead seemed clear (though their mission failures were simply not reported). While Explorer's success restored some confidence in the US effort, the USSR was now sending its first probes toward the Moon. Luna 1 came within 3,725 miles (6,000 kilometers) of the Moon, and then became the first probe to go into orbit around the Sun. Luna 2 was more successful; hitting the Moon on September 13, it was the first artificial object to reach another world. Luna 3, launched a month later and sent back the first images of the far side. The blurry pictures showed a surface quite different from that visible to ground-based telescopes, with far more craters and many fewer smooth maria.

On the US side, five Pioneer spacecraft were aimed at the Moon. Of these, one failed at launch, three failed to reach orbit, and only Pioneer 4 had a modicum of success when it passed within 36,650 miles (around 60,000 kilometers) of the lunar surface.

The Soviet victories, meanwhile, reached a new peak when Yuri Gagarin became the first person in space, in April 1961. Launched from the Baikonur cosmodrome, he completed an orbit around the Earth, landing in Central Asia. Gagarin became a national hero, received the Order of Lenin, but tragically died in an air crash in 1968.

US President John F. Kennedy, who took office three months before Gagarin's flight, is credited with energizing the Space Race in the US with his address to Congress in July 1962, and at Rice University in September of the same year. Kennedy spoke after just four successful crewed Project Mercury flights, only the latter two of which had placed astronauts in orbit. With the words: "We choose to go to the Moon in this decade and do the other things, not because they are easy, but because they are hard," he committed the US to an ambitious goal of sending men to the Moon—and bringing them safely home.

All of the US astronauts at the time, and, with the exception of Valentina Tereshkova, all Soviet cosmonauts, were men. In 1960 a group of American women were privately funded to go through "First Lady Astronaut Training," with thirteen qualifying for the next stage at the Naval School of Aviation in Florida. However, without an official NASA request, this stage was canceled. NASA also only accepted military test pilots with engineering degrees, something impossible for women at that time, and despite a congressional hearing, the astronaut candidates were not reinstated. It took until 1983 for Sally Ride to become the first US woman astronaut, and it wasn't until 1999 that Eileen Collins became the first woman to command a space mission.

NASA did employ women behind the scenes as "computers," following a long-held tradition that the drudgery of repetitive calculations was a suitable female

occupation. Katherine Johnson, who went on to do critical work that ensured the Apollo-program spacecraft could dock successfully, worked for the space agency for decades, was awarded the Presidential Medal of Freedom in 2015. Another female Medal-winner, Margaret Hamilton (see pages 104–105), led the team that developed the Apollo guidance software.

The 1962 Kennedy speech also acknowledged the high cost of the moonshot, with that year's space budget higher than the previous eight years combined. At its peak in the mid-1960s, NASA accounted for more than 4 percent of government spending, compared with around 0.5 percent today.

Attempting a lunar landing required both political support and steps forward in engineering. With all this in place, a detailed plan of the lunar surface was required in order to identify reasonably smooth sites suitable for a touchdown of a crewed vehicle. In parallel with the development of spacecraft, both the US and Soviet programs continued to send robotic probes to the Moon for this purpose.

From 1961 to 1965, the US Ranger series again started with mission failures, but the final three spacecraft (Rangers 7, 8, and 9) impacted different lunar sites, en route transmitting close-up images of the lunar surface. These were 1,000 times sharper than pictures from terrestrial telescopes and showed a landscape rugged on the smallest scales, revealing how difficult it would be to find safe sites for the Apollo landers.

Luna 9 ended a run of Soviet failures in the same period, making the first soft landing on, and sending back the first images from, a world other than Earth. The transmissions were picked up by the Jodrell Bank radio observatory in the UK, where they borrowed a machine from the *Daily Express* offices, decoded the data to recreate the picture, and the newspaper published it the next day.

NASA similarly used the Surveyor craft to test the ability to make soft landings, using retrorockets to slow down, with five of seven attempts being successful. Like Luna 9, they returned photographs from the lunar surface. Five spacecraft complemented the landings, mapping 99 percent of the Moon in 1966 and 1967, paying particular attention to potential landing sites.

At the same time, Project Gemini was moving spaceflight forward with two uncrewed test flights and ten crewed missions each taking two astronauts to Earth orbit. The program extended the time that humans could remain in orbit to a fortnight, tested docking between spacecraft for the first time, saw the first US spacewalks, and enhanced navigation—all prerequisites for the moonshot itself.

The stage was set for the Apollo program. By 1967 the Saturn V rocket, the launch vehicle, was ready. This was a direct result of the leadership of von Braun, by now director of the NASA Marshall Space Flight Center. The payload design for the lunar missions included a command module that carried the crew into space, and separated off for re-entry into the Earth's atmosphere and splashdown in the ocean; a service module with an engine and electrical supplies; and the lunar module that landed two astronauts on the Moon and returned them to the command module for the journey home.

The first flight, Apollo 1, was scheduled for February 1967, with astronauts Virgil Grissom, Edward White, and Roger Chaffee set to enter Earth orbit. During a test on the launch pad, with the three astronauts locked in the command module, a spark led to a rapidly spreading fire, fueled by

Traveling
Robert Massey

the high-pressure, pure oxygen atmosphere then in use. Rescuers were unable to open the cabin door, and all three crew members were killed. With such a terrible setback, crewed Apollo flights were put on hold for nearly two years, though test flights of the Saturn rockets continued.

With Apollo 7 in October 1968, a crew was once again sent into Earth orbit to—successfully—test docking the command and lunar modules, a maneuver that would be essential for recovering astronauts on their way home. Apollo 8 was more ambitious. On December 21, 1968, Frank Borman, James Lovell, and William Anders launched into Earth orbit atop a Saturn V rocket, and then initiated translunar injection—setting course for the Moon. Their flight took them to, and around, the Moon for the first time, traveling out of radio contact to the far side. The crew completed ten orbits around the Moon before a successful return, and on Christmas Eve broadcast a reading from the first chapter of *Genesis*, ending with the words, "Good night, good luck, a Merry Christmas, and God bless all of you—all of you on the good Earth."

Apollo 9, launched in April 1969, performed a longer set of dockings and maneuvers in Earth orbit, and Apollo 10 carried out a dress rehearsal for the landing (see pages 62–63), with its lunar module separating and approaching within 10 miles (16 kilometers) of the surface.

On July 16, 1969, a Saturn V rocket blasted off from Cape Kennedy in Florida, starting the Apollo 11 mission and carrying Neil Armstrong, Michael Collins, and "Buzz" Aldrin into Earth orbit. The engine on the third stage of the rocket fired two hours and 44 minutes later, and the three men headed for the Moon.

Apollo 11 arrived in lunar orbit on July 19, and the next day Armstrong and Aldrin entered the lunar module. The dramatic journey to the surface included a last-minute course correction to avoid a crater, unexpected alarms (later established to be a computer rebooting), and 30 seconds worth of fuel remaining. The footage of the landing, watched live by an audience of more than 500 million, tracked the astronauts' descent through their staccato messages to Mission Control. After a two-and-a-half-hour flight, with Armstrong's words "Houston, Tranquility Base here, the Eagle has landed," the goal set by JFK seven years earlier had been accomplished.

The crew of the Eagle were expected to sleep, but instead prepared for their walk a few hours later. On July 21, they opened the hatch and twelve minutes later Armstrong started his climb down the ladder. He stepped off, placed one foot on the lunar surface, and spoke: "That's one small step for [a] man, one giant leap for mankind." Armstrong and Aldrin spent about two and a half hours on the lunar surface, gathering rock samples, deploying a seismometer, laser reflector, solar wind composition experiment, and, of course, the US flag and plaque with the words: "We came in peace for all mankind."

After seven hours of sleep, and 21 hours and 36 minutes on the surface, the engine fired to take the astronauts back to the command module and the waiting Collins. (Armstrong broke off the handle of the firing switch climbing back in, but improvised with a pen instead.) The crew returned safely to Earth on July 24, spending 21 days in quarantine, as no one could be quite sure the Moon was lifeless. Post release, the three astronauts traveled to New York City, welcomed by the largest ticker tape parade in the city's history. Neither author of this book remembers the Apollo landings, but the words of the softly spoken Armstrong still resonate, not least in their symbolism of a different era.

Traveling
Robert Massey

Only twelve astronauts, in six of the seventeen Apollo missions, have stepped on the Moon, and each time the crew were beyond hope of rescue should something go wrong. One—Apollo 13—nearly did end in disaster. Fifty six hours into the flight on April 13 1970, the no. 2 oxygen tank exploded, rupturing the no. 1 tank too, and shutting down the fuel cells that supplied electrical power. The astronauts were at this point about 200,000 miles (about 320,000 kilometers) from Earth and committed to travel to the Moon. Moving to the undamaged lunar module, the crew survived through ingenuity, conservation of water, and some luck in navigation, which still depended on sextants.

All the Apollo crews were lucky too to avoid solar flares and ejections of solar material, which could have led to dangerous levels of radiation, particularly to anyone outside of the spacecraft. There is disputed evidence that the radiation they were exposed to led to higher levels of heart disease, and health risks remain a serious concern for future space travelers.

Apollo 15, 16, and 17 saw the deployment of the Lunar Roving Vehicle (LRV), an electric car that greatly extended the distance astronauts could cover, with a top speed comparable to a cyclist on Earth. The crews traveled dozens of kilometers around the landing sites.

In December 1972, the program came to a close. The crew of Apollo 17 included geologist Harrison Schmitt, the only scientist to walk on the Moon, who spent more than 22 hours exploring the lunar surface, identifying the orange soil later linked to an ancient volcanic eruption. The mission carried 250 lb (115 kg) of samples back to Earth, and splashed down on December 19.

Kennedy's pledge had been met. Responding to budget pressures, NASA had canceled Apollo 18, 19, and 20 two years earlier, curtailing ambitions to explore the craters Copernicus and Tycho. In the nearly half a century since, no one has returned, despite the ambitions of three US presidents (George H. W. Bush, his son George W. Bush and lately Donald J. Trump), and pledges from space agencies around the world.

With far less public attention, the USSR Zond project had tried to gain the edge on the Americans up until the successful Moon landing of 1969. With a newly adopted but problematic launch vehicle, many of the missions failed, and even the successful flights were dogged by technical glitches. The Soviet engineers piloted the use of a Soyuz-like spacecraft (an updated version of this system carries astronauts to the International Space Station to this day). Four Zond launches carried modules around the Moon, with the September 1968 flight of Zond 5 taking a "crew" of two tortoises, insects, planets, and bacteria, and a man-sized mannequin, and returning them to Earth unharmed six days later. But after the success of Apollo, the program was quietly canceled.

Despite abandoning the attempt to send cosmonauts to the Moon, the Soviets continued their scientific program into the 1970s. Luna spacecraft landed on the Moon and returned samples of rock to Earth, with the final mission leaving in 1976. The rovers Lunokhod 1 and 2 were the first remote-controlled vehicles to drive on the surface of another world, and operated for eleven and four months respectively. Lunokhod 2 traveled 23 miles (37 kilometers), and held the distance record for a remote-controlled rover until it was surpassed by NASA's Opportunity on Mars 43 years later.

NASA spending declined after Apollo, and the agency concentrated on the Space Shuttle program. Both

Traveling
Robert Massey

superpowers were now exploring other targets. NASA's Voyager spacecraft and the Viking landers on Mars, and Soviet missions to Venus, returned scientific data and dramatic images of other planets, at a lower cost than a single Apollo flight. With the single exception of a mission using the Moon's gravity to accelerate into the solar system, no probes went to the Moon in fourteen years from 1976.

Elsewhere in the world, the US-Soviet duopoly in launch vehicles ended in 1965 with the French launch of the Astérix satellite from Algeria. China followed in 1970 with the launch of Dong Fang Hong I ("The East is Red"), a satellite that broadcast a song of the same name in a statement appropriate for Mao's premiership. Japan launched a satellite later that year, the UK launched its only satellite to date in 1971, and India entered the space club in 1980. The European Space Agency (ESA), initially with ten member countries, was established in 1975.

Competition between space agencies, and in the private sector for space contracts, drove down costs so that placing satellites in Earth orbit has become routine. The acceptable cost of space missions is also lower than in the past, accommodated by science and engineering teams through smaller vehicles, and helped by step changes in computing power. Though international teams enjoy a healthy rivalry, most space projects today rely on a cooperation between nations that would have been impossible in the Apollo era and the Cold War. Russian, Indian, Chinese, Japanese, Canadian, European, and American missions (though the US limits cooperation with China) share at least scientific instruments and launch facilities, and in the 2007 Global Exploration Strategy, and the 2013 roadmap that followed, agreed on at least some priorities for the years ahead.

Japan ended the fourteen-year lunar hiatus with the 1990 Hitomi probe, a technology test with the partially successful release of an orbiter, the main probe eventually deliberately crashed into the surface.

In the years since, the US, Europe, India, Japan, and China have all explored the Moon. There are highlights like HDTV footage (from Japan's Kaguya mission), the discovery of water ice in the soil at the South Pole (detected through the plume of material kicked up when the NASA LCROSS crashed into Cabeus crater in 2009), moisture in rocks across the Moon (India's Chandrayaan-1 probe), and China's Jade Rabbit rover, named after Chinese moon goddess Chang'e's pet rabbit. Though the motives in the 1960s were very much about national prestige, opportunistic scientists took full advantage of the space program.

Analyzing rocks and other materials brought back helped piece together the history of the Moon and provide a means of calibrating the age of craters found across the solar system. Timing the laser beams fired from Earth, which reflect off mirrors left behind on the lunar surface, confirms the Moon's slow drift away. Seismometers placed there detected moonquakes for years. And from orbit, high-resolution cameras found cave-like features that might one day be a suitable refuge for future astronauts.

Beyond the science, the Apollo program and its astronauts continue to inspire scientists and engineers. Grand challenges of this kind fascinate adults and children alike, and in at least in some cases, motivate young people to pursue scientific careers of their own—and to think of how they too might explore the universe for themselves, whether in the depths of the Earth's oceans, out in space, or inside the nucleus of an atom.

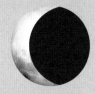

ARRIVING

AFTER THE COSMIC DREAM COMES TRUE

It has been half a century since humans first made a serious and eventually successful attempt at reaching the Moon. The Apollo missions, during which only a dozen men walked the surface of the Moon, disrupted dust that had lain undisturbed for millions of years on its surface. The Moon landings, in particular the first, are part of our global collective memory, and the photographs produced during these journeys have become among the most iconic of the twentieth century. Finally, we had close-up images of that mysterious orb in the sky that had had such power over our imagination, beliefs, and emotions, quite apart from its actual physical impact on the Earth. How did seeing and experiencing the Moon at close quarters change how we look at it, what we think about it, and how we depict it?

In the years just after the First World War the idea of actual space travel was slowly gaining momentum. Given the advances in transport technology and aviation, it began to seem almost possible that in the future humans might be able to go into deep space and reach other places in the universe. Rockets developed during the Second World War by the Nazis as defence weapons ironically helped move the American plan of conquering space forward, after they successfully engaged the German engineer Wernher von Braun, who championed the US space effort. It is thought that film director Stanley Kubrick's 1964 dark black comedy *Dr. Strangelove or: How I Learned to Stop Worrying and Love the Bomb* is a thinly disguised comment on this unsavory aspect of the Space Race.

By the mid-twentieth century, science fiction had moved on from whimsical visions of journeys to the Moon by means of impossible flying machines or supernatural intervention to more scientific narratives of what might actually be possible. H. G. Wells had introduced a focus on rocket science at the beginning of the century. The next generation of science-fiction writers would witness many aspects of their own stories (and the genre overall) coming true—or becoming desperately inconsequential. Arthur C. Clarke, who in 1968 would co-write the screenplay for Kubrick's highly sophisticated and deeply disturbing film *2001: A Space Odyssey*, was interested in the real possibilities of, and developments in, space exploration and joined the newly founded British Interplanetary Society when still a teenager. The society promoted space travel and exploration and provided the young writer with up-to-date

Arriving
Alexandra Loske

material for his stories. His work has been classed as "hard" science fiction, meaning it is concerned predominantly with the physical, chemical, and technological challenges of space travel, with particular focus on accuracy.

The story of reaching the Moon, of course, begins long before Neil Armstrong and Buzz Aldrin first kicked up some Moon dust in 1969, and involves more than just the arts and sciences. It is valid to look back at the race to the Moon and discuss its significance in the greater philosophical context of humanity, but in many respects it is a story of political ambitions, posturing, vanities, and propaganda, set against the backdrop of the Cold War and the constant threat of another, wholly destructive war breaking out. In western Europe and the United States, the 1950s and 1960s were a time of rebellious, loud, exciting youth culture that was at serious risk of being cut short by the battlefield the previous generations had created. It was also a time of unexpected and unprecedented economic growth, at least for some countries, resulting in a period of joyful and largely unapologetic consumerism. The Space Race was therefore partly escapism, and cosmic fantasies were high currency, with TV shows like *Star Trek* enjoying huge popularity alongside more fact-based documentaries. Yet these were still relatively early days for television, when very few people had color TV. Behind the iron curtain, in Eastern Europe and the Soviet Union, space exploration had a less consumerist dimension but was even more politicized, and exploited in a much bolder visual style. Soviet propaganda graphics were unashamedly sensationalist, colorful, and idealized, and entirely orchestrated by the government.

Apart from the global enthusiasm about the calculated spectacle of a race to the Moon, there were also critical voices. Questions were, and still are, asked about why so much money should be spent on something with potentially very little measurable long-term impact? And there were more philosophical and ethical questions, too. Should we really taint the untouched Moon with our presence? And why were we doing it? There is no single answer to these questions, but political power struggles between the US and the Soviet Union played as big a role as inherent human ambition. We may simply have put men on the Moon because we could.

Soviet Space-Age art and propaganda material differs considerably from the American output. The Americans tended toward a literal approach, illustrating their progress often with impressive detail about the processes and technology involved. The Soviet aesthetic was much more figurative. Technical detail was eschewed for blocky, post-revolutionary graphics full of saturated colors and geometric shapes that reflect both the designs of Space-Age machinery and the outlines of cosmic bodies. The illustrated faces of cosmonauts exude strength, pride, and youth, with their eyes firmly fixed on their goal in the distance. The vast amount of Space-Race memorabilia and toys produced by the Soviet Union were considerably more colorful than the actual rockets, modules, or indeed the Moon itself.

After the devastation of the Second World War there was among artists a general sense of the inevitability of a complete rethinking of what mattered. How could art reflect the state of the world? There was a need for a new visual language, and many of those who created it felt that it should be abstract: the iconography of old did not hold any more. The result was that Space-Race era coincided with the age of pop art and abstract minimalism. All the

Arriving

Alexandra Loske

more interesting then that what humans saw, when Aldrin and Armstrong left the lunar module, was essentially an awe-inspiring landscape that they wanted to capture as an image, just as the Romantics had when they witnessed a storm over the Alps or a cumulonimbus cloud over the sea. The Apollo 14 astronaut Edgar Mitchell once described his impression of standing on the Moon to Andrew Smith, who collected the personal stories of the Moon walkers: "The stillness seemed to convey that the landscape itself had been patiently awaiting our arrival for millions of years". It is reminiscent of those solitary figures looking at a vast landscape in a Caspar David Friedrich painting (such as the one on page 37). At that moment, Mitchell stood for humankind contemplating its ultimate achievement: to go beyond the world as we knew it, to a different world, still alien to us, and utterly inhospitable.

So there was the Moon, in all its monochrome gray and surprisingly smooth shapes. None of the ragged, spiky mountain ranges all those science-fiction tales and films had suggested. No strange plants, no bizarre creatures, no aggressive native Selenites defending their land—quite the opposite: the lunar landscape was utterly barren. Buzz Aldrin described it as "magnificent desolation." Scientifically it was, of course, hugely interesting, but visually we had been short-changed. A couple of thousand years of visions of lunar voyages, expressed in poetry, painting, novels, TV programs, and films, had been answered with gray rock and dust.

The answer to this disappointment came partially from the abstract artists, who delighted in the shapes and geometry offered by space travel. The clean lines of spacecraft, the circular shape of the Moon and planets silhouetted against the blackness of the universe. Much of what was anticipated earlier in the century by Modernists and Expressionists was now revisited and sometimes distilled. There are many elegant and almost entirely geometric compositions from artists such as Paul Klee, Roy Lichtenstein, and Barbara Hepworth that can perhaps be interpreted as visual comments on the Space Race. Pop and rock music, fashion, and design also responded, albeit in a more light-hearted and playful way, with David Bowie perfecting the role of post-modern, disconnected, and almost comical spaceman in the early and mid-1970s, filling the emotional void that followed after the amazement of the first Moon landings with a fictional version of himself. Bowie was not only creating a satire of pop culture but was also officially ringing in a new post-Apollo era.

Did we lose the Moon as a benign, serene, Romantic metaphor? Did we lose that silver mirror in the sky, the nightly wanderer, the anthropomorphized disc, the spiritual timekeeper, the winking eye, the object of contemplation, the symbol of love, melancholy, loneliness? It seems that for a while we did. Interest in the Moon and subsequent space missions waned in the early 1970s, and images of the Moon in art, whether abstract or realistic, are relatively rare in the later twentieth century, with a few exceptions. One of these is Alan Bean, who walked on the Moon during the Apollo 12 mission. Just over a decade after the mission, Bean became a full-time painter: He almost exclusively paints the Moon and the Apollo mission he was part of, in hyper-realistic detail, with colors that appear as if certain filters have been added to the image. It is clear that to Bean the experience of leaving Earth and walking on the Moon was so intense that he will keep on analyzing and visualizing this event for possibly the rest of his life.

Arriving
Alexandra Loske

By comparison, the Hayward Gallery London staged an exhibition of photographs taken during the Apollo missions on the thirtieth anniversary of the Moon landing. While Bean was struggling to find the right colors for his depictions of the Moon, the photographs appeared like black-and-white prints until the eye adjusted and picked out some small color element. A special printing ink had to be created to accurately depict the blackness of space. In this context, the photographs not just documentary sources, but works of art in their own right. As a group, they made a visual journey through those extraordinary events, and the exhibition was hugely popular.

The Moon remains a major source of inspiration in art and culture, and there are many contemporary artists who make it one of their main themes. Aleksandra Mir, for example, has photographed herself in fake Moon landing scenes, raising questions about male dominance in the history of lunar exploration, while her collages (see page 17) combine familiar images from space exploration with female faces and religious imagery. Katie Paterson explores our fascination with the Moon as a source of wonder and inspiration, as well as a symbol of distance, creating immersive multi-media spectacles, such as a mirror ball reflecting images of every documented solar eclipse in human history (see pages 102–103), or a recording of Beethoven's Moonlight Sonata, sent to the Moon in morse code and returned to us in an altered, fragmented version. Fergus Hare references landscape painters from previous centuries in his work. He bases many of his pensive landscapes on careful study and observation of natural phenomena, and has created a series of drawings of the Moon as seen through a telescope. It is fascinating to see how today's artists incorporate the collective experience of humankind yearning for and eventually reaching the Moon in their art, each in their unique way.

Half a century after the Apollo missions, we may have enough distance from those heady days of the race to the Moon to begin to bring the imagined Moon and the Moon we briefly touched together in our minds and collective memory. We can now perhaps recognize the long-term impact of reaching the Moon on the human psyche, and are realizing that, however exciting or disappointing it was to see the Moon close up, it was perhaps even more important to see ourselves from a distance. Only twelve humans have stood on the Moon, but that picture of the Earth rising beyond the Moon is for everybody.

RETURNING
BACK TO THE MOON

Immediately after 1969, and certainly when the authors were children in the 1970s, space travel back to the Moon, then to Mars and beyond, seemed a certainty. Wernher von Braun argued for a NASA mission to Mars by 1983 using a nuclear propulsion system, but with the political ambition of the Moon landing achieved, and the budget in retreat, there was little prospect of this becoming a reality. The US Space Science Board in 1969 argued for continued exploration of the Moon using existing technology and a further fifteen crewed missions—but strongly against large-scale expenditure on new systems at the expense of other projects.

In the nearly five decades since the first Moon landing, plans for lunar exploration and science have appeared from time to time, both as a stepping stone for travel on to Mars and in its own right. Artists of a space (or science-fiction) inclination regularly enjoy creating images of Moon bases, with rovers traveling around the surface and launches of mined material back to Earth. We now live in an era where the chief executives of large companies, inspired by these visions and with cash to spend, are developing space vehicles of their own, in contrast to the government monopoly of the past.

There undoubtedly is a scientific case for humans returning to the Moon, with proponents arguing that the flexibility and ingenuity of human beings still far exceeds the capabilities of robots. Planetary scientists and astronomers identify various benefits of a return to the Moon. The Apollo missions, and the Soviet sample-return spacecraft, visited only a handful of locations on a world with a surface area nearly as big as Europe and Africa combined. The result is a gap in samples from the youngest and oldest terrain, which in turn makes our understanding of the history of the Earth and other planets less certain. Human missions could flesh out the samples by traveling to the Moon's far side, South Pole, and younger craters like Copernicus. Building on the legacy of Apollo, planetary scientists would love to see a new set of instruments stationed on the Moon, to measure moonquakes and magnetic field strength, and use their data to better understand the lunar interior.

Intriguingly, astrobiologists, scientists who study (still-hypothetical) extraterrestrial life, also see the Moon as a source of evidence. The lunar soil may contain organic material from the early solar system, the record of which has long since been destroyed on Earth. When they return to the Moon, future lunar explorers could look at the

Returning
Robert Massey

landing craft that previously arrived unsterilized from Earth, and record the fate of any bacterial and fungal stowaways that traveled with them.

Additionally, the far side of the Moon would be an excellent site for a radio telescope, the tool astronomers use to study objects by detecting their radio signals. A site there, with the whole Moon between it and the Earth, would be completely shielded from interference from terrestrial transmissions that compromise astronomical radio sources, which include the remnants of exploded stars and huge jets from the center of galaxies. A lunar radio telescope could even search for faint signals from extraterrestrial civilizations.

The Apollo program had cost 20 billion US dollars by 1973—the equivalent of at least 110 billion US dollars today. Some large-scale space projects, like the International Space Station (ISS), required a comparable investment, and governments around the world are understandably unable to commit this kind of sum to a single endeavor too often. It is possible to mitigate the expense by sharing the cost and coordinating the plans with spacefaring nations, while private-sector entrepreneurs also look for direct economic benefits accruing from a presence on the Moon, or at least by being the preferred supplier of spacecraft for publicly funded missions.

Existing private-sector initiatives are diverse. Some see the Moon as a potential site to mine for so-called "rare Earth elements"—minerals that have a variety of applications in engineering, optics, and energy. Even setting aside the prohibitive cost of setting up the equipment and on-site processing (sending ore back to Earth would be a wasteful starting point), their typical concentration in lunar rocks appears to be low, so at the moment the business case is weak. The same arguments apply to Helium-3, mooted as a clean fuel for future nuclear fusion reactors, but again apparently not abundant enough for lucrative commercial extraction.

The crowdfunded robotic mission Lunar Mission One, meanwhile, aims to drill a deep hole in the lunar surface and deposit human DNA there in an "ark" to preserve a record of humanity. A very different initiative was the 30-million-dollar Google Lunar XPRIZE. This was on offer to the private team that sent a spacecraft to the Moon, achieved a soft landing, and made its rover or other vehicle travel 1,600 feet (500 meters) across the surface. Five teams from the US, India, Japan, Israel, and the multinational Synergy Moon, were seriously in the running until the deadline passed early in 2018. Despite missing out on the prize, the engineers and scientists involved designed spacecraft that are light and cheap, a valuable step forward for future missions.

Larger-scale companies, led by technology billionaires, are more ambitious. These rival organizations, helped by lucrative government contracts and their earlier business success, are pushing new vehicle designs, with their CEOs looking to the Moon and farther afield in a new kind of Space Race.

SpaceX, led by the high-profile entrepreneur Elon Musk, routinely supplies the International Space Station in a contract with NASA, and expects to take astronauts to the orbiting outpost in the near future. The company is working on reusing the two or three stages that make up a launch vehicle, one way to deliver lower-cost access to space. SpaceX is making good progress: it successfully returned a first stage to its launch pad in 2015, and the high payload Falcon Heavy rocket made its inaugural flight in 2018,

Returning
Robert Massey

displaying its success by carrying Musk's Tesla Roadster (and a dummy driver in a spacesuit) into interplanetary space. Musk now plans to use the Falcon Heavy to send astronauts around the Moon in the near future.

Jeff Bezos, the Amazon CEO with a longstanding interest in space, founded the rival space company Blue Origin with a similar interest in the ISS, its own NASA contract, and similar ambitions for reusable launchers. Bezos has a more direct interest in conquering the Moon: his proposal is an "Amazon-style delivery" of materials to build a lunar base, part of a grand—or grandiloquent—vision of the colonization of space.

Long-established space players are not leaving it all to the younger companies. Boeing, which supplied NASA in the Apollo era, is developing supply spacecraft for the agency in a new contract. Lockheed Martin and Boeing formed the United Launch Alliance back in 2006, and plan to send a robotic lander to the Moon in 2019. It remains to be seen if this is viable, but the two companies even propose a "cislunar economy," with space-based manufacturing, solar energy, lunar mining (notwithstanding the difficulties described above), and the transportation of assembled goods back to Earth.

The buzz around commercial and private space exploration might suggest that governments are scaling back their efforts. But though there is less fanfare than in the 1960s, spacefaring powers all have lunar ambitions. In the US the Orion spacecraft, designed to carry astronauts to the Moon and Mars in the 2020s, saw its first successful test in 2015, with a four-and-a-half-hour uncrewed flight and splashdown. Europe, Japan, Russia, and China have set their sights on sending people back to the Moon too, aiming to of seeing astronauts on the surface in the 2030s.

Their space agencies have all sent robotic probes in the last two decades, with China sending the first soft-landing vehicle (the Jade Rabbit rover) in nearly 40 years.

A long-term goal, and one purportedly suggested as early as the seventeenth century by Bishop John Wilkins, is the construction of a permanent lunar settlement. The idea of living on the Moon, even for short periods, is fascinating and a mainstay of science fiction. And in 2016, Johann-Dietrich "Jan" Wörner, the new Director General of the European Space Agency (ESA), announced a proposal for a "Moon Village," partly constructed using 3D printing, and open to partners from around the world (see page 199). According to Wörner, the base would not be a place to "combine the capabilities of different spacefaring nations," with the inhabitants working on science and perhaps eventually mining and tourism.

Any lunar base needs regular supplies from Earth, but there are plans to "live off the land" too. The estimated six trillion tonnes of water ice in polar soil could be a vital supply, for drinking, to be broken into hydrogen and oxygen to make rocket fuel, and for agriculture. NASA has tested the practicalities of hydroponics (growing plants in water) for several decades, and in 2013, Dutch researchers tested the growth of plants in lunar soil with some success.

Whether toward a permanent Moon base, or as another series of fleeting moonshots, plans for a return to the Moon always deserve some scepticism. With the legacy of Apollo, the idea of sending astronauts to a target that is 250,000 miles (400,000 kilometers) away manages to seem both readily achievable and impossibly ambitious. Yet perhaps now, 50 years after the first footprints on the lunar surface, the nations of the world are ready to aim high once again, and start the human journey into the wider universe.

INDEX

advertising 75, 112–113, 115, 191, 219
Aitken Basin *see* Moon, South Pole
Al-Attar, Suad 120–121
Al-Biruni 151
alchemy 166
Aldrin, Buzz 7, 54–55, 57, 60, 63, 64, 76, 124, 226, 230–231,
An American Werewolf in London 126, 130–131
ancient civilizations 6–7,12, 26, 70, 208–209, 211, 218
ancient Egypt 26, 70, 167, 209
Ancient Greece 12, 70, 132, 186, 211–212
Anders, William (Bill) 76, 226
Apis Bull 25
Apollo (god) 32, 129
Apollo program 54, 63, 76, 104–105, 195, 198, 204–205, 215, 223–228, 231–232, 233–235
 Apollo 1 76, 227
 Apollo 7 226
 Apollo 8 76, 226
 Apollo 9 226
 Apollo 10, 62–63, 226
 Apollo 11 7, 57–61, 63, 64–65, 84, 104, 143, 198, 206, 222, 226
 Apollo 12 9, 64, 66, 154, 158 231
 Apollo 13 227
 Apollo 14 155, 231
 Apollo 15 86–87, 227
 Apollo 16 63, 86, 88, 227
 Apollo 17 54, 63, 86, 184–185, 227
 Apollo-Soyuz mission 63
Arbo, Peter Nicolai 137
Aristarchus of Samos 212
Aristotle 141, 212
Armstrong, Neil 7, 54–55, 57, 60, 63, 64, 222, 226, 230–231
Astérix satellite 228
Astronaut Miss Barbie 20, 107
astronomers 6, 50, 141 156, 161, 172, 178, 191, 210, 211–215, 233–234
 ancient 211
 Muslim 212
Atkinson Grimshaw, John 138–139, 180–181, 219
Ay Yildiz 162

Baluschek, Hans 72–73
Barbier, Georges 118
Bayer, Herbert 117
Bean, Alan 154, 231–232
Benois, Alexander Nikolayevich 28–29
Beer, Wilhelm 50
Beethoven, Ludwig van 216, 232,
Bezos, Jeff 235
Bizley, Richard 192–193
Blake, William 52, 73
Blommér, Nils 36
black Moon 178
Blue Marble 184–185
blue Moon 178
Blue Origin 235
Bogdanovich, Peter 115
Borman, Frank 76, 226
Bowie, David 107, 231
Braque, Georges 165

Carpenter, James 80–83
Cassini, Giovanni Domenico 153, 214
Cernan, Eugene 63, 86, 185
Chaffee, Roger 225
Chandra (or Soma) 26–27, 33
Chandrayaan-1 26, 228
Chang'e 168, 175, 228
chariots 14–15, 26, 29, 30–33, 73
Cheredintsev, Valentin 100
Christianity 26, 162, 208–210, 212, 218
Cicognara, Antonio 19
Clarke, Arthur C. 229
Clementine spacecraft 159
Collins, Michael 7, 60, 224, 226
Columbus, Christopher 44
command module 63, 225–226
commercial space exploration 234–235
Conrad, Charles 154
Copernicus, Nicolaus 213
Copernican theory *see* solar system, heliocentric model
Courrèges, André 106–107, 111

da Vinci, Leonardo 213
Daguerre, Louis 214
Dam, Michael 183
Davis, Donald E. 202–203
de Loutherbourg, Philip James 216
Deep Space Climate Observatory

(DSCOVR) satellite 196
Dembosky, Ron 200
di Duccio, Agostino 30–31
Diana 14, 26, 32, 129, 209, 218
Dick, Thomas 161
Dong Fang Hong 228
Draper, John William 214
Drückmuller, Miloslav 46–47
Duke, Charles 86, 88
Dulac, Edmund 210

Earth-Moon system 6, 141, 144, 185, 194–195, 196, 198, 204–206, 208, 211–213, 229
Earthrise 76–77
eclipses 26, 40, 44–45, 48–49, 101, 102–103, 144, 208–209, 211, 217
 etymology 208
 lunar 44–45, 149, 191, 212
 solar 44, 46–47, 144, 156, 232
Elswa. Johnny Kit 174–175
environmental movement 76, 185
European Space Agency (ESA) 199, 229, 235
Evans, Ronald 185

fairy tales *see* folk tales
fashion *see* Space Age, fashion
film 7, 39, 74–75, 115, 126, 130–131, 198, 216, 220–222, 229, 231
Fitzgerald, Ella 115
flat-Earth theory 185
folk tales 74–75, 115, 126, 208, 210, 222
Frau im Mond 20–21, 222
Friedrich, Caspar David 37, 216, 231

Galilei, Galileo 146, 172–173, 213
Galileo spacecraft 8–9, 142, 194–195,
Gagarin, Yuri Alekseyevich 94, 99, 111–112, 224
Géry-Bichard, Adolphe-Alphonse 53
Gilbert, William 213
Glushko, Valentin 99
Goethe, Johann Wolfgang von 218
Goff, Bryan 44–45
Google Lunar XPRIZE 234
Gray, Thomas 34
great bombardment
 see Moon, origin

236

Great Moon Hoax 160–161, 214, 221
Grissom, Virgil 225
Grünberg, R. 78

Hallinan, Dennis 84
Hamilton, Margaret 104–105, 225
Hare, Fergus 232
Harriot, Thomas 172–173, 213
harvest season 70, 175, 178
Hayman, Francis 135
Hepworth, Barbara 231
Herrmann, Alfred 21
Herschel, Caroline 161, 214
Herschel crater 66
Herschel, John 161, 214
Herschel, William 66, 161, 214
Hevelius, Johannes 214
Hiroshige, Utugawa 119
Hitomi probe 228
Hubble Space Telescope 76
Huggins, Margaret and William 214
Hughes, Ted 207, 210

Indian space program *see* Indian Space Research Organization
Indian Space Research Organization 26, 228
intercontinental ballistic missiles (ICBMs) 99, 223
International Space Station (ISS) 227, 234–235
Irwin, James 86–87
Islam 6, 144, 162–163, 212

Jackson, Michael 126
Jade Rabbit rover 175, 228, 235
James I 172
Jerram, Luke 188–189
Johnson, Katherine 225

Kennedy, John F. 224–226, 227
Kepler, Johannes 141, 213, 221
Kircher, Athanasius 150–151
Klee, Paul 147, 231
Khonsu 26, 167, 209
Knowth passage tomb 211
Korolev, Sergei 98–99, 224
Kubrick, Stanley 198, 229

Laika 99, 176–177, 223
Lang, Fritz 20–21, 222
Lascaux Cave 208
lava tubes 156–157, 198, 206
Le Voyage dans la Lune 74–75, 115, 221–222
Les Nouvelles de Moscou 96
Lichtenstein, Roy 231

Lilja, Nils 79
Lippershey, Hans 172, 213
Locke, Richard Adams 161
Lord Byron 219
Lovell, James 76, 226
Lucian of Samosata 220–221
Luna (deity) 14–15, 26, 190–191
Luna program 95, 227
Luna 1 224
Luna 2 224
Luna 3 90, 143, 224
Luna 9 225
lunacy 132–133, 218
lunar
 atmosphere 6, 80, 205, 214–215, 222
 see also lunar, environment
 calendars 6–7, 70, 144, 162, 178–179, 208, 211, 212
 craters 6, 10, 50–51, 64, 66, 82–83, 86, 99, 144, 152, 156, 205–206, 207, 214, 215, 221, 224, 226–228, 233
 cycle 12, 178, 209
 see also Moon, phases
 deities 6, 12, 14, 24, 25, 26–27, 32, 33, 162, 167, 168, 175, 186, 209–210, 211, 215, 218, 222, 228
 environment 80, 86, 198, 206
 see also lunar, atmosphere
 halo 67
 inhabitants 74–75, 156, 161, 212, 214, 220–223, 235
 maria 9, 80, 143, 175, 206, 207, 211, 214, 224
 see also lunar, craters
 module 9, 54, 62–63, 64–65, 88, 89, 104, 225–227, 231
 mountains 144, 156, 205–206, 207, 214–215, 216, 221, 222, 231
 night 144, 206, 215
 probes 26, 90, 99, 205, 224–225, 228, 235
 radio telescopes 225, 234
 rovers 86–87, 175, 198, 227–228, 234–235
 X 50–51
Lunar Mission One 234
Lunar Orbiter spacecraft 225
Lunar Reconnaissance Orbiter Camera (LROC) 80, 143
Lunar Roving Vehicles (LRVs) 86–87, 227
 see also Jade Rabbit rover, lunar rovers, Lunokhod 1 and 2
Lunokhod 1 and 2 227
lycanthrope *see* werewolf

Mädler, Johann 50
Madonna *see* Virgin Mary
Mann, Edward 107

Marie, Queen of Romania 210
Martin, John 217
Mattingly, Ken 88
Méliès Georges 74–75, 115, 222
menstrual cycle 12, 209
Miotte, P. 150
Mir, Aleksandra 16–17, 232
Mitchell, Edgar 231
Modersohn-Becker, Paula 155, 178–179
Moirai 186
Molino, Walter 125
Monument to the Conquers of Space 30
Moon
 and death 7, 34, 38–39, 42, 186, 208–209, 211, 218
 and fate 7, 186–187
 and femininity 12–13, 39, 134, 186, 209–210, 218
 and fertility 7, 12, 26, 39, 209–210
 and night 6, 34, 39, 186, 207, 209–210, 218
 and water 12, 22–23, 36, 39, 132, 166, 188–189, 195, 210, 220
 see also tides
 anthropomorphized 74–75, 174–175, 209, 220–221, 231
 as benign 12, 34, 207, 218–219, 231
 as male 12, 26, 222
 as paradoxical 6, 207, 210, 216–219
 base 7, 156, 198–199, 234–235
 color of 44, 54, 178, 208–209, 215
 dust 54, 86, 198, 229–231
 far side of 6, 90, 99, 143, 144, 205–206, 214, 224, 226, 233–234
 fictional journeys to the 73, 74–75, 161, 220–222, 229–230
 landing 7, 54, 56, 63, 104, 206, 223–228, 232, 233
 Man in the 174–175, 220
 mapping *see* selenography
 Native American names 178–179
 origin 6, 192–193, 204–206
 phases 6–7, 12, 132, 144–145, 146, 150–151, 186, 208–210, 211–213, 218
 rabbit 175, 176
 returning to the 198, 206, 233–235
 rock 154, 155, 158, 226–227, 231
 South Pole 152, 205–206, 215, 229, 235
 temperature *see* lunar environment
 terminator 144, 172
moonlight 22, 34, 120, 135, 137, 139, 147, 180, 183, 216, 218–219
Moore, Sir Patrick 215
Muchery, Georges 186–187
Munch, Edvard 34–35, 189
Musk, Elon 236–237
mythology 6, 22, 26, 41, 69, 126, 135, 208–210

Aztec 175
Babylonian 208–209
Chinese 176, 208
Egyptian 25, 167
Greek 39, 126, 186
Hindu 26, 33
Norse 36, 137, 186
Ottoman 162
Roman 24, 126, 186, 208

Nanna *see* Sin (or Nanna)
NASA 9, 57, 61, 62, 64, 66, 76, 80, 88, 89, 99, 104–105, 142, 143, 152, 154, 155, 158, 159, 185, 195, 196, 197, 202, 215, 223–228, 233–235
　women in 104, 224–225
Nash, Paul 219
Nasmyth, James 80–83
Nat King Cole 115
Nebra Sky Disc 70–71, 208, 211
New York Times 56
Newton, Isaac 213
Nielsen, Kay 210
Nixon, Richard 54
Noel, Guy Gerard 126–127
Norns 186

Obama, Barack 104
O'Neal, Ryan and Tatum 115
Offenbach, Jacques 222
Orion (lunar module) 88
Orion spacecraft 235
Osiris 26, 209
Osman I 162
Ovid 126
owls 34, 39, 42,

paper moons 114–115, 116, 219
Parcae 186
Parrag, Emil 22–23
Parsons, Laurence 215
Paterson, Kate 100, 102–103, 232
Percy, Henry 172
Perugino, Pietro 14–15
Peterchens Mondfahrt 72–73, 222
Picturesque *see* Romantic art
Pioneer program 224
Pleiades constellation 70–71
Plutarch 212, 220
Poe, Edgar Allan 161
poetry 34, 186, 207, 209, 218–219, 220
Predis, Cristoforo de 190–191
Project Gemini 225
Project Mercury 224

Quetzacoatl 175

R-7 rocket 99

Rackham, Arthur 136–137
Raleigh, Sir Walter 172
Ranger series 225
Raspe, Rudolf Erich 221
regolith 198, 199
Reiman, Andrea 140–141
Romantic art 37, 39, 182–183, 216–219, 231, 233
Rousseau Henri 129
Russell, John 68, 148–149
Russell, Sally 50–51

Saint-Gaudens, Augustus 14
Saros cycle 211
Saturn 1B rocket 225
Saturn V 63, 221, 223, 225–226
Schmidt, Johann Friedrich Julius 11, 50
Schmitt, Harrison 54, 86, 185, 227
Schroeter, Johann H. 218
science fiction 78, 160, 185, 198, 220–223, 231, 237
Scott, David 86–87
Selene 24, 209, 223
selenography 50–51, 68, 146, 148, 153, 172–173, 211–215
Shakespeare, William 218
Shelley, Mary 218
Shelley, Percy Bysshe 218
Shepherd, Alan 155
Smith, Andrew 233
Smith, Charles Piazzi 215
Sin (or Nanna) 26, 209
solar system
　heliocentric model 212–213, 221
　Ptolemaic system 212–213
Soma *see* Chandra (or Soma)
Soviet
　propaganda 30, 90–91, 223, 230
　space program 90, 95, 99, 223–228
Space Age 99, 213, 215, 232–233
　fashion 106–107, 109, 111
Space Race 7, 90, 94, 95, 99, 107, 198, 223–228
　toys 92, 93, 97, 230
space colonization 90, 202, 203, 230, 235
Space Shuttle program 227
Spaceship Earth 76
SpaceX 234
spectroscopy 214
Sputnik 90, 99, 100, 223
Sputnik II 223
Stafford, Thomas 63
Stalin 99
STEREO-B spacecraft 197
Stonehenge 73, 211
Storm, Theodor 171, 223
Stratton, Helen 170

Sun
　corona of 40–47, 198
　deities 12, 32
　supermoons 140–141
Surveyor craft 225
symbolism 6–7, 12, 34, 39, 39, 162, 166, 175, 178, 204, 207–210, 216–219, 222, 226, 231–232

Taiso, Yoshitoshi 176
telescopes 50, 80, 144, 156, 161, 172, 175, 205–206, 207, 212–215, 218, 221, 232
Tereshkova, Valentina 95, 96–97, 224
Theia 204–205
Thiele, Karl Friedrich 12–13
Thoma, Hans 22, 40–41, 69
Thoth 26, 209
tides 6–7, 12, 70, 141, 195, 205
Tishkov, Leonid 10
Trouvelot, E. L. 40–41, 149
Turner, J. M. W. 216–217, 219
Tycho crater 9, 82–83, 156, 227–229

Ulugh Beg 212
US space program *see* NASA

V-2 rocket 222, 223, 229
van der Neer, Aert 180
van Eyck, Jan 208, 213
van Gogh, Vincent 132–133, 189
von Braun, Wernher 99, 224, 225, 231, 233
von Bassewitz, Gerdt 72, 222
Vedder, Elihu 40
Verne, Jules 17, 75, 79, 221–222
Victorov, Valentin Petrovich 94
Viking landers 229
Virgin Mary 16–19, 218
Volokov, Vadim 101
Vostok spacecraft 98–99
Voyager spacecraft 228

Warhol, Andy 124
water ice 7, 206, 228, 235
Wells, H. G. 75, 222, 229
Wenz-Vietor 171
Werewolf 126–127, 128, 130–131, 132
Whitaker, Ewen 215
White, Edward 227
Whistler, J. A. M. 219
Wilkins, Bishop John 235
Wörner, Johann-Dietrich "Jan" 235
Wright of Derby, Joseph 182, 216–217

Yeats, William Butler 186, 210
Young, John 62–63, 86, 88

Zond project 227

PICTURE ACKNOWLEDGMENTS

akg-images 13, 36, 41, 53, 78, 120, 171, 179, 189; arkivi 114; Erich Lessing 180; Fototeca Gilardi 125, 134; Universal Images Group/Universal History Archive 92, 93.

Alamy Stock Photo AF Archive 131; Art Collection 3 69; Chronicle 176; DE ROCKER 30; Dennis Hallinan 84; dpa picture alliance archive 71; Encyclopaedia Britannica, Inc./NASA/Universal Images Group North America LLC 155; Everett Collection, Inc. 21, 130; Fine Art Images/Heritage Image Partnership Ltd. 94l, 110, 112; Florilegius 108; Granger 133; Granger Historical Picture Archive 56, 62, 74, 95br; H. Armstrong Roberts/ClassicStock 85, 200; Heritage Image Partnership Ltd. 35; INTERFOTO 122; ITAR-TASS News Agency 100; John Frost Newspapers 96; Keystone Pictures USA 106; Lebrecht Music and Arts Photo Library 91; Martin Bond 163; Mattia Dantonio 95acr; Myron Standret 95cl; NASA Image Collection 105; Paul Fearn 22; Photo Researchers/Science History Images 58, 61, 98, 151; Prisma Archivo 25; Ruslan Kudrin 95al; Ryhor Bruyeu 94br; Sergey Komarov-Kohl 95acl; 95cr; Stephan Stockinger 164; The Print Collector 94ar; World History Archive 37, 109, 177; Zoonar GmbH/Alexei Toiskin 95bl; Zoonar GmbH/V.Sagaydashin 95ar.

© **Aleksandra Mir** 16.

Courtesy Alexandra Loske 72, 82, 83.

Beinecke Library, Yale University 166, 174.

Bridgeman Images 127, 129; British Library, London, UK/© British Library Board. All Rights Reserved 29; Private Collection/© DACS 2018 117; Biblioteca Estense, Modena, Emilia-Romagna, Italy 190; Biblioteca Nazionale Centrale, Florence, Italy/De Agostini Picture Library 146; Bibliotheque de l'Institut de France, Paris, France/Archives Charmet 128; Bibliotheque Municipale, Boulogne-sur-Mer, France 32; Bildarchiv Steffens/Ralph Rainer Steffens 24; Birmingham Museums and Art Gallery 148; British Library, London, UK/© British Library Board. All Rights Reserved 42, 68, 118; Collegio del Cambio, Perugia, Italy 15; De Agostini Picture Library/A. De Gregorio 31; Detroit Institute of Arts, USA/Bequest of John S. Newberry 147; Drammens Museum, Norway/Photo © O. Vaering 137; Everett Collection 89; Fitzwilliam Museum, University of Cambridge, UK 52; Gamborg Collection 101; Granger 57, 154, 159; Leeds Museums and Galleries (Leeds Art Gallery) U.K. 138, 181; NASA/Science Astronomy/Universal History Archive/UIG 197; Photo © CCI 187; Pictures from History 27, 168; Private Collection 23, 121; Private Collection/© Look and Learn 67; Private Collection/© Look and Learn 116, 192, 201; Private Collection/© Look and Learn/Rosenberg Collection 191; Private Collection/Photo © Agnew's, London 182; Private Collection/Photo © Christie's Images/© 2018 The Andy Warhol Foundation for the Visual Arts, Inc./Licensed by DACS, London. 2018 124; Private Collection/Photo © Christie's Images/© ADAGP, Paris and DACS, London 2018 165; Private Collection/Photo © GraphicaArtis 123; Pushkin Museum, Moscow, Russia/© ADAGP, Paris and DACS, London 2018 28; The Higgins Art Gallery & Museum, Bedford, UK 136; UCL Art Museum, University College London, UK 43.

British Library via Flickr 79, 170.

ESA/Foster + Partners 199.

Getty Images Manuel Litran/Paris Match via Getty Images 111; Bettmann 160; Buyenlarge 97; DEA PICTURE LIBRARY/De Agostini 135; DeAgostini 19; Field Museum Library 11; Florilegius/SSPL 169; James Hall Nasmyth/George Eastman House 157; Space Frontiers/Hulton Archive 65; Time Life Pictures/NASA/The LIFE Picture Collection 60.

© **Katie Paterson** 102.

© **Leonid Tishkov** 10.

© **Luke Jerram** 188.

Metropolitan Museum of Art Gift of Francis M. Weld 1948, 119; Gift of George A. Hearn, in memory of Arthur Hoppock Hearn 1911, 139; Gift of Paul J. Sachs 1917, 48; Rogers Fund 1928, 14.

Courtesy Miroslav Druckmüller 46b, 47.

NASA 9, 55, 77, 87, 88, 152, 158, 184, 202, 203; Goddard/Arizona State University 143; JPL 64, 142, 194; JPL/USGS 8; NASA Goddard/Arizona State University 66; NOAA 196.

National Gallery of Art Washington Corcoran Collection (Gift of the American Academy of Arts and Letters) 38; Rosenwald Collection 18.

New York Public Library 149, 167, 46.

Public Domain 17.

REX Shutterstock Granger 113; Mattel/Solent News 20.

© **Sally Russell** 51.

Science Photo Library Max Alexander/Lord Egremont 173; Richard Bizley 192; Douglas Peebles 81.

Royal Astronomical Society 145, 153; SPUTNIK 49.

Unsplash Michael Dam 183; Bryan Goff 45; Andrea Reiman 140.

Wellcome Collection 150, 38.

www.lacma.org Gift of Paul F. Walter (M.83.219.2) 33.

Yale Center for British Art Paul Mellon Collection 73.

AUTHORS' ACKNOWLEDGMENTS

ROBERT MASSEY:

Co-writing "Moon" has been a pleasure, albeit one that demanded patience from my family and friends, and would not have been possible without the support of a good few people.

These lists are always incomplete, but I have to give huge thanks to Alexandra Loske, who persuaded me to do all this; to Sian Prosser, for helping me so much with material in the library of the Royal Astronomical Society, to Jane Greaves, Katie Joy, Ian Crawford and Lucinda Offer for fact-checking and proofreading, to Sally Russell for sharing her work, and to Phil Diamond, John Zarnecki and Nigel Berman for letting me pursue writing alongside my day job. Our editors Rachel Silverlight and Zara Anvari deserve our gratitude too, for giving us the honest feedback our writing needed.

My wife Jenny and my daughter Ada did all they could too: firstly in letting me spend time writing on our family holiday, and secondly in reminding me how everyone, young and old, reacts to seeing the Moon through a telescope for the first time. Without their love and support, this book could not have happened, so it should be dedicated to them.

ALEXANDRA LOSKE:

For support and lunar inspiration I would like to thank Clare Best, Eva Bodinet, Clive Boursnell, Franky Bulmer, Patrick Conner, Steve Creffield, Jenny Gaschke, Fergus Hare, Colin Jones, Renate Klauck-Neils, Shan Lancaster, Flora Loske-Page, Robert Massey, Klaus Neils, Jeremy Page, Jim Pike, Steve Pavey, Hazel Rayner, Jacqueline Rietz, Linda Rossbach, Lindy Usher, Ian Warrell, Marianne Wiehn, Chandra Wohleber, and CDF.

This is for my goddaughter Clara Rietz.